Remarkable Modernisms

DANIEL MORRIS

Remarkable Modernisms

CONTEMPORARY AMERICAN AUTHORS ON Modern ART

UNIVERSITY OF MASSACHUSETTS PRESS AMHERST AND BOSTON

Copyright © 2002 by
University of Massachusetts Press
All rights reserved
Printed in the
United States of America

LC 2001005766
ISBN 1-55849-324-7

Designed by Sally Nichols
Set in New Baskerville and Baker Script
Printed and bound by Thomson-Shore, Inc.

Library of Congress Cataloguing-in-Publication Data

Morris, Daniel, 1962–
Remarkable modernisms : contemporary American authors on modern art
/Daniel Morris.
p. cm.
Includes bibliographical references and index.
ISBN 1-55849-324-7
1. Art, American—20th century—Literary collections. I.
Title.
N6512 .M597 2002
810.9'357–dc21
2001005766

British Library Cataloguing in Publication data are available.

This book has been published with the support and cooperation of the
University of Massachusetts Boston.

For Joy and Isaac

CONTENTS

ILLUSTRATIONS

ACKNOWLEDGMENTS

I want to thank the several kind persons who read portions of this book in draft, tentative or final, or who encouraged me in other ways. I began this book in the summer of 1993 at the NEH seminar for college teachers held at Cornell University. I "workshopped" parts of the manuscript in the History and Literature Writers Group at Harvard in 1993 and 1994. At Purdue, Ann Astell, Wendy Flory, Charles Ross, and Phil Douglas commented on parts of the manuscript. I would also like to thank Purdue's Interlibrary Loan Staff for helping me access materials not owned by Purdue. Jack Rummel, Paul Wright, and Carol Betsch of the University of Massachusetts Press edited my prose with enthusiasm and precision. I must thank *Talisman: a journal of contemporary poetry and poetics, a/b Auto/-Biography Studies, PLL: Papers on Language and Literature,* and *Mosaic: a journal for the interdisciplinary study of literature* for permission to reprint portions of chapters 1, 2, 3, and 7, respectively. I wish to thank my family for the love and support they have given me over the years.

D. M.

Remarkable Modernisms

Introduction

In *Rereading the New: A Backward Glance at Modernism,* Kevin Dettmar argues that modernist studies changed when contemporary scholars realized that "modernism was not just a way of writing, but equally a way of reading" (13): "Surely one component of what we have learned to call Modernism is only a recuperative habit of 'interpreting' texts, whereas the most enduring of those 'Modernist' texts, read in another spirit, in another age, look strikingly postmodern" (15).

Perhaps the most notorious aspect of *modernist* reading was the emphasis placed on stylistic purity, on separating the arts from each other and from their connection to the experiences of authors, readers, of everyday life. As Daniel R. Schwarz has observed, "Modernism provided not merely the texts but the *argument* for New Criticism, namely that a literary work was a selfcontained ontology, and that there was no *formal* relationship between the creator and his or her creations" (1993, 67–68). According to New Critics such as I. A. Richards and John Crowe Ransom, modern poetry was "autotelic."

It was an "imitative fallacy" for readers to assume that poetry represented actual life in its form or sound. It was an "affective fallacy" to assume that the reader's emotional response (or the reader's race, gender, or ethnicity) mattered when evaluating the work. It was an "intentional fallacy" to assume that the poem or story reflected on conscious or unconscious dimensions of the author's own experience. Poetry, Archibald Macleish wrote in his ironically didactic "Ars Poetica," "must not mean, but be." As Peter Schmidt has stated, much criticism written by modernist poets affirmed Macleish's wish to bind the range of existence in poetry to the artifact itself:

> [In William Carlos] Williams' essays on how Marianne Moore and Gertrude Stein taught him the virtues of seeing and hearing words for "themselves," with "a curious immediate quality quite apart from their meaning," as if each syllable had been cleaned of the dirt of everyday use and reminted . . . the goal seems to be to discover a lost point of origin for each art outside history. (1988, 2)

By contrast to Williams's instruction by Moore and Stein in "seeing and hearing words" removed from history and the "dirt of everyday use," new modernists instruct readers to take a cultural approach that "would not pit artistic experimentation against everyday experience, but would find connections and relationships between the two" (Heller, A22). Taking such an ecumenical approach, Rita Felski argues that "modern art raids the world of mass culture, scooping up newspaper headlines, advertising images, popular design, fragments from the lyrics of popular song. In turn, every experience is shaped by the trickle-down of the avant-garde, which dissolves into popular styles and taken-for-granted ideas" (Heller, A22). Understanding modern art as an unbounded extension of twentieth-century life, new modernists such as Felski, Schwarz, and Dettmar are reading and writing against the grain of how the modernists themselves taught us to appreciate their project through the stories they told about their practice in the form of New Criticism.

As a literature professor who teaches courses in the interpretation of modern and contemporary poetry, but who is equally fascinated with twentieth-century painting and American cultural history, I was pleased to notice the appearance in the eighties and nineties of monographs on modern art written by contemporary novelists and poets. Like the academic "new modernists" who are revising the period through scholarship

that reconfigures the relationship between literature and its sociopoliti-
cal contexts, the contemporary authors in *Remarkable Modernisms* chal-
lenge the strictly formalist approach promoted through the New Criti-
cism. At the same time, they diverge from the strictly contextual (or new
historicist/cultural studies) approaches favored by most academic new
modernists. As poets and novelists, they remain unabashedly sensitive to
the value of compositional techniques when they address a visual artifact.
In this regard, they are heirs to the line of modernist/formalist art theo-
rists in the United States that includes Clement Greenberg and Michael
Fried. As contemporary authors representing diverse backgrounds and
points of view, they are aware of the influence a viewer's "subject posi-
tion" holds over the way she or he perceives both art objects and the
wider social implications of representation in the United States. They are
sensitive to how power relations establish aesthetic value and representa-
tional significance. What I find so compelling about the creative writers
that form the basis of this new modernist study, is that they dismantle the
shibboleth of "content" versus "formalist" approaches to art. They reveal
that the content versus form dyad fails to account for what the visual the-
orist W. J. T. Mitchell has referred to as "the semantic of form," or the
interwoven relationship between the "how" and the "what" of a visual
artifact.

Selective rather than synoptic in its focus, *Remarkable Modernisms*
examines modernist critical assumptions as well as postmodern social
and ethical perspectives that enable a range of contemporary authors to
extend their views beyond the frame of the picture plane (that is, read-
ing modern art as modernism). Like that of other new modernists, my
work is informed by a "cultural studies" model that takes into account
the "nonart" contexts of history, politics, authorial identity, and social
life, often from a perspective in which power relationships and the socio-
economics of aesthetic production are emphasized. At the same time, I
allow myself the freedom to explore what Schwarz calls "the process of
examination of cultural figures in configurations that put new light on
cultural history." Grouping the triptych of Picasso, Joyce, and Stevens in
an essay on modernism's "genetic code," Schwarz uncovers phenomena
that bind modern art and literature together with urbanism and the
attendant café culture, scientific relativism and physics, war trauma, and
the philosophies of religious doubt that informed aesthetic structures

such as pictorial cubism and literary collage. Like Schwarz, I maintain a formalist approach while placing aesthetics into a meaningful frame that emphasizes the ethics of representation and that foregrounds the act of viewing pictures as a metaphor for human relations of sameness and difference in the everyday context of imagining interpersonal exchanges within the social realm.

Many new modernists dismiss formalist approaches to art as a retrograde attack on popular culture and the significance of ordinary life. I do not. Instead, I prefer to join such contemporary art theorists as Thomas Crow and T. J. Clark in recovering the meaningful aspects of a formalist approach without denying the link between aesthetics and the politics of representation. Before discussing how the authors of *Remarkable Modernisms* twist the meaning of formalism to create a hybrid approach that is more appropriate to the postmodern context in which we live and work, let me sketch out the tenets of formalist art criticism during modernity.

Modern formalist critics are indebted to the philosophy of the German Idealist Emmanuel Kant for their central idea that through self-conscious reflection they can identify the essential features of the picture plane. In the preface to the *Critique of Pure Reason,* Kant raised a "call to reason to undertake anew the most difficult of all its tasks, namely, that of self-knowledge" (p. xi). Describing "self-criticism as the essence of modernism," Clement Greenberg argued in "Modernist Painting" (1960) that painting could only remain distinct from "entertainment pure and simple" if artists and critics paid exclusive attention to the medium of representation. He centralized the medium because it was the site where "each art is unique and strictly itself" (Greenberg 1993, 4:86; Kuspit, 42). Believing that the fine arts needed to be protected from economic pressure, mass culture, the nascent consumer society, and the political exploitation found in the form of social realism typical of totalitarian regimes, Greenberg, in "Toward a Newer *Laocoön,*" honored "the opacity of the medium" (Greenberg 1993, 4:32). At least in his most programmatic essays, many of these written after 1950 when his position became codified, Greenberg stated that the intention of the dialectic between "perfection of form" and the "resistance of content" should be toward the painter's ability to "triumph over the resistant matter of life—things and feelings—by unifying them stylistically" (Kuspit, 37).

Unlike new modernists, Greenberg was uninterested in contesting the border that existed between high and low cultures. To the contrary, he felt that with the declining influence of formal religious systems, the fine arts had emerged as the primary respite from the disabling pressures of commodity capitalism and the industrialization of culture in the United States. A writer on the left and an archetypal New York Jewish intellectual who published important essays in the *Partisan Review*, and who was the art critic for the *Nation*, Greenberg worried about the abuse of representational art through social realism in the United States, especially since that was the visual style Joseph Goebbels had selected to establish the emergent fascist regime in Germany in the 1930s. In 1935, Greenberg translated *The Brown Network: The Activities of the Nazis in Foreign Countries*, a report by the World Committee for the Victims of Fascism (Golub, 19). In his view, the avant-garde and abstract art in particular were needed to maintain a split between the two levels of culture that were becoming absorbed into each other through the mass cultural movement he labeled as "kitsch." Since, according to T. J. Clark, Greenberg felt that kitsch revealed how the bourgeoisie had forfeited art to the "masses" as an aspect of their own cultural control, the avant-garde artist must reconfigure the separation of the fine arts from what Greenberg perceived to be the sociopolitical desolation surrounding it. By distinguishing high culture from low, the avant-garde could preserve the vestiges of an aristocratic perspective on life and uphold the quasi-religious values of art in a period of religious doubt and the manipulation of art as propaganda by Hitler in Germany and Stalin in the Soviet Union. Greenberg's theory of the avant-garde becomes an example of what Clark labels an "Eliotic Trotskyism." A paradoxical hybrid, Eliotic Trotskyism applies the elitist perspectives on tradition found in Eliot to a critique of the negative impact of capitalism and totalitarianism on cultural production in a way that is reminiscent of Brechtian theater.

In an article written for the journal *Critical Inquiry*, Michael Fried, Greenberg's most prominent follower, has dismissed Clark's sociopolitical reading of the rise of American modernist formalism. Fried has been especially critical of Clark's argument that modernism fundamentally involved negation, a paring down of art to its essential aspects to preserve its transhistorical role as a conservatory of value that remained free of political or economic appropriation. At the same time, Fried follows Greenberg

in his wish to renew the attack in the wake of romanticism on the "confusion of the arts" discussed by the German Idealist Gotthold Ephraim Lessing in *Laocoön: An Essay on the Limits of Painting and Poetry* (1766). Greenbergian formalism continues to be found, for example, in Fried's "Three American Painters": "The history of painting from Manet through Synthetic Cubism and Matisse may be characterized in terms of the gradual withdrawal of painting from the task of representing reality—or of reality from the power of painting to represent it—in favour of an increasing preoccupation with problems intrinsic to painting itself" (115).[1] Fried is self-consciously indebted to Eliot's "Tradition and the Individual Talent" and to Harold Bloom's theory of agon, as well as to Greenberg, in his understanding of art history as an evolving struggle for cultural power. In Fried's view, the new artist must confront an evolving, historically inflected version of the standard works of generative value from the past masters. If he is to be remembered as a peer to the canonized, he must absorb their perspectives into his own canvases. In recent writings such as "Painting Memories: On the Containment of the Past in Baudelaire and Manet," Fried *does* express an interest in the psychology of memory, in the role of the viewer, and the residue of history on modern representation. He deals with the psychology of memory to the point of sounding like contemporary trauma theorists such as Cathy Caruth and Dominick LaCapra in his description of the presentness of the past in Manet. But for Fried the power of the past to shape a modern painter is restricted to the realm of art historical memory. Manet is a painter with a historical sensibility, and therefore, he is among the most powerfully totalizing of modern painters because his art so thoroughly absorbs "the enterprise of representational painting in the West since at least the Renaissance" (1984, 516). By history and memory, Fried means what Eliot meant by tradition and individual talent and what Bloom means by the anxiety of influence: "the remarkable degree to which the products of that enterprise were made from painting, from previous painting" (1984, 516). Although interested in history, memory, and the shifting definitions of cultural value in a contested relationship between present representations and past masterworks, Fried writes in the modern formalist tradition of Greenberg because he is focused on "problems intrinsic to painting itself."

Greenberg argued that "the 'message' of any given work of art can never be thought of as independent from its 'formal fact.'" The writers in *Remarkable Modernisms* agree that the "message" of art, however much it is concerned with history, with psychology, with memory, is dependent on "formal fact." They twist modernist formalism, however, by resisting "the logical priority of the medium to what it conveys" and by refuting the idea that "natural communication" should bring order to human disorder. They also oppose the commitment to artistic "purity," an aesthetic that "makes demands only on the optical imagination."[2] Invested in aesthetic purity ("opticality") and the separation of the arts as a reaction against the oppressive mechanisms of capitalism and the dehumanizing impact of mass culture, Greenberg focused on what form "*does*—how it works, how successfully it works, as art." By contrast, contemporary formalists relate the composition of art to the construction of social identity—the body as text—and to the visual appearance of the political realm as an artifact, a "representational" government. New modernist formalism explores the ethics of representation by examining how an artist's mediation of subject matter is analogous to how he or she negotiates human encounters in a "nonart" context. By contrast to authors who forge links between aesthetics and citizenship, Greenberg "forgive[s] the modern painter" for concentrating "his interest on his medium . . . because he puts the feeling he withholds from the object into his *treatment* of it" (Kuspit, 19, 35). Instead of focusing on internal dialectics, the contemporary authors, who assume that *art has no sake of its own because only human beings can have a sake*, argue for the social relevance of art through the semantic implications of form outside the picture plane.

John Ashbery: Poet and Critic

Of course, some contemporary writers continue to adapt vestiges of modernist/formalist theory on modern art into their writing. John Ash-bery is a good example. In a review of a Museum of Modern Art show of the Gertrude and Leo Stein collections, *Four Americans in Paris* (1971), Ashbery states that "poets when they write about other artists always tend to write about themselves, and none more so than Gertrude Stein" (106). The comment is doubly reflexive because Ashbery, who, like Stein,

"experiment[s] with the interrelationship between the juxtaposition of words on a page and their disembodied suggestiveness," is visualizing a modernist poetics by analyzing Stein's fascination with Picasso (Gery, 131). Ashbery detects affinities between Stein and Picasso in terms of their ability to "escape critical judgment by working in a climate where it could not exist" (1971, 110). Ashbery states that regardless of the final outcome to their achievement "what remains is a sense of someone's having built" (1971, 110). Ashbery opposes the security of Henri Matisse's reputation with the ubiquity of Stein's verbal experiments and Picasso's art, a position that leaves their reputations "excitingly in doubt and thus alive" (1971, 111).

Introducing a collection of essays on art by twentieth-century poets, J. D. McClatchy writes that "by praising or analyzing the painters, these poets have found a sure way (their objective correlative, let's say) to describe themselves, or, more generally, to describe the creative process itself" (xvi). Following McClatchy, Ashbery's art writing can be applied to his own ubiquitous, massively "built," and yet critically problematic accomplishment as a poet. Like Picasso and Stein, Ashbery often defies interpretation as he enacts a creative flow that illustrates Roland Barthes's idea of endless semiotic play in "From Work to Text." Ashbery remains "excitingly in doubt and thus alive" (perhaps frustratingly "alive" to many critics) because he deconstructs the poem as a definitive unit through which to identify the author's place in literary history. It would be difficult to find two critics to agree about which Ashbery poems are exemplary lyrics comparable to "Birches" or "Mending Wall" by Frost, "Kaddish" or "Howl" by Ginsberg, "Lady Lazarus" or "Daddy" by Plath, or "The Moose" or "In the Waiting Room" by Bishop. It is uncertain even if it is possible to "understand" Ashbery, to borrow the title of a well-known essay by Helen Vendler. Ashbery warrants, but also defies, interpretations that value closure. In one of his well-known long poems (*Flow Chart*, 1991), Ashbery exhibits a rich on-goingness, a "landscape" of the author's mind that is, in Bonnie Costello's words, "an unmappable, metamorphic terrain" (63).

Author of *Reported Sightings: Art Chronicles 1957–1987* (1991), Ashbery has stated that he "wanted to be a painter when [he] was young" (Bellamy, 11). His art writings suggest that, on a semantic level, no significant differences exist for him when addressing verbal and visual media. For this

reason, critics such as David Bergman often interpret his prose as a parallel discourse to his poetry:

> while the career [as art critic] may have been accidental, it has not been insignificant to his development as a poet. He has credited [art review] journalism for altering his writing methods. The weekly obligation to "grind out several pages," as he put it, and "to produce an article . . . rain or shine, exhibition or no exhibition" broke down his resistance to poetic composition and led to the recognition that he could "sit down the same way with a poem." (Bergman, xi–xii)

Ashbery's essays on Giorgio de Chirico, Fairfield Porter, and Henri Michaux, all of whom either have written extensively themselves on art or are among the most literary of painters, allow readers a glimpse into his poetics. The criticism on Porter, for example, may reveal more about the poet's literary style than about the American realist painter:

> This is perhaps the lesson of [Porter's painting] that there are no rules for anything, no ideas in art, just objects and materials that combine, like people, in somewhat mysterious ways; that we are left with our spontaneity, and that life itself is a series of improvisations during the course of which it is possible to improve on oneself, but never to the point where one doesn't have to improvise. (Ashbery, 10)

Commenting on his prose style, rather than on the content of his observations, Bergman suggests that Ashbery's *improvisational* critical mode parallels his poetics. "Here is lack of 'finish,' and the quick brushstrokes removed from his more canonical works. Here we may find the focuses of time and circumstances embedded in the very texture of the work" (xxii). From a formalist perspective, Ashbery's prose style exists in a dialogue with poems such as "Self-Portrait in a Convex Mirror" (1974), which takes Francesco Parmigianino's famed 1524 depiction of himself as its inspiration.[3] But poems by Ashbery such as "Soonest Mended" that are not graphic renderings of a visual artifact also resonate with his prose because they too enact the author's idiosyncratic vision and highly personal relation to the world around him. In his hands, poetry and prose fluctuate between active and passive responses to psychic experiences of visuality.

In the poetry, Ashbery exhibits the open-ended textuality, sensitivity to all levels of cultural experience, and improvisatory manner of a postmod-

ernist. At the same time, he writes formalist criticism that is indebted to modern theorists of visuality such as Roger Fry, who perceived art as having a sake of its own and who also contended that art represented another world that existed outside the usual sphere of human relations. Comparing postwar New York painters such as Jackson Pollock to the French surrealist Yves Tanguy, for example, Ashbery writes:

> The automatic gestural painting of Pollock, Kline, and their contemporaries looks very different from the patient, minute, old-master technique of Tanguy, yet he was perhaps the Poussin of the same inner landscape of which Pollock was the Turner. Both pushed the concept of art a little further in their exclusive attention to what Eluard, reviewing a play by Raymond Roussel, defined as "all that has never been, which alone interests us." (27)

The analogy of Poussin and Turner as realists of nineteenth-century externality and Tanguy and Pollock as surrealists of twentieth-century internality is witty, persuasive, and memorable. At the same time, I question the ethics of the focus on representations of "all that has never been." Following Tanguy and Roussel who did not wish to confront the entanglements of the visual with the verbal, and their relation to the social world, Ashbery refuses to engage with features of postmodern culture that exist outside textuality, because he does not perceive an outside to the text. "I write mainly for escapist purposes," he has stated. "I am aware of the pejorative associations of the word 'escapist,' but I insist that we need all the escapism we can get and that isn't going to be enough" (Bellamy, 14, 15).

Ashbery expresses a philosophy of life through his aesthetics that tilts toward mystery and open-ended textuality, and in this limited sense he reminds me of the authors discussed in this book. Ashbery describes the relations between visuality and his own poetics of improvisation and introspection. He connects art to the bizarre ways that different types of people mix in a social setting, but his remark about poetry being "escapist" indicates his indifference to the relationship between aesthetics and the ethics of citizenship. He admires the surrealism of Tanguy's "inner landscape," a space that is "self-created, totally autonomous, [and exists] in a world where time, space and light are functions of other natural laws than ours" (19). An explorer of how poetry and art go together, his

image/text comparisons remain within the aesthetic sphere—witness the linkages he finds among Tanguy, Pollock, Kline, Poussin, Turner, Eluard, and Roussel in the brief sample I quoted above. Like Fried on Manet's absorptive relationship to prior masters, Ashbery perceives representation as an enclosed sphere, even as he is involved in a collaboration with visual artists. For this reason, he strays from the paradigm of my study, which is devoted to writers who perceive their relation to visuality as analogous to humankind's link to the temporal world of bodily decay, political change, and the ebb and flow of history.[4]

For the contemporary poets John Yau, Charles Simic, and Mark Strand, as well as for the fiction writers Ann Beattie and Joyce Carol Oates, writing about modern art not only defines the identity of the artist under discussion. As in Ashbery's account of Picasso, Stein, and Fairfield Porter, their prose serves as a visual stimulus to self-portraiture; it reveals as much about their life and work as it does about the visual objects reviewed. Unlike Ashbery, however, the authors I study extend their analysis beyond the scope of their own poetics and autobiographical impulses. In all five cases, writing about art becomes a critical inquiry into the nature of public acts of witnessing and private acts of seeing and not seeing.

Academics and Poets

The author of monographs on Ezra Pound and James Joyce, Christine Froula is a leading proponent of new modernist scholarship within the academy. Like Felski and Dettmar, she is not a poet, a fiction writer, or an art theorist, but I want to situate the approaches to art that inform this book by contrasting Ashbery's art writings to her reading of a multimedia artist, Barbara Kruger. In "The X-Rayed Gaze: Self-Portraiture, Cen-sorship and Narrative of Public Conscience in Twentieth-Century Art," Froula reflects on the ethics of witnessing art as an analog to how Kruger has imagined social relations as the problem of seeing or not-seeing the other person as closely related to the self. In the *Bus Shelter* series of large, black-and-white photographs that appeared on Plexiglas panels at bus kiosks throughout New York City, Kruger portrays homeless persons as dispossessed citizens with the word "Help!" emblazoned over their image. Froula observes that the portraits slip from reporting to exhort-

ing. In contrast to the world's indifference, the sitters appear to glance back at viewers, which, Froula argues, reframes spectators as fellow human beings who are being called to respond to the suffering of other citizens. The homeless are not imagined as existing in some other realm, beyond some aesthetic veil or geographical border. Instead, they appear to be right here, living on the same streets where the spectators wait at the bus stop every morning. Perhaps hoping to provoke a response other than sympathy and indignation, Kruger has transformed these troubled objects of the beholder's gaze into troubling living subjects. They await a meaningful response (of immediate financial assistance? of a kind word? of a call for political activism or legislative reform?) from a spectator who is turned into a witness. Kruger doesn't tell us how to react, but she unsettles the type of boundary fostered between the beholder and sub-ject in modernism. A similar strategy is found in Ashbery's poems, the setting of which has been described by John Koethe as a type of terra incognita, a "fragmented personal world constituted by an inaccessible past, disrupted relationships, and communicate indeterminacy; and the subjectivity is an almost solipsistic one" (88). Kruger prompts viewers such as Froula to examine their understanding of the relationship be-tween art, repression, and the politics of everyday social encounters in a big city. By locating her images in the bus kiosk, rather than in the muse-um or gallery space, where the boundary between ordinary life and fine art is more securely delineated, Kruger reminds the viewer that the visual realm is an extension of social life, not a protection from scenes many citizens might wish to repress.

Froula notes that Kruger's *Bus Shelter* series calls on the viewer to respond to the emotional, physical, and economic needs of the persons represented in her work. For Froula, the work demands a fully empathet-ic response, an understanding of the shared vulnerability as mortal human beings, persons who live on the verge of anonymity in an urban setting, of the viewer and the viewed. Similarly, *Remarkable Modernisms* concentrates on authors who respond to art from an ethical perspective that, in Charles Altieri's phrase, "allows us to treat formal choices as test-ing exemplary existential possibilities" (26). As with Froula's contextual reading of Kruger, the authors negotiate the contested borders between visual culture and a political space that extends beyond the picture frame and into the realm of the body and social relations. Discussing

Robert Creeley's collaborations with a range of artists including Francesco Clemente, Elsa Dorfman, Robert Indiana, Alex Katz, Marisol, and Susan Rothenberg, John Yau focuses on their sensitivity to the fluid relationships among mind, body, and the moment of artistic production and reception. He admires their attempts to display "the flux of the continuous present" as they consider "the possibility that a poem [or picture] can exist in the same physical space as the reader, and can by virtue of this have a direct impact on the reader's life" (2000a, 59). Like Yau on Creeley's collaborations, the other writers in *Remarkable Modernisms* claim that an artist imagines social investments (or disinvestments) with subject matter through designs that cannot be neatly separated into the pure field of aesthetic appreciation. In *Studies in Iconology*, Erwin Panofsky distinguished between subject matter or meaning on the one hand and form on the other: "When an acquaintance greets me on the street by removing his hat, what I see from a formal point of view is nothing but a change of certain details within a configuration forming part of the general pattern of color, lines and volumes which constitutes my world of vision. . . . However, my realization that the lifting of the hat stands for a greeting belongs to an altogether different realm of interpretation" (Owens, 96). By reading social meaning into form, and by bringing the viewer into the foreground, the authors challenge the claim made by modernists such as Panofsky that, in the terms of Martha Nussbaum, "beauty gives pleasure without interest" (102). Implicit within their formalism is the view that representation should include the cultivation of "an attitude toward familiar texts that is not the detached one that we sometimes associate with the contemplation of fine art" (Nussbaum, 100). Like Nussbaum, who writes that "compassion is essential for civic responsibility," *Remarkable Modernisms* advocates the representation of human suffering in a manner that suggests authorial and spectatorial involvement, rather than psychic detachment. Nussbaum contends that art may serve as a model for an ethics of witnessing human strife in a nonart context. "Art has the power to make us see the lives of the different with more than a causal tourist's interest—with involvement and sympathetic understanding, with anger at our society's refusals of visibility" (103). Like Nussbaum, the authors question the idea that attention to the significance of form and a critical treatment of the ethics of witnessing (and commenting on) human strife through art must be mutually exclusive activities.

Art Writing as Collaborative Form

Caroline A. Jones argues in "The Romance of the Studio and the Abstract Expressionist Sublime" that the fetishization of the male artist as a genius who toils in isolation from the commercial world has permeated the reception of figures such as Vincent van Gogh, Pablo Picasso, and Jackson Pollock, all of whom have been presented in films as original and self-sufficient. Demonstrating that the trope of the male artist in the studio was "tied to nineteenth-century Romanticism and notions of the sublime," Jones contends that the abstract expressionist studio (as found for example in the documentary film by Hans Namuth of Pollock dripping paint on a floor of unprimed canvas in his Long Island studio barn in East Hampton and the biopic, *Pollock* [2000], starring Ed Harris) was a modification of modernist European formulations: "[The] studio establish[ed] the American artist in the immediate postwar period as an isolated, depoliticized, angst-ridden man, whose solitude in the studio was an article of faith (for artist, critic, and viewer)" (1996, xiv). Critiquing the iconography of modernism from a feminist perspective, Jones notes the exclusion of the (most often female) "Other" implied by the image of the solitary artist toiling in a quasi-religious space. I challenge the solitary view of (male) artistic production by joining forces with Jones and others who have traced the history of the phenomenon of artistic collaboration. Contemporary critics of modernism such as David Shapiro, Daniel R. Schwarz, Debra Balken, Tom Wolfe, J. D. McClatchy, Murray Krieger, W. J. T. Mitchell, and Marsha Bryant have shown that multimedia interactions have been a dominant feature of avant-garde arts and letters internationally throughout the twentieth century. "Trivialized by most interpreters of the culture of modernism as marginal, inconsequential, and most of all as mere fun," Balken writes, "these joint projects confound our traditionally received notions of art" (37).

From poster art advertising Sergei Eisenstein's film *The Battleship Potemkin* (1925), designed by writers and artists associated with Russian suprematism, to the surrealist "Cadavre Exquise" collages of the late 1920s and early 1930s in France, and more recently in the United States, to the combination of stage sets and lyrical scripts designed by New York School figures such as Larry Rivers, Kenneth Koch, and Alex Katz, and the "cut-ups" of William Burroughs and Bryon Gysin from the 1960s, for-

mal and informal alliances among verbal, visual, and performing artists have been an ongoing and extensive feature of modern art.[5] Artists as diverse as Ida Applebroog, Jean-Michel Basquiat, Jim Dine, Jenny Holtzer, Jasper Johns, Roy Lichtenstein, Robert Morris, Robert Rauschenberg, Cy Twombly, Andy Warhol, and Carrie Mae Weems, as well as Kruger, have incorporated writing onto their canvases, photographs, or electronic museum installations. By mixing media in a composition, these artists suggest how verbal and visual representations may be understood as coordinated grammars, or, as in the case Kruger, Holtzer, and Weems, as ironically juxtaposed grammars that challenges normative arrangements of social life and the political world. Once paired, words and images become aspects of a multimedia ensemble that may express political commitments, social resistance, or philosophical reflections about an often-static culture. These ensembles critique or undermine stereotypes and other restrictions placed on personal experiences that refuse to fulfill cultural obligations. The effect of such collaborations and image-text compositions has been to "decentraliz[e] a single authorial or artistic voice" (Balken, 24).

In "Art as Collaboration: Toward a Theory of Pluralistic Aesthetics: 1950–1980," David Shapiro has argued that the dynamic process of collaboration associated with such loosely connected groups as the New York School in the 1950s and 1960s provided a countervailing force to "the more extreme Romantic and modern version of individual creation" deconstructed by Caroline Jones (1996, 45). Shapiro's essay also contradicts the agonic theory of literary production, developed by Harold Bloom in the 1970s, in which he said that "strong" male poets in the English and American tradition have competed with one another in a "zero sum game" of survival based in Oedipal formations among members of different poetic generations. Writing poetry is a type of critical reading, according to Bloom, but one that involves misrepresenting the precursor's work in order to make room for the authorial self. Unlike Bloom, Shapiro emphasizes the perspective of Meyer Schapiro, the influential art historian from Columbia University, who viewed art criticism as a "communal collaborative endeavor." Like Meyer Schapiro, David Shapiro attempts to see "generativity as dialogue rather than a game of conflict" (1984, 46).

Anthologists have documented the history of cross-genre fertilization, known as ekphrasis, in which an iconic poem is written with a painting in mind as subject matter, as in "Musée des Beaux-Arts" by W. H. Auden and "Landscape with the Fall of Icarus" by William Carlos Williams, two poems based on the sixteenth-century Flemish painter Pieter Breughel's *Landscape with the Fall of Icarus*, or the more recent collaborations that involved Philip Guston and contemporary poets such as Clark Coolidge, William Corbett, and Stanley Kunitz. Gail Levin's catalog for an exhibition of Edward Hopper paintings, *The Poetry of Solitude*, which consisted of poems inspired by the artist's work; *Voices in the Gallery*, a collection of poems informed by paintings chosen by Dannie and Joan Abse; *The Poet Dreaming in the Artist's House: Contemporary Poems about the Visual Arts* (1984); the *Poets and Painters* exhibition catalog for the Denver Art Museum's exhibit of 1979–80; and *Transforming Vision* (1994), the collection of writings on art selected by the poet Edward Hirsch, document the prevalence of collaboration in representation even as the myth of the individual genius painting in an isolated studio or the poet working in a cold-water flat has persisted.

While artists have incorporated language into their art, John Hollander in *Types of Shape* (1991) has gathered a collection of pattern-shaped poems whose printed format presents the shape of an object that is also the subject of the text. In "A State of Nature" (1969)—a poem shaped like a map outlining the state of New York—Hollander follows in the direction of pattern poets such as William Carlos Williams in "The Red Wheelbarrow" (1923) and begun in England by poets such as by George Herbert. In his poems "The Altar" and "Easter Wings" (both 1633), Herbert used visual devices to frame and formalize the content of his religious testimonies. "When Pound demanded 'direct treatment of the 'thing,' and William Carlos Williams urged 'no ideas but in things,' the *thing* they had in their mind's eye might as well have been the painter's motif," writes J. D. McClatchy (xi).

My focus is on a strange type of collaboration, conversation, and camaraderie between writers and artists when placed beside the group work produced by the Russian supremacists, French dadaists and surrealists, and the New York School. The art writings I discuss are eccentric revisions of modern art because the dialogue between author and artist occurs implicitly, in the apparently impersonal genre of criticism, rather

than in the explicit form that takes place when painters and poets design a multimedia assemblage. By maintaining the idea of "collaborative dialogue," however, I mean to discuss art writing as a type of reader response criticism, advocated by Stanley Fish and Wolfgang Iser, which stresses intersubjectivity and community. Following reader response critics as well as a line of thinking developed most forcefully by Mikhail Bakhtin in "Toward a Philosophy of the Act" (1919–24), I concentrate on authors whose art writings, when placed beside their fiction and poetry, become in Bakhtin's terms "creative understandings," or "live-enterings" into the life and work of the artist.

Bakhtin argues that "creative understanding" does not imply that the reader (or spectator) needs to identify with the perspective of the author (or artist). Such a merger of self and other, Bakhtin claims, would produce unrestrained empathy, removing the relational and, therefore, the critical, aspects of dialogue. "A rich dialogic standpoint allows one to encounter the otherness of the text without sacrificing one's position," write Gary Saul Morson and Caryl Emerson in *Rethinking Bakhtin*. "As in all genuine dialogue, something unforeseen results, something that would not otherwise have appeared. The text allows for and invites this sort of interaction, but does not contain its results" (4). The critical engagement becomes a third type of creative activity—an event that is exclusively authorized neither by the writer nor by the artist—and the end result cannot be reduced to the dyad of self and other. The type of critical engagement advocated by Bakhtin requires the energies of each participant for the event to become meaningful. Bakhtin's ideas of "creative understanding" and "live-entering" encapsulate my sense of how the contemporary authors maintain the distinct characteristics of their identities while they participate in understanding art in a way that revises the meaning of their own poems or fictions.

Some years ago Richard Rorty characterized the history of philosophy as having taken a "linguistic turn" that would now address the semiotic and rhetorical nature of reality. More recently, W. J. T Mitchell has spoken of a "pictorial turn." "Certainly I would not be the first to suggest that we live in a culture dominated by pictures, visual simulations, stereotypes, illusions, copies, reproductions, imitations, and fantasies," he writes (1994, 3). While there is no question that we are surrounded by images, I think the graphic response to visuality in *Remarkable Modernisms* signals

what we might call a "verbal re-turn." In the act of reading modern art from new perspectives, the authors transform our vision of the past by revising its narrative apparatus. Indebted to visual art as a basis for their own compositional discoveries, their writings have the effect of turning pictures into a language that extends the modernist's frame of reference beyond the flat surface of the picture plane. Thus the visual artist's work becomes absorbed into the author's multivoiced version of a contemporary social text, which is a fluid and evolving construct.

Strangers and Selves

John Yau's Writings on Contemporary Art

In *Strangers to Ourselves* (1991) Julia Kristeva contributed to the politiciza-
tion of psychoanalytic theory by extending Freud's notion of the uncan-
ny (*unheimlich*, or, literally, unhomelike) into how persons are defined as
citizens. Kristeva speculates that xenophobia occurs when a national citi-
zen, denying self-estrangement, projects "strangeness" onto "foreigners":

> Strangely, the foreigner lives within us: he is the hidden face of our identi-
> ty, the space that wrecks our abode, the time in which understanding and
> affinity founder. . . . Not belonging to any place, any time, any love. A lost
> origin, the impossibility to take root, a rummaging memory, the present in
> abeyance. The space of the foreigner is a moving train, a plane in flight,
> the very transition that precludes stopping. (Kristeva, 1, 7–8)

A protean author who has published nearly two dozen books of poetry
and fiction, many with Black Sparrow Press, as well as numerous essays
and museum catalog articles on art, John Yau has described the uncanny
aspects of his identity as a hyphenated, "Chinese-American" citizen in

Radiant Silhouette: New and Selected Work, 1974–1988 (1989) and, more recently, in *Hawaiian Cowboys* (1995). Born in Lynn, Massachusetts, in 1950, Yau writes autobiographically, but as if his identity were "strange to himself." As described by Priscilla Wald, "With neither history nor country to which he can return, Yau finds himself struggling with the terms that constitute subjectivity in the United States, profoundly distrustful of 'a language that comes from an 'I.'" (Wald, 133). In prose poetry and autobiographical fiction from the 1980s and 1990s, Yau has inscribed himself, to again quote from Wald, as "an I who doesn't know who the I is," a verbal collage, and, therefore, a compositional text that is "strange to himself." With Kristeva's comment about the power of language to frame another person's identity in mind, I will connect Yau's "strange" autobiographical writings to his formal analysis of identity found in the work of Jasper Johns and his critique of the self-identification that informs the art of Andy Warhol.

In a study on women writers of Chinese ancestry, *Between Worlds*, Amy Ling observes that "the feeling of being between worlds, totally at home nowhere" characterizes writings by Chinese-American women (Ling, 14). Like an autobiographer such as Maxine Hong Kingston, whose attention to the trickster figure suggests that identity is not stable but always shifting, Yau's attention to Johns's art of "in betweeness" reflects on his own identity as a hyphenated American citizen, or one whose identity crosses the boundary between normative forms of social definition.

In assessing Yau's interest in visual artists such as Johns who explore the fluid realm of "in-betweeness," it may be reductive, but is nonetheless informative, to note his own commentary about his international background. In interviews, Yau acknowledges his "in-betweeness" by talking freely about his mother, who was born in Shanghai, while admitting that he feels no immediate connection to China as a country of origin. "My father has never talked about [when he left China], won't. And my mother has said that she sailed out on the last boat out of Shanghai just before it fell and left behind her entire family" (Foster 1990, 39). Yau's parents, who he has described as "half English and half-Chinese," spoke Shanghaiese to each other when he was a child in Massachusetts during the 1950s and early 1960s, but he has not visited China and he does not speak any of the dialects of Chinese. His parents, who left China in 1949 at the onset of the Cultural Revolution, "could never go back to live

there, so the notion of return seems to me both an impossibility and a repressive illusion" (Foster, 39). Further, Yau has explained that his parents encouraged him to speak English and to develop "American" styles and habits. "My parents were perplexed as to what to do, you know, how to raise me in terms of language. My mother—I suppose out of guilt and denial—has said that as a baby I refused to learn Chinese. You know, they wanted me to be American, and then they were shocked by how American I became" (1990, 40).

Amy Ling has written that "Chinese-American writers are such rarities that the Chinese-American community looks to the few who are master-manipulators of English to speak for them, to record their history, their hopes, frustrations, and experiences, to give voice to this otherwise silent minority" (20). Yau has resisted defining himself as a spokesperson for other "Chinese-Americans," a metonym for the experience of a whole class of persons. He suggests that the stereotyping he experienced in Boston as a child has, ironically, been repeated in his adult life when, under the assumption that he will write about a restricted set of experiences related to his ethnicity, he is labeled an "Asian American" author. "I think sometimes we're all expected to write the immigrant railroad poems. . . . I'm Chinese-English-American. What does that mean? All the ghetto thinking gets you locked in a box, then you are appealing to other people in that ghetto" (Yau 1994, 49, 57). Yau's response to artists such as Johns, who imagine the zone of "is" and "is not," becomes his way to visualize an alternative to the "ghetto thinking" about imagining identity that he verbalizes in *Hawaiian Cowboys* and in the *Bughouse* interview. Yau discusses Johns's art in terms of a tension in self-definition. Instead of denying his complex subject position when coming to terms with modern art, Yau interprets himself as a contemporary, hyphenated American who questions the idea of national origins as a way to fix the self in the artificial realms of geographic maps and state borders. Like the strips of cloth and newsprint that are partially concealed and partially revealed by Johns's encaustic process in *Flag*, Yau composes his self-portrait as a palimpsest, that is to say, as a text written over another text. In chapter 2, I will read his prose poems as a multilayered array of verbal materials that is semantically related to Johns's art, but for now I want to start with a reading of how he displays his memories of childhood in autobiographical prose fiction.

"A New Set of Rules"

"A New Set of Rules Every Other Day," a chapter in Yau's 1995 book, *Hawaiian Cowboys*, is a specific expression of his ambivalent relationship to his status as a citizen whose desire for self-expression is fraught with the paradoxes of inscribing an "'I' who doesn't know who the 'I' is." In "A New Set of Rules," Yau's boyhood persona is imagined as a text composed in a social context that determines the meaning of the self. In "Nicknames," a section of "A New Set of Rules," Yau explains that his identity was mediated by the name calling of children whose models of "Asian Americans" were based on images found in comic books and Hollywood war films: "Sneak Attack, Kamikaze, Banzai, General Toe Jam" (28). However painful the litany of "nicknames" might have seemed to Yau if his parents had been born in Tokyo, and not Shanghai, the labels demonstrated to Yau how his connection to a specific national origin had been erased from the visual realm of the popular American cultural imaginary. In "Mythology," he presents images of Chinese Americans that are not, on the surface, as pernicious as the names he recorded in "Nicknames," but they suggest the speaker's indifference to distinctions among members of the classified group. "They are studious, quiet, and well behaved. They wear glasses and white socks, pants that are too short, and dresses that are too long. The smartest ones major in math or physics. They never go out for sports. They tend to have poor eyesight and buck teeth. They talk funny, and can't tell left from light." The racist stereotyping in "Mythology" disables Yau's ability to be recognized as "Chinese" American while also leaving him room to explore areas of expression (art versus science, for example) that defy "mythological" behavior. In "Image," he pokes holes in stereotypes and established hierarchies by distinguishing between his sense of himself and how others perceive him: "I look like one, but I don't act like one" (24). The comment is ironic because it implies that Yau is, in this example, criticized for *not* maintaining the stereotypical patterns of behavior that were repudiated in "Mythology."

In "Social Studies," Yau's ability to seek affection from other children is restricted by the lack of a term that could enable him to fit into the binary sorting of *black or white*: "Some girls said they wouldn't kiss me because I wasn't black. Others said it was because I wasn't white. And still

others kissed me because they were sure I was an exotic plant in need of constant tending" (23). His persona receives affection through kisses, but the paradox of the "constant tending" of his body is related to the lack of a subject position within a social text flexible enough to validate his "in between" identity. He receives attention from the girls, but in the form of pity, and as an "exotic plant." In "Social Studies," Yau's concern for affirming the "exotic" body is related to how representation influences personal appearance through interpellation. He is questioning how the culturally invisible (because neither black or white) body can receive affection when it cannot be inscribed as a legitimate part of a wider social text. In "Geography," Yau offers an unsatisfying alternative to the textual and verbal misidentification of China that he noted in "Social Studies," but through a binary system of classification that leans toward erasure or unsayability: "There are two Chinas. One is a large blank spot on the map and in text books. The other is only mentioned in passing" (23).

Throughout "A New Set of Rules," Yau explores the relationship between name calling and abjection (the turning of the subject into an object) in a national context, but in the final section, entitled "Anthropology," he opens up a space for a surprising outcome to stereotypical types of naming. He records an incident when a friend told him, then aged sixteen, that a guitar instructor named Celeste, an attractive twenty-five-year-old, wanted to meet him after her final lesson at the music studio. In a tone of voice that suggests his recollection of a very pleasant memory, Yau remembers how loudly his heart beat as Celeste initiated him into sex at a highland area overlooking the city in the back seat of her car on a warm spring night. At the end of "Anthropology," Yau notes that she told him, "I thought you were an Indian when I first saw you. A beautiful Indian warrior" (34). Her misperception of him is, categorically, related to the miscomprehensions that have restricted his access to a distinct appearance in "A New Set of Rules Every Other Day." In this case, however, Celeste's projection of the Indian warrior image produces a shaping moment in his life; misidentification becomes a form of ennoblement instead of scapegoating. The whimsical anecdote is important to Yau's overall thesis. Instead of imagining the self in terms of an autonomous ego, Yau sees identity as a contradictory and fluid construct

that is not subject to rational discourse. Yau is thus freed from being pin-
ioned into units of "this" or "that"; instead he affirms Kristeva's thesis
that "strangely, the foreigner lives within us: he is the hidden face of our
identity."

In his 1994 *Bughouse* interview, Yau answered a question about "who
or what are you?":

> I don't know how to say who I am. Am I an Asian-American poet? Am I not
> Asian? It's crazy. You're supposed to get yourself in a ghetto. I could say
> I'm an Asian-American, heterosexual poet who lives in New York City.
> That's an honest statement about who I am, but is that who I want to be? Is
> that the image I want to broadcast? I'm not even sure I know what it
> means. . . . How you do get beyond yet not deny it? (57)

His comment about the paradoxes of defining himself through fixed
social categories or ethnic classifications puts in question his ability to
announce himself as an author in control of his own autobiography. For
Yau, inscribing himself as a subject in narrative is a contradictory event
with ambivalent outcomes. Because he understands the coincidence of
political representation and cultural inscription, he relates the writing of
the self to larger social narratives that are based on principles of exclu-
sion that restrict which persons can be recognized as fully present and
which are to remain abject. Paradoxically, the autobiographical fiction
that enables Yau to appear within the cultural realm is also the linguistic
resource that has excluded, or at best that has only partially revealed, his
experience as available to be witnessed by other citizens. Rather than
abjecting the stranger, as in Kristeva, Yau's autobiographical fictions and
art writings represent his recognition of self-estrangement as a meaning-
ful state of being. In the writings on Jasper Johns and on the contempo-
rary American artists who have followed his example, Yau responds to
images of provisional states of being that pivot between coherence and
incoherence, meaning and meaninglessness, control and disorder. Like-
wise, he is drawn to an understanding of identity that is split between the
material realm of the body and the artifacts of aesthetic design. To re-
turn to another linguistic concept of Kristeva's, Yau responds to artists
who imagine the eruption of the "semiotic" realms of dreams and the
preverbal locus of the "amniotic deep," when the child is still bound up
in the mother's body, into the "symbolic" language of social documenta-
tion of waking life (Geok-lin Lim, 105).

Regarding the Semantics of Form: John Yau's Revision of
Jasper Johns and Andy Warhol

Jasper Johns (1930–) and Andy Warhol (1928–1987) emerged as artists in New York City in the late 1950s and early 1960s: Johns after his first show at Leo Castelli's gallery in 1958, and Warhol, who had shown thirty-two, hand-painted canvases of Campbell's soup cans at the Ferus Gallery in Los Angeles in 1962, after his one-man exhibit at the Stable Gallery in 1964. Credited by historians with transforming American painting from abstraction toward a new realism, Warhol and Johns seemingly have much more in common with each other, at least regarding their art, than they do with Yau, who established himself as a language-oriented poet after John Ashbery selected *Corpse and Mirror* (1983) for the National Poetry Series. Yet in monographs on the semantics of form as found in Warhol and Johns, Yau suggests that traditional categories for grouping artists and writers together—such as genre, subject matter, periodization, association with a movement like "hand-painted Pop," or placement within a historical narrative such as the "evolution" of American art from abstraction to a new realism—fail to acknowledge semantic distinctions between formal displays by artists of the same generation. Yau's prose poems seem to be influenced by the graphic depictions found in Warhol's classic, midcareer subject matter—death and disaster. Indeed, Yau at times directly addresses Warholian subject matter. But Yau also seems to draw from Johns: his awareness of how textual strategies intersect with the construction of personal identity in a nonart context is comparable to how Johns develops his fluid identity by creating his flags and ale cans as an unstable reflection of his interior life and public self.

Yau on Warhol

In *In The Realm of Appearances* (1993), Yau's critique of the *Death and Disaster* series centers on Warhol's use of design strategies he learned in commercial art classes at Carnegie Tech (later Carnegie Mellon University) between 1945 and 1949, and later as a leading magazine and newspaper illustrator of shoes for the I. Miller shoe store in New York City in the 1950s. Yau claims that Warhol's commercial training was significant because he applied publicity methods to his museum art so he could separate the pain

of bodily experience from the appearance of cosmetically drenched partici-
pants in a hypermediated culture of celebrity. In Warhol's repetitive, silk-
screen panels of the disembodied face, blurry red lips, and airbrushed yel-
low hair of Marilyn Monroe, for example, the fact of her death by an
overdose of sleeping pills in 1962 seems inconsequential when compared
to the lingering trace of her iconic specter in his art piece (which was based
on Hollywood publicity stills taken by Gene Kornman for the 1953 film
Niagara). What is important to Warhol about Monroe is that she appears to
have survived her physical death by remaining in the public imagination as
an image trace.

In two diary entries recorded near the end of his own life, Warhol
extended his fearful relation to illness, pain, and death to people, in-
cluding close friends such as Robert Mapplethorpe and a man named
Martin, who had contracted AIDS:

> Bruno wanted to sit with Robert Mapplethorpe, but I didn't want to. He's
> sick. I sat at another place. . . . And after the play Martin met me backstage
> and there was a big chocolate leg there from Kron and everybody was eat-
> ing it, and Martin was too. And it's so sad, he has sores all over his face, but
> it was kind of great to see Madonna eating the leg, too, and not caring that
> she might catch something. Martin would bite and then Madonna would
> bite. I like Martin, he's sweet. (Doyle et al., 5)

Given that Warhol's diaries reveal that he was repulsed by his own body, a
posthumous existence such as Monroe achieved through the Hollywood
publicity machine may have appealed to his desire to renounce the or-
ganic nature of embodied life in favor of a symbolic existence in what
Yau calls "the realm of appearances."

Warhol celebrated the afterimage of media personalities such as
Monroe, but he also represented anonymous citizens who gained notori-
ety when their sad fate prompted sensational headlines in tabloids such
as the *New York Post*. As with his representations of Monroe's face as a
series of transparent images that trail off like smoke rings, Warhol's *Death
and Disaster* series uses techniques that disentangle him from identifying
with victims of plane crashes, car wrecks, or a man who jumps from the
window ledge of a mental hospital. He distances himself and his audi-
ence from other citizens who have suffered bodily disfiguration by repre-
senting trauma through the grid, repetition, and colorful make-overs of
images he discovered in the tabloid press.

Warhol's establishment of an impregnable boundary between the

image of the human body in pain and "the thing itself"—the actual lived experience of persons in trouble—links his art to a consumerist ideology and connects his art to the politics of abjection that defines the "stranger" as the "unclean other" in Kristeva. Advertisers construct a sanitized realm of "elsewhere" by associating personal contentment and safety with hygienic products. Like commercials for detergents and cleaning products such as Brillo scouring pads, Warhol's art style promises to remove spectators from evidence that human existence resides within the vulnerable body. In the realm of "elsewhere" found in advertisements of the good life, where cleanliness is next to godliness and to America, Warhol abjected what Yau describes as "duration and entropy" and "dirt and death" through his depiction in *Brillo* (1964) of a white-washed box made out of wood that replicates the cardboard boxes that in a supermarket would contain the small, white, orange, and blue boxes of Brillo scouring pads. Yau writes that "Warhol attempts to convince himself and the viewer that it is possible to obliterate time, make it stand still forever. It is this negation of experience that connects Warhol to commercial culture" (45).

In spite of the break from abstraction signaled by Warhol's return to "low" (popular) subject matter, Yau presents his art as a late example of modernist formalism because it negates contact with the human body and with ordinary life through an extreme attention to aesthetic control. Yau, therefore, returns Warhol to the idealist tradition of Greenberg, who stated that art was an "independent vocation . . . absolutely autonomous, and entitled to respect for [its] own sake," and who praised Piet Mondrian's art for no longer being "windows in the wall but islands radiating clarity, harmony, and grandeur—passion mastered and cooled, a difficult struggle resolved, unity imposed on diversity" (Kuspit, 39, 33). Unlike Mondrian's "islands," Warhol's art is a veiled window on social life.

In his silk-screens, Warhol deploys the "cooled" and "mastered" tones of Mondrian's grids (used by Mondrian to point toward a transcendental realm organized according to the rational structural principles of geometry) to enable spectators to gaze from the safe distance of the art gallery, the living room, or the museum on hypermediated images of the suffering of other people. By showing that Warhol uses form to screen viewers from experiencing subject matter *as a part of* their life, rather than *apart from* their life, Yau tells a story of modernism that goes against the grain of dominant readings of Warhol's art as, in Calvin Tomkins's words,

"resonant" and "oracular." He challenges the image of Warhol as the artist from the early 1960s who "made visible what was happening to us all" (Coplans, 14).

In "Postmodernism, or The Cultural Logic of Late Capitalism" (1984), Fredric Jameson famously describes Warhol's colorful lithograph called "Diamond Dust Shoes" (1980) as illustrating the predominant features of postmodern representation: its superficiality and tendency to disconnect images from their historical milieu. Warhol's lithograph features "a whole new type of emotional ground tone—what I will call intensities—which can best be grasped by a return to older theories of the sublime," and Jameson also speaks of the "newer cultural experience" of postmodernism in general as characterized by "euphoria" and "intensities" (6, 32). Yau agrees with Jameson that Warhol desensitizes viewers to the historical process by separating art from social experience, but he disagrees with how Jameson gauges the level of "intensity" evident on the surface of Warhol's pictures. Yau argues that Warhol's use of repetition, grids, and make-overs to display the riots in Birmingham, Alabama, in which Police Chief Eugene "Bull" Connor sent his men with police dogs to attack African American civil rights protesters in 1963, *reduces and contains* the "intensity" of this dramatic event. The Birmingham march and other acts of civil disobedience supporting black civil rights led to the passage of landmark federal legislation that produced real economic, political, and social change during Lyndon Johnson's administration in 1964 and 1965.

In the silk-screens *Mustard Race Riot* and *Red Race Riot*, based on a 1963 photograph in *Life* magazine by Charles Moore showing policemen and their dogs confronting civil rights demonstrators in Birmingham, Warhol transforms terrifying images that indict Jim Crowism into a slapstick (laugh riot) comedy that could be consumed by art patrons from a great psychic distance (15, *The Prints of Andy Warhol*). "The events are engaging," Yau writes. "But they don't involve us directly. We are invisible bystanders who can walk away at any time" (101). Taking into account the semantics of form, Yau criticizes Warhol's use of silk-screening from an ethical perspective. A technique that gives to images a detached and decorative air, silk-screening disturbs Yau because through it Warhol represents bodily trauma as "bodiless event."

Yau's analysis of how Warhol represented key events in the civil rights movement demonstrates the artist's political *conservatism*. His reading dif-

fers from accounts of Warhol by Arthur Danto and Benjamin Buchloh that have praised him for reducing the difference between lived reality and representation. Their line of argument would appear to place Warhol in a camp opposed to the emphasis modernist's placed on solving problems intrinsic to the sphere of advanced painting.[1] According to Danto, Warhol departs from modernism because he did not fetishize the hand-painted artifact as authenticated by the signatory gestures of the artist. Although a commercial Brillo box is already an aestheticized object, for Danto, Warhol deconstructs the boundary between fine art and ordinary material culture. Following Danto's line of reasoning for assessing Warhol's aesthetic *radicalism*, Buchloh writes that "Warhol underlined at all times that the governing formal determination of his work was the distribution form of the commodity object and that the work obeyed the same principles that determine the objects of the cultural industry at large" (55). Buchloh perceives Warhol to be a populist who subverts the purity of modernism. For him, Warhol's late portraits of such aristocratic figures as Imelda Marcos, Princess Caroline of Monaco, and the shah of Iran are unrelated to what he considers to be Warhol's prior subversive aesthetic gestures in *200 Soup Cans* (1962) and in *Brillo, Corn Flakes, Mott's Boxes* (1964).

Buchloh perceives Warhol's portraits of the rich and famous as examples of the artist's reactionary backsliding in later life. The portraits of dubious figures such as Imelda Marcos were a form of overcompensation by Warhol, who wanted to escape from a working-class, immigrant (Czech) background by obtaining everything he lacked as a poor, awkward boy who grew up in Pittsburgh during the Great Depression: good looks, wealth, possessions, celebrity, and social acceptance. The fact that Warhol began to publish *Interview* magazine in 1969, a primary display of his fascination with publicity and appearance, did not, according to Buchloh, undermine the radical critique of museum culture found in his early pop art.[2] By contrast, Yau finds a continuity between Warhol's celebration of Nancy Reagan in *Interview*, his role as an American version of the European court portraitist, and the techniques he used to cast the beholder of *Death and Disaster* as one of the fortunate few who are not "contaminated" by the misery of life. Yau argues that Warhol's popularity rested not so much on his choice of recognizable subject matter, which often provocatively challenged the status quo, but because he screened victims

from viewers in apparently radical works such as the *Race Riot* series (1963–64) and the *Death and Disaster* series (1963).

Yau interprets Warhol's art to be in line with his refusal to eat the chocolate leg at the party even as he considers his friend Martin to be, like the chocolate, "sweet"—evidence of a massive "act of denial" (27). As in the diary entries on Mapplethorpe, Martin, and Madonna from the 1980s, Warhol's repackaging of other people's experience into units of "before" and "after" in his art from the early 1960s reveals his body phobia. He conceals the reality of human life as a metamorphic temporal flow that is subject to change, illness, and expiration. Even when he depicts social unrest, as in his *Death and Disaster* series, his art diminishes the sensations of physical and emotional suffering. By representing participants in a struggle for a just cause such as civil rights as a parade of ridiculous protesters and pathetic victims, Warhol defames their cause through the self-conscious way in which they are framed. This aesthetic choice is not unlike his refusal to take into his own body a part of the "big chocolate leg"—the symbolic national body of those in some way touched by the AIDS epidemic—that "everybody," including Martin, his "sweet" friend who was dying from AIDS, represented in his symbolic relation to other bodies at risk.

Yau on Johns

In *In the Realm of Appearances*, "Famous Paintings Seen and Not Looked At, Not Examined" (1992), an essay primarily devoted to Chuck Close entitled "Continuous Change" (1995), and in *The United States of Jasper Johns* (1996), Yau has distinguished Warholian detachment from how Johns represents popular imagery such as flags, ale cans, maps, light bulbs, and flashlights in multimedia art from 1955 to 1965. Yau writes that Warhol's subjects exist primarily as unfeeling objects, "hermetically sealed [in] worlds from which nothing and no one will escape to contaminate our aesthetic experience" (1993, 101). By contrast, Yau shows that Johns, whose art is often identified as hermetic and detached, identifies the artist's and the spectator's predicament as mortal human beings with the metamorphic states of the subject matter he represents.

According to the new modernism, interpreting modern art involves reading and writing, and one major aspect of the verbal composition of

modernism is its narrative within art history. In terms of their placement
in the history of modern American art, Johns's flags and ale cans have
often been placed in what Mitchell calls "institutional traditions" read-
ings of art history beside Warhol's soup cans as icons of "hand-painted"
pop from 1955 to 1962. Richard Francis, for example, writes that "Johns's
peers are the artists born in the 1920s and '30s who have also changed
the history of American art: Ellsworth Kelly, Robert Rauschenberg, Claes
Oldenberg, and Andy Warhol" (13). In *American Pop Art*, Lawrence
Alloway links Johns and Warhol in terms of exceptionalism by reading
their art as exemplifying a uniquely American mastery of technique:

> What is characteristic and entirely American about Pop art is the high level
> of technical performance. Johns' mastery of paint handling, Rauschenberg's
> improvisatory skill, Lichtenstein's locked compositions, Warhol's impact as
> an image maker, reach the point that they do because of the high level of
> information about art in New York. In the background are the abstract ex-
> pressionists, setting an aesthetic standard of forceful presence and impec-
> cable unity. (18–19)

When Warhol and Johns are not placed as contemporaneous figures, as
in Alloway and Francis, they are presented as leading characters in a nar-
rative of progress, the "evolution" of postwar American art that was de-
scribed by Irving Sandler as a "triumph" over the Paris School. In one
version of the narrative, Johns plays a transitional role in the shift from
abstract expressionism in the late 1940s and early 1950s to the rise of
"hardcore" industrial pop that Warhol and Lichtenstein would eventually
perfect in the late 1950s and early 1960s.[3] Narratives by Jon Coplans,
Robert Rosenblum, and Paul Schimmel on the transition between ab-
stract expressionism and early "hand-painted" pop situate Johns as a limi-
nal figure in postwar American art. These art historians place Willem de
Kooning and Jackson Pollock on one side of the bridge toward postmod-
ernity and Warhol and Roy Lichtenstein on the other. Johns's hesitan-
cies, spontaneities, and signs of building up the picture plane with a lot
of creamy paint as well as with bits and pieces of quotidian material such
as the newspapers and bed sheets that make up the base of *Flag* are said
to be vestigial traces of modernist collage. His style is often said to convey a
nostalgia for the emotionalism and painterly gestures of de Kooning,
rather than an acceptance of the mechanically reproduced surface appear-
ances of a Warhol soup can or a melodramatic Lichtenstein cartoon. Ac-
cording to Rosenblum and Schimmel, the vestiges of expressionism in

Johns are superseded by Warhol's version of "hardcore" Pop as a form of machine art produced in a factory with little trace of the artist's fingerprints remaining on the finished product. In Rosenblum's view, Warhol has synthesized artistic process (mass production) and subject matter (commercial products).

Johns does perform what Harold Rosenberg termed "action painting," but he extends the examination of identity beyond Pollock's realm of fascination: the inner life of the artist. "When I am in my painting, I'm not aware of what I'm doing. It is only after a sort of 'get acquainted' period that I see what I have been about," Pollock said. Like Pollock, Franz Kline, and de Kooning who preceded him, Johns explores human consciousness, but also the relation between political symbolism and aesthetic constructs by representing flat objects such as flags and maps that already possess a cultural significance. Johns extends the boundary of what is usually considered to belong to the set of objects "in" the painting, the place where Pollock stood on unprimed canvas with his sticks and buckets to drip and pour his exquisitely controlled articulations of conscious and unconscious impulses.

Pollock included but left unexplored nails, tacks, buttons, keys, coins, cigarettes, and matches as objects that are both concealed and revealed in *Full Fathom Five* (1947). By contrast, Johns's incorporation in *Flag* of everyday objects within his paintings is a fundamental aspect of his art as a form of critical inquiry. By focusing on the problem of how to incorporate elements of the real world onto (or into) the artifact—an issue that Pollock only hinted at in his major works; he spoke of the result of his best "allover" paintings as the achievement of "pure harmony"—Johns questions the idea of abstract expressionism as a statement of aesthetic purity. By focusing on the indeterminate relationship between the flag as an iconic symbol and the flag as a meaningless, flat, but colorful design in a way only hinted at in Pollock's inclusion of bits of partially buried things in *Full Fathom Five*, Johns critiques Pollock's disengagement with political, geographical, and ideological meanings. Instead of pursuing aesthetic purity and all-over harmony, which was Pollock's stated aim, Johns literally punctures the surface of the picture plane.

Johns shows how nonart contexts, often in the form of newsprint and aspects of domestic life such as bed sheets, intrude on aesthetics. In *4 the News* (1962), for example, he alters the surface of the painting and

thereby questions Greenberg's theory that modern art such as Pollock's should take place on a "breathing" flat surface and not be a window on reality as it was before modernism. He inserts a rolled up newspaper into the horizontal crack that is left open by one of the four panels that, bolted together, make up the canvas so that "the work becomes a mail slot, the world passes through art" (Francis, 45). In *Painting with Ruler and "Gray"* (1960), Johns includes things from the world of work, such as the wooden ruler that becomes altered and metaphorized as a measuring device and a method of moving paint around the surface (Francis, 45). As Schimmel writes, in *Tango* (1955), Johns dismantles the boundary between artist and spectator by creating a work that encourages the viewer to consider the relationship between spectatorship and voyeurism: "He draws the viewer into the composition with the necessary action of turning the key to activate a music box. In this close proximity the painting becomes a field and the activator/viewer becomes lost in the composition (i.e., like Pollock lost in the action of his own paintings)" (41).

By reading compositional strategies as expressions of an artist's social views, Yau revises modernist formalism. By rewriting art history, he troubles the shopworn historical narrative of a groundbreaking art movement, New York Pop. Released from the story in which Johns becomes what Schimmel calls the "connective tissue between eras" that leads to the harmony of form and content in industrialized pop described by Rosenblum, new questions emerge about whether it was Warhol or Johns who remained with the Greenbergian aesthetes, and whether it was Warhol or Johns who brought art out of the gallery and into the street (Schimmel, 61). In Yau's version of the story, Warhol exhibits the desire to go "elsewhere" to the sublime destination longed for by abstract painters such as Mark Rothko, and by color field and "stain" painters such as Barnett Newman, Morris Louis, and Helen Frankenthaler. Warhol, and not Johns, wanted to remove himself from "dirt and decay," signs of mortality. Replacing the narrative of Amer-ican painting as an evolution from abstract (Pollock) to pop (Warhol) by way of Johns (who was a little bit Pollock, a little bit Warhol), Yau revises the categories on which affinities are based and "institutional traditions" histories are set in place.

Yau also challenges the traditional placement of Warhol and Johns in postwar American art by showing how both artists were, in effect, readers and writers of European modernism, and how both interpreted how a

European modernist precursor, Marcel Duchamp, should be read as a precursor to postwar American art. Warhol and Johns learned to read the significance of material culture from Duchamp's "readymades," but Yau argues that each man absorbed a different lesson. Duchamp was important to Warhol because he asserted the difference between nonart contexts and the realm of art by, ironically, placing ordinary things into the museum in *Bicycle Wheel* (1913) and *Bottlerack (Bottle Dryer)* (1914). Warhol learned from Duchamp that by locating the aesthetic value of the object in the artist's decision to remove it from its everyday context, "functionalism," as Duchamp had stated, "was already obliterated by the fact that I took it out of the earth and onto the planet of aesthetics." By placing replicas of functional, manufactured objects in the museum, Warhol shows that he learned from Duchamp to assert the difference between the real world and the sphere of art even as he appears to be combining them.

Instead of reducing his aesthetic gesture to the removal of a "ready-made" object from ordinary life, Duchamp's "the earth," into the realm of art, Duchamp's "the planet of aesthetics," Johns examines the interstice between manufactured objects and handmade art. Johns's work was, like Warhol's, destined, and, as Philip Fisher has observed in "Making and Effacing Art" (1984), designed, for the museum where objects must compete for the attention of the viewer as if in a glutted marketplace environment. Johns, however, furthers the aspect of the "readymade" found in Duchamp's *Fountain* (urinal) (1917). Like Johns's art, Duchamp's *Fountain* addresses what Yau calls "the various ways human beings frame and aestheticize experience, both to deny their awareness of mutability and to ignore the relationship between what a thing is and what it looks like" (35): "When Duchamp upended a urinal, signed it 'R. Mutt,' and placed it on a base, he was calling attention to the fact that art should not flee its roots. It wasn't the body he was pointing at, but the nature of the body as a constantly changing thing over which one has no final say. Duchamp's urinal implies that it is from this place that art and artists draw their sustenance (27)." Duchamp made viewers aware of a choice. In the terminology of the essay on Chuck Close entitled "Continuous Change," Yau describes the choice as being between entering "the realm of objectivity and Platonic ideals"—the School of Warhol—or "the experiential realm of Herakleitos"—the School of Johns. In terms of the book

on Warhol, "either we live in the world of appearances or we choose to plunge into the realm of experience. The former offers the illusion of comfort, while the latter promises nothing" (35). Yau suggests that Warhol represents the former course and Johns, by investigating "the realm of experience, the during," the latter (35).

Throughout "Famous Paintings Seen and Not Looked At, Not Examined" and in *The United States of Jasper Johns*, Yau examines how Johns provides an alternative to the Warholian aesthetics of "elsewhere." To illustrate how the "experiential realm of Herakleitos" appears in Johns's art, he concentrates on the two most famous images, *Painted Bronze* (Ale Cans) and *Flag* (1954–55). He shows that Johns relates the commercial subject matter of his art to the construction of human identity, which emerges in the act of composition: "He would 'live' in his materials rather than through them. By, as he put it, 'negating his impulses,' by surrendering his feelings and thoughts to the materials' demand, their inherent behavior and specific properties, he would be able to glean some evidence of 'what' he was" (1996, 137). Johns constructs the base of *Flag* out of apparently unrelated materials such as a bed sheet, newspaper, enamel, and plywood. He then seals these materials together by encaustic, a method of painting with liquid wax in which pigment is dissolved. Encaustic is a translucent surface. It bears the record of its own making by allowing materials of the composition, such as newspaper clippings, to partially show through the waxy surface (Francis, 20–21). A protean substance, encaustic can exist as liquid or solid, depending on the temperature. The fact that Johns chose to work in the quick-to-dry encaustic medium, rather than with oil-based paint, in which compositional changes must occur more slowly (as oil takes a relatively long time to dry compared with encaustic) is important to Yau's argument concerning the semantics of form. Encaustic signifies Johns's engagement with materials that acquire new meanings in the process of the artist's development of the picture in the real time of its composition. Johns's use of encaustic "acknowledges the world it inhabits" (Yau 1996, 143).

Yau's authorship of a new story about modernism involves his reading of it as deeply fused in the artist's own experience of political, social, and embodied life, a way of reading that had been disavowed by American New Critics in the wake of T. S. Eliot's theory of impersonality in "Tradition and the Individual Talent." Johns's "flag" is for Yau a displaced

form of self-portraiture. The painting, and the series of "takes" on the flag that followed in subsequent paintings, suggests that the coherent or "united" image of the self—the integrated "I" as a marker of full presence outside the text—is a meaningful fiction of a stable human life. The fiction of the self as a "united" entity masks the fragmented nature of a human being who exists in "states" of consciousness that experience the world through a variety of sensations, memories, and perceptions. "The individual may believe he is part of something 'united,'" Yau writes in *The United States of Jasper Johns*, "but in actuality the individual occupies a separate and distinct state and in turn is made up of separate and distinct states, the five senses and the mind" (33).

Flag reveals the artist's involvement in the design of the image of America as a stable entity that is also represented as on the verge of breaking apart and dissolving. Johns appears to embrace but also to critique the idea of personal unity and national union by laboring with materials that convey and deconstruct the coherence of personal identity (United/States) and the stability of social reality in the visual figure of the nation as a structure of unification symbolized by the flag. Rather than enforcing a frame of reference that distinguishes between consumer fantasies and violent political reality, as in Warhol, Johns defamiliarizes the frames of reference in *Flag*. In Kristeva's terms, he allows the "semiotic" realm of dream and imagination to erupt underneath the "symbolic" realm of social control. He does so by producing a richly impastoed and distorted surface image of a flag that does and does not resemble its iconic source. Spectators, who were dissuaded by Warhol from experiencing an emotional involvement with the subject matter of his silk screens, are in *Flag* encouraged to become citizens who are called on to construct its meanings.

In *Flag*, Johns conceals much of what is underneath the surface, but he does reveal bits of newsprint and painted words such as "Pipe Dream" and "United States" that may be relevant to the message of his overall composition. He encourages the viewer to perceive his visual/verbal text with an "up close" engagement in order to account for his or her own act of witnessing a representation of a flag that is also not a flag, but a text including newsprint, advertisements, and comic strips. Johns's shimmering colors, irregularly shaped stars, and the tactile quality of the lines

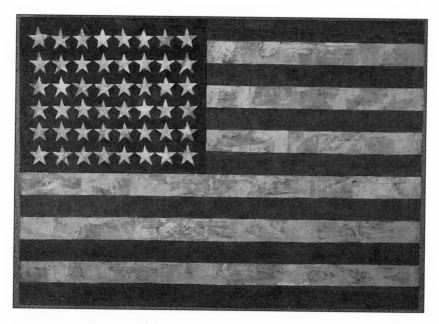

Figure 1. Jasper Johns. *Flag* (1954–55; dated on reverse 1954). Encaustic, oil, and collage on fabric mounted on plywood, 42 1/4 x 60 5/8 in. (107.3 x 153.8 cm). The Museum of Modern Art, New York. Gift of Philip Johnson in honor of Alfred H. Barr Jr. Photograph © 2000, The Museum of Modern Art.

and shapes that form the likeness of a powerful symbol suggests that it is difficult to access the news under the glimmering surface of the patriotic American social text. In order to comprehend the relationships between "America" and the news, citizens must pay close attention to an aspect of the visual realm that is always seen, rarely looked at, but to which individuals are asked to stand in allegiance of its ideological significance. The effect of the composition is not to aestheticize the flag as part of another realm of appearance. Instead, Johns defamiliarizes the icon so that citizens-spectators-readers can revise their initial impressions of it by taking a look at it *as if for the first time.* Although he does not deny the flag's potential value for expressing unity and coherence, he calls attention to how each spectator—and, by extension, each citizen—is responsible for the construction of its public value and private meanings. To Johns, beholding

art suggests involvement and implication, rather than removal and disinterest. Johns said he deliberately chose subjects such as the flag that seldom received close attention from spectators: "I was concerned with the invisibility those images had acquired, and the idea of knowing an image rather than just seeing it out of the corner of your eye" (*Modern American Painting*, 171).

In *Flag*, "Old Glory" is not quite intelligible, but it is a visual statement of Johns's rebellion against the prohibition of figurative content in the first generation of New York School painters. Especially considering that Johns produced his flag series in the cultural context of the 1950s, a period when America was consumed by the cold war and its attendant hysterical fear of communism, and when artists, college professors, and Hollywood screenwriters had to submit to loyalty oaths in order to avoid being blacklisted, the painting takes on a political resonance. He addresses the issue of the individual's relationship to the public sphere—to the realm of national identification, patriotism, social protest, and the meaning of citizenship.

In his reading of *Painted Bronze* (Ale Cans), Yau calls attention to how materials of art may be interpreted as elements of personal composition in an unpredictable domestic environment. Like the public image of the flag, the private sphere of *Painted Bronze* is a continually changing or metamorphic state of affairs. Yau addresses Johns's emphasis on the unrepresentable (immediate) state of "now" that exists between the segmented units of "before" and "after" that Warhol isolated in his *Jackie* series and, prior to that series, in his profile of a woman's face "before" and "after" a "nose job" entitled *Before and After* (1962).

By examining art that is often seen but rarely looked at by critics determined to place Johns into an established art historical paradigm, Yau notices that each painted bronze "ale can" is unique. Each can is slightly different in size and shape. The smaller can of the two has been opened and, most important, the opened can is empty of liquid and the sealed can is, presumably, full:

> Johns's sculpture embodies the artifacts of someone drinking alone. He or she has paused between what has been finished and what has not yet started. Together, as something open and consumed and something closed and unconsumed, the cans frame the way one experiences continuous time or what is called the now. Rather than being in the now, an individual experiences it in terms of past and future, memory and desire. (1993, 38)

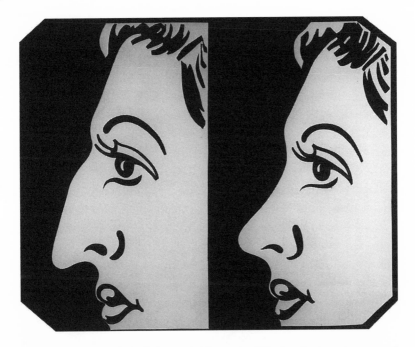

Figure 2. Andy Warhol. *Before and After, 3* (1962). Synthetic polymer and graphite on canvas, 72 x 99 5/8 in. (182.9 x 253 cm). Collection of Whitney Museum of American Art, New York. Purchase, with funds from Charles Simon, 71.226. Photograph © 2001, Whitney Museum of Art.

As with Johns's use of the encaustic seal on *Flag* as a "mediating material which simultaneously preserves and transforms the flag," Yau locates experiential meanings in the art materials, paint and bronze, that Johns uses to prepare a work that exists between the permanent and static states associated with sculpture and the fluid and changing nature of bronze (1996, 143):

> In the realm of art, bronze's solidity is considered permanent, while in the world it may only be temporary. *Painted Bronze* (Ale Cans) consists of two ale cans, one solid and the other hollow. The solid one is waiting to be used, both as a can of "beer" and as a bronze cylinder, while the contents of the hollow one have been "poured" out. Thus bronze's two states, solid and liquid, are underscored by the cans of beer." The permanent, Johns seems to be suggesting, may only be temporary, and there is a larger cycle of time that art will probably not escape. (1993, 39)

In spite of the diverse opinions he holds about how Johns and Warhol relate art to the world in which things (and persons) change under different circumstances such as temperature, or whether an object such as a ruler is contextualized within an art canvas or a carpenter's tool kit, Yau writes formalist criticism that is indebted to modernist forebears such as Greenberg and Fried, but his ethical judgment on how aesthetic choices frame content also takes into account the semantics of form.

Interpreting *Brillo*, Yau writes that Warhol "is saying that in the end we do have control over our bodies and environment, and that we can live in a house without dirt and death" (1993, 27). In the prose poems about a car accident, he represents an event in which "control over our bodies," and life without death, are shown to be aesthetic fantasies that deny the unpredictable nature of life and our proximity to death. Considering how his recollection of trauma is indelibly bound to the repetition of iconic features of the text, such as the electric drills, which produce a sense of narrative coherence to Yau's incoherent past, the writing could be said to be a fundamental aspect of his identity, an attitude toward identity and representation that Yau locates in Johns's art, not Warhol's.

2

John Yau's Painterly Poems

John Yau's art writings illustrate the new modernism in that he revises the narrative history of painting in the United States since about 1940. Like Creeley and Frank O'Hara before him, Yau is also able to write ground-breaking poems because he is what Marjorie Perloff called "a poet among the painters," an author who adapts nonliterary means into his writing. Yau's poetry extends from art, even as he does not react to art by trying to describe it in any direct way. A form of establishing the self through a relationship to a visual manifestation of the not-self, Yau's poetry illustrates Kristeva's notion of an uncanny identity that is simultaneously oneself and a stranger to oneself. Yau's observation that Creeley's "experience of someone else's art" turns out to be "the starting point of his contribution" is certainly true of his own work (Yau 2000a, 47).

In essays on relatively obscure artists at work in the 1980s and 1990s, Yau has called attention to what he loosely refers to as "The School of Johns." In the photographer Thomas Daniel; the "abstract" painters Alan Cote, Robert Mangold, and Don Van Vliet; and the sculptor Jackie Winsor,

Yau finds what he calls an "active stimulus" for how to imagine himself in language while remaining sensitive to his position as a hyphenated citizen. In "Electric Drills" and "The Telephone Call" (both 1980), prose poems from the time he produced the art essays, Yau adapts the artists' compositional strategies to compose his own autobiography while remaining neither subservient to their art nor appropriational of it. His response to artists who follow Johns in imagining an "unfolding present" and the zone of "is" and "is not" becomes his way of reading politics into aesthetics by visualizing an alternative to the "ghetto thinking" he reported in *Hawaiian Cowboys* and in the *Bughouse* interview. Yau invokes a variety of artists working in two- and three-dimensional media, and in a wide range of styles, but they all represent the person as uncertainly situated in a nonhuman, natural, or cultural context over which the individual has little or no control. In all cases, the artist is in a position to construct a provisional, metamorphic identity out of the materials of art.

In a poignant essay that appeared in Clayton Eshelman's journal *Sulfur* entitled "Meeting Thomas Daniel" and in "A Matter of Pride," a catalog essay for a 1999 retrospective exhibition held in Richmond, Virginia, Yau describes how Daniel photographs characters in a way that implies his empathetic identification with them. A Vietnam veteran from Richmond who has existed on the margins of society, at times, Yau reports, "living in rooming houses or on the street" (1988, 45), Daniel has represented members of alternative communities. He has photographed "the surviving members of the Daughters of the Confederacy; triptychs of tent revival meetings, river baptisms, and blessings; the members of a Yoruba religious sect that is involved in the practice of animal sacrifice and snake handling" (1988, 45). Such a list of "exotic" subjects might lead viewers to suspect that Daniel will use irony to underscore the distance between himself and his weird sitters. Instead of irony or condemnation, Yau stresses that as with his own "meeting" of Daniel in Richmond, Daniel "met" the figures he photographed without scorn or judgment. Describing a photograph of a man "holding a toy gun, and dressed in what looked to me like a silver lamé, Buck Rogers/Marlon Brando biker outfit," Yau writes: "Nothing indicated whether this was a costume or everyday clothes. The combination of the clothes, the leaving out of anecdotal information, and the man's ease in the presence of the photograph was what caught my attention. Daniel was able to use the camera to explore his own tenderness . . .

not to delineate separation" (1988, 44). Yau focuses on Daniel's ambiguity, a New Critical piety, but he does so to extend the range of our view of who or what constitutes American culture. His interest in Daniel is related to his own image in "A New Set of Rules Every Other Day" as a citizen whose ambiguous existence outside the realm of the black-or-white dyad that prevailed in midcentury Boston caused him to be scapegoated and stereotyped as a child. Similarly, he argues that Daniel's exclusion from major museums is the result of the ambiguity of his vision. His "tender" and "implicated" relationship to the Brando man, a figure of ambiguous style, challenges mainstream expectations that an artist separate rational from irrational identities. Daniel challenges "either/or" ways of thinking about identity by representing persons who exist in between make-believe constructs of the self and natural life; Daniel's biker has refused to mark the difference between "a costume or everyday clothes."

Yau argued in his book on Warhol that the *Death and Disaster* series divided "us" and "them" by distancing the viewer of car wrecks and plane crashes through grids, aerial perspectives, and colorful makeovers of previously published materials. Warhol also played it safe by sticking to accepted subject matter in his depiction of celebrities such as Marilyn Monroe, Troy Donahue, and Elvis Presley. Unlike Warhol, Yau finds in Daniel's photographs a *counter-cultural* expression that explores the "underside" of the surface appearances that were Warhol's special area. "As subject matter, both the marginal urban dwellers and those belonging to the losing side extend out of Daniel's understanding of the years he spent in Vietnam. . . . Daniel is particularly sensitive to the people history has proclaimed the losers, the defeated" (2000b, 11). By going beneath or beyond Hollywood's illusory version of reality as the space of celebrated winners, Daniel depicts representatives of notorious lost causes. Vietnam veterans, the Daughters of the Confederacy, German World War II veterans, Dineh Indians—these persons may seem dangerous, hopelessly lost in the past, or perverse to many viewers, but they remain part of an inclusive representation of the United States. Daniel's pictures link participants in the art world to other segments of culture, such as to readers of the *National Enquirer*. The *Enquirer* is often perceived as an "other" experience, even as Nancy Reagan and countless ordinary citizens have consulted the alternative media for information about issues ranging from one's love life to historic decisions about international politics.

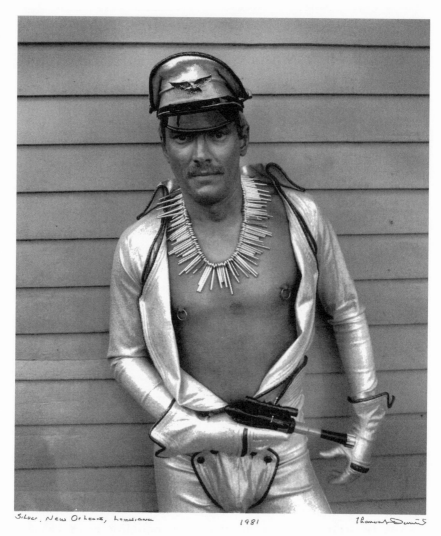

Silver, New Orleans, Louisiana 1981 Thomas Daniels

Figure 3. Thomas Daniel. *Silver, New Orleans, Louisiana* (1981). Publication print courtesy of the artist.

Yau's focus on artists who disrupt simplistic definitions of good and evil, stable discourse, and fixed definitions of the self includes those who have chosen not to work with representational images such as those found in Daniel's photographic portraits. In criticism on "abstract" painters such as Alan Cote, Robert Mangold, Don Van Vliet, Brice Marden, and on the

sculptor Jackie Winsor, Yau reads the distinction between illusionist and conceptual levels of art to be a part of a modernist project that honored aesthetics while denying its immediate relevance to other life experiences. Yau examines the social meanings of Mangold's painting style, even though the artist is indebted to modernism in avoiding the human figure, but working with shapes, lines, and color tones. He interprets Mangold's line drawing onto predominantly abstract canvases as a challenge to mainstream expectations that he should distinguish between "realism" and "abstraction." Combining painting and drawing, Mangold blurs the distinction between imposed structure (the draftsman's line-making) and an organic type of painting that feels loose and tactile. Challenging the prohibition against reference to the world outside the canvas, Mangold revises modernist interpretations of Jackson Pollock that stressed hermeticism and transcendentalism, rather than the social valence of his compositions. After viewing Mangold, Yau revises his understanding of an archetypal American modernist: "the stakes involved in Pollock's attempt to make art exist in the same physical world as the viewer" (1994, 6–7). By combining drawing, color fields, and abstract shapes, Mangold has "continued to discover and register revelations about the provisional relationships between seeing and knowing, between the unified whole and its individualized parts." As with Daniel's photographs, Mangold visualizes a state of affairs that disrupts social and aesthetic systems that function through a Manichean ethics of binary classifications.

In "Alan Cote: The Role of Drawing," Yau focuses on an artist who has been ignored by most critics and museum curators. Initially, Cote "employed a predetermined compositional approach" related to Warholian grids, but in the mid-1970s he "began prying apart the implied grid of his early paintings" (142). Yau reads Cote's formal choice to remove the grid as a sociopolitical statement, a sign that he wanted to destabilize the relationship between art and life, actor and witness. On a semantic level, Cote's "prying apart of the implied grid" transformed his art into a form of resistance to the disciplinary power signified by the grid as a mechanism of social control. "It is a conceptual image in which a natural event and the act of painting is understood as being both interchangeable and synonymous" (142).

As Yau implies in the title of his essay "Neither about Art nor about Life, but about the Gap between Seeing and Knowing: The Sculpture of

Jackie Winsor" (1991b), Winsor is his example of a post-Duchampian
sculptor who, like Johns, understands three-dimensional art to be a bor-
der experience that challenges the difference between spectatorship and
participation. Winsor's art suggests the viewer, like the artist, must strug-
gle to produce significance by determining meaning from the processes
and materials that go into making art. "The viewer cannot remain passive
before her work, but must in some way engage in, wonder about it. It is
in the wondering that [an] open-ended dialogue with it begins" (50). As
with Johns, Cote, Mangold, and Daniel, Winsor troubles the viewer's con-
fidence that what she or he witnesses is straightforward and intelligible at
first glance. Describing *Rope Trick* (1967–1968) as "a substantial length
of thick, sturdy rope that rises straight up from the floor" (47), Yau sug-
gests that Winsor's fusion of natural materials and those manufactured
by human beings creates "an open-ended potentiality for meaning":
"The viewer knows something is holding *Rope Trick* up, but doesn't know
what" (47). As with Johns, who included nonart elements in *Flag* to
break down modernist conceptions of pure form, Winsor brings nature
and nonart materials such as "mirrors, sheet rock, wooden logs, plaster,
wire, and laminated plywood" into her work (49). Yau admires how
another work, *Interior Sphere Piece* (1985), opens up the viewer's ability to
"enter them, while preventing him or her from fully knowing their interi-
or spaces and hidden dimensions." Winsor conjures Yau's perspective on
social relations. She invites the viewer to move beyond his or her own
reflection (the world as mirror to the self) to realize that other experi-
ences, other lives, and other people's references into/onto the reflec-
tion(s) might be projected in art:

> We tend to like seeing ourselves in others, rather than recognizing the
> differences between the "I" and the "you." However, if one is to achieve
> an equal or non-hierarchical relationship with another, a relationship
> that is not dominated by the struggle for power, then the "I" must recog-
> nize that it cannot speak for the other, cannot reduce the other to being
> a reflection of the "I." . . . This rhyme between art and being is what dis-
> tinguishes Winsor's sculptures from those of other sculptures. (48)

No human figures appear in *Interior Sphere Piece*, and yet a spatial con-
cept—*Interior*—appears to have a double meaning when Yau relates it to
the interior dimensions of the self. Similarly, the play on mirrored exteri-

ors that are also apertures into the inside of the piece enables Yau to dis-
cuss relationships between individuals who must acknowledge their dif-
ferences, if equal relationships are to be established.

In Don Van Vliet (b. 1941), a painter and avant-garde rock musician
from Glendale, California, who recorded classic art rock albums such as
Trout Mask Replica, Safe as Milk, and *Doc at the Radar Station* from the
1960s until the 1980s with the Magic Band under the name of Captain
Beefheart, Yau has discovered an artist who visualizes a psychic realm of
simultaneity that defies categorizations of perception such as realism and
illusion. "It is a world that is simultaneously dense and apparitional, phys-
ical and transitory. It comes into being when he merges paint's material
densities with the various conditions of his fleeting inner world," he
writes (unpaginated introduction). Yau describes Van Vliet's paintings as
"hovering in a zone" and as "lying somewhere in between" two realms of
being—the material and the ephemeral, the visible and the invisible, the
symbolic and the meaningless, the transitory and the fixed. By eroding
"barriers between the inner and outer realms of experience," Van Vliet
challenges the art world and the wider society to stop perceiving them-
selves as exclusive spaces that project strangeness onto other persons in
the process that Kristeva described as abjection and that could also be
understood through the psychology of scapegoating. Yau argues that the
exclusive space of the art museum is related to the commercial culture,
which needs to represent the world as a solid and stable market, rather
than as a place of contingent meanings that are constantly open to inter-
pretation and subject to radical political change. "The inherent pictorial
paradoxes of *Boat and Locks No. 2* hold the viewer's attention without
translating themselves into 'things' that can be either categorized or
explained away."

In some of his most pointed critiques of the relationship between muse-
um culture and the repressive society he writes about in *Hawaiian Cow-
boys,* Yau connects Van Vliet's obscure position in the art world to larger
issues of social control. "One of the ways we are repressed, that is social-
ized, is through learning to train our sense to construct falsehoods, which
repeatedly fool us into thinking the world is a solid and stable place. Van
Vliet doesn't participate in this historically accepted pattern of repression.
The world he both occupies and is preoccupied by is a conditional one."

Van Vliet's absence from museum culture is a metonymic reflection of a repression of those persons whose identities challenge the idea of the personal and political realms as being fixed and stable.

In Yau's response to Daniel's photographs, as well as to his semantic reading of abstract compositions by Cote, Van Vliet, and Mangold, and to Winsor's sculptures, he poses a challenge to the gatekeepers of the mainstream art world. In "From Work to Frame, or, Is There Life after 'The Death of the Author'?," Craig Owens interrogates how in avant-garde art from the 1970s and 1980s "the 'frame' is treated as that network of institutional practices (Foucault would have called them 'discourses') that define, circumscribe and contain both artistic production and reception" (Owens, 126). As in his own fiction and poetry, which asserts that a denial of one's own strangeness is related to the logic of abjection, scapegoating, and xenophobia, Yau challenges fixed values in museum culture by calling attention to art that breaks open dyads such as madness and sanity, inside and outside, self and other, nature and culture, or "formal" and "political" art.

In "Electric Drills" and "The Telephone Call" from *The Sleepless Night of Eugene Delacroix* (found in *Radiant Silhouette*, 1989, a compilation of Yau's writings), Yau challenges either/or ways of thinking about representations of the self by writing what Michael Davidson calls "painterly poems." Following Davidson, I am exploring how Yau "activates strategies of composition equivalent to but not dependent on" the work of artists that he groups under the loose heading of the "School of Johns."[1] As in his interpretation of "The School of Johns," Yau encourages readers to participate in the creation of his identity by becoming involved with textual meaning. In contrast to Warhol, who denied life's mutability, Yau narrates his life story without separating time into artificial units of "before" and "after." Instead, he represents his experience as a flow; the impact of traumas such as the car accident extend, uncontrollably and inexplicably, back and forth in time and space with the motion of a wave.

I borrow Davidson's definition of "painterly poems" to distinguish Yau's writings from the "classical painting poem" that directly refers to a specific work of art, but even with Davidson's help I find the relationship between verbal and visual representation in Yau's case to be especially tricky to describe. The distinction between what John Hollander has called "notional" versus "descriptive" forms of ekphrasis, or poems that refer to imaginary works of art versus poems that refer to familiar visual

representations, simply doesn't apply as a system of classification in Yau's case. I say this because Yau's "painterly poems" describe Warholian subject matter—"Death and Disaster"—in the manner of Johns and his recent followers, that is, using materials to produce an image of the self as a visual collage. Yau's prose poems only appear to be monodimensional (or united) discursive fields. When examined with care, his poems can be seen as thickly layered compositions that have been developed from a variety of discursive materials. Yau composes a self-portrait from an array of verbal materials that—like the strips of cloth and newsprint that are partially concealed by Johns's encaustic process in *Flag*—reveal gaps and inconsistencies in the autobiographical pattern he creates even as he connects key moments in his life into a meaningful discursive frame.

Yau offers readers, simultaneously, a glimpse into the coherence and disarray of an author's life. He is attempting to interpret the role of violence in his past by focusing on how images, such as the electric drill, have played a real and symbolic part in formative experiences from his childhood in Boston with an abusive father to his time at Bard College when he brushed death in the car crash. The title of one prose poem, "The Telephone Call," emphasizes the transmission of information as a primary aspect of the speaker's recollection of the event. The other title, "Electric Drills," suggests that Yau's recovery of experience through narrative has also entailed shock and disfiguration, a repetition of traumas that the author may have wished to forget through acts of concealment. Playing with the second person pronoun, the "you," Yau upsets the distinction between ideas of what is "inside" and what is "outside" the discursive frame. By addressing "you," he places the reader inside the text as a participant with the characters who appear within the poem. By sharing the responsibility of composing the authorial self between writer and reader, Yau dismantles the boundary between representation, or the "appearance of the thing," and lived experience, the "thing itself." The "thing itself" includes acts of reading and writing, or witnessing and remembering, as indelible aspects of the events he recalls.

"Electric Drills"

In "Electric Drills," Yau does not offer readers the comfort of a linear narrative about his car accident. Instead, his prose poem is a meditation

on narrating the self as a coincidental process of remembering and forget-
ting. His poem, therefore, displays what Sigmund Freud called "screen"
memories. As argued by Michael Moon, "screen memories," while drawn
from actual life, are also textual constructs because they create, as well as
recount, what happened. "The objects and events recalled become belat-
edly and retroactively charged with a set of meanings that simultaneously
mask and reveal a network of formative perceptions and fantasies from
and about one's early life" (Moon, 80). In Yau's case, the electric drill
becomes transformed in the course of writing into a "screen memory,"
but he also locates key memories through a symbol that he associates
with healing and with bodily pain.

Yau recalls the accident that landed him in the hospital for six months
and that killed two classmates, but the prose poem is devoted to *reassem-
bling the story of how the author constructed his history of the crash* into the ver-
bal collage entitled "Electric Drills." He distinguishes what he remem-
bers as a firsthand witness about his hospitalization from information
that he admits he learned through reports from those who participated
in his physical and psychic recovery. Just as Yau's shattered femur must
be reconstructed by a surgeon who inserts metal plates and steel pins
into his leg using an electric drill, the author realizes that his own memo-
ry must be relayed to him by other characters in his story. Yau realizes his
autobiography is a dialogic event that involves the "you" as participating
witness and coauthor. His life story is not entirely in his own words, but
has many coauthors.

Yau remembers being in the hospital "under morphine" and hovering
in a state between consciousness and unconsciousness that also high-
lights the textual quality of the self (stitches, bandages). "I tore out my
stitches, undid my bandages, ripped the tubes for the plasma and glu-
cose out of my arms, and called the nurses names that, as one of them
said with a smile months later, she didn't know existed" (73).

After recalling this incident as a documentary piece of an autobiogra-
phy that, we assume, he was in a better position than anyone else to
recall, Yau admits, "I don't remember any of these things, since they all
took place at night, and I was supposedly asleep" (73). Similarly, the
image of what a part of his body, a damaged femur, looked like before
surgery, required his doctors to supply him with a metaphor to visualize

it: "the doctors said [it] 'looked like a stack of marbles'" (74). He also learned about the steel plate through a commercial assemblage when the "doctor showed me the plate in a catalog that reminded me of Sears. Beneath the picture was a list of its vital dimensions" (74). Concerning the surgery, he writes, "I don't remember the whine of the electric drill as much as the realization that something horrible was happening to me. I was tied to the operating table's cold narrow slab. I managed to sit up and see one of the doctors drilling through my left leg, just below the knee. The drill was green, like the living room of the apartment on Beacon Hill"(73). Yau writes that he *does not remember* hearing the "whine of the electric drill," but he recalls thinking that "something horrible" was happening during the surgery. Why would surgery be "something horrible," rather than a blessing that, however painful, might provide him with the benefit of rehabilitation? One way to respond to my inquiry is to read his interpretation of the surgery as "something horrible" in the context of childhood memories, also related to "electric drills," as Yau juxtaposes them in his prose poem.

Physically restrained during the surgery, Yau says he managed "to sit up and see" the drilling. His most distinct memory of the surgery, however, is surprisingly banal; he remembers the color of the drill, which was "like the living room of the apartment on Beacon Hill." I want to suggest that Yau recalls the color detail because the surgery is also screening a memory related to a prior traumatic experience involving an electric drill. At the start of the poem, Yau remembers the Boston apartment where the childhood trauma took place was "industrial green" (72):

> While I was sitting there, feeling smaller than I should have in this chair for adults, my father would get out the electric drill, plug it in, and open the closet door until I could see both him and it in profile. He would then drill some holes in the door, while telling me I had been "bad," and the possible consequences that might result if I continued to misbehave. The insistence of his voice competing with the whine of the electric drill was always what frightened me the most. (72)

Eighteen years later, Yau's childhood memory influences how he saw, and then in writing "Electric Drills," how he imagined the surgery that employed the drill for constructive, rather than destructive, purposes. He remembers the surgery as "something horrible" even though he doesn't remember hearing the "whine of the drill."

According to the associative logic that Yau applies to his childhood memories as part of a verbal collage, the image of the drill repeats the father's scare tactics in which "his voice competing with the whine of the electric drill was always what frightened me the most." It was in childhood on Beacon Hill in Boston in the 1950s, and not during his college years in upstate New York, that Yau developed a "fear of tools, largely because of my father" who "developed a ritual to scare me when I misbehaved" (72). The fact that Yau opens the poem with the declaration that "I used to have a fear of tools" suggests that writing has enabled him to work through his trauma by "thinking of electric drills, and the part they played in my life—both in the psychological development and the physical reconstruction of my body" (74). Unlike the subjects in Warhol's *Death and Disaster* series, who Yau writes "inhabit an endless after" and who are "the faces of an event rather than the body (or bodies) in it," he employs the figure of the drill to consider how representation extends, rather than contains, his awareness of the painful and metamorphic qualities of human experience. His poem demonstrates that the pain caused by one event may echo and resound to other experiences in ways that are as inconclusive as the connections between vehicle and referent in a metaphor.

Yau was not at the steering wheel and, therefore, he was not legally responsible for driving the "baby blue '65 Chevy" into the tree. Yau, however, accepts responsibility by admitting he took the keys from a drunken roommate's pocket. In this sense, he says, he "borrowed" the car by daring his friends to "go for a ride" (72). At the same time, Yau, in a subsequent interview, has placed the accident into the context of the national political trauma of the Vietnam War. He suggests that the decision to go out for a drunken ride that night verged on a form of group suicide. Since all four young men were vulnerable to the draft, each held out little hope in their future survival. In Yau's interpretation of the accident in 1990, the distinction between his identity as defined as a national subject whose body was at the disposal of the military wing of the government through the draft, and his characterization of himself as a "misfit" and art student at Bard, produced a disagreement that left him, on the night of the crash, in his words, "up in the air."

> One person had graduated and come back to the school for a visit. One
> person was about to drop out. One was about to graduate. And I was up in
> the air because the school had just taken away my student deferment. I was
> paralyzed at that point in my life and was unable to deal with much of any-
> thing. So I think all of my anxieties contributed and everyone else's in the

car contributed to the accident, which was basically avoidable. . . . It was
1971, you know, and we were all nervous. What's our future? How are we
going to survive? And who are we? (Foster, 41–42)

Yau realized control of his life story was being challenged by other narra-
tives defined by other narrators: the military planners who were less
interested in the hopes and dreams of John Yau, an art student from
Boston, than in furthering national objectives in southeast Asia. Instead
of representing his experience as a product of his own will, his story
depends on the actions (including the speech acts) of others (the draft
board, the drunken friend who drove the car, the doctors and nurses
who reconstructed his shattered body) as well as through the choices he
made to encourage his classmate to drive the car.

Reconstructing his story through the image of the drill is, then, anoth-
er kind of "electric drill," once the drill is understood as a practice, a
verb, and not as a tool for boring into things, a noun. The verbal act of
remembering, which Yau considers to be essential to the formation of
identity as a practice of self-construction in an open system of contested
signs, is also identified as a painful experience. Writing is compared to
drilling, an act of piercing the skin surface. Like writing, scarification is
accomplished by means of artifice, the steel plate inserted beneath the
skin so that Yau could walk after the accident. Suturing a wound is com-
parable to the method of connecting disparate moments in his experi-
ence through narrative. For Yau, writing is a low-tech "electric drill," an
act of repetition and a machine that pierces the skinlike surface of the
present moment to locate the cause of disturbances that have shaped
personal identity. But Yau shows that the cause of the disturbance turns
out to be difficult to locate in space and time because the "fear of elec-
tric drills" coils back and forth in unexpected ways and at unexpected
locations. Writing is represented as repetition of physical and psychologi-
cal distress, but it also is construed as an act of recovery through a con-
frontation with personal and interpersonal trauma.

"The Telephone Call"

In "The Telephone Call," Yau revises Warhol's freeze-dried images of car
crashes as unrealistic fictions. For Yau, such visual fictions assume that
tension and pain can be managed in a way that contains trauma to one

individual at a time, or to one event at a time. "Warhol attempts to break down experience into what precedes and follows its occurrence," Yau writes. "Warhol was a voyeur; he wanted to believe death and old age happened to other people, but that in his case he could control or deflect it" (1993, 44). In the post-op recovery ward in "The Telephone Call," Yau's self-portrait moves in unpredictable and multiform directions. Lives and stories intersect. In the ward, individual narratives become subject to new directions as personal histories combine with each other in a common setting. By setting "The Telephone Call" in a ward where vulnerable human beings meet on intimate terms and at the margin between life and death, his experience at Northern Duchess Hospital in 1971 leads him, by chance, to meet other patients who participate in his experience of survival, recovery, and bereavement.

The "Telephone Call" begins, "He was my third roommate" (75). This opening sentence declares that instead of focusing on his own accident, as in "Electric Drills," Yau's main subject will now be on his relationship to other patients. Not wishing to idealize his experience, he represents his six months in the hospital as a mess of entangled personalities who have been thrown together by chance. He admires some of his roommates, such as John Bouton and Art Blauvelt, but he states that one of them, Mr. Pell, "had managed to completely unnerve me within three days" (75). The main focus is on "the third roommate," Art Blauvelt, whose heart failure while Yau was on the telephone with a friend becomes the title event that also concludes the work as a meditation on the relationship between memory, compassion for the suffering of another person, and narrative transmission to an indeterminate "you."

Yau traces his relationship to an intriguing character named John Bouton, a thirty-two-year-old tree surgeon with ulcers, and his wife, Irma, who "sixth months later . . . would come into the hospital, have her fifth child, a boy, and get her tubes tied" (76). As in the subjects of Thomas Daniel's photographs, the Boutons are presented as a compelling admixture of the strange and the familiar, the known and the unknowable. Even as Yau tries to understand them, the Boutons remain enigmatic figures, resisting his interpretations. However peripheral their experience might appear to be from the perspective of Yau's self-portrait, they remain worthy of narrative reflection. Their story involves birth (Irma's fifth child), the pressures of life, and the cessation of the possibility for

creating new life (John's ulcers, and Irma's decision to "get her tubes tied"). Yau does not pretend to understand the Boutons, but through his selection of images from his hospitalization with John Bouton, and by recalling chance encounters with him after the hospitalization, Yau registers his ongoing curiosity about them.

Yau relates two incidents concerning John Bouton that call attention to the difference between surface appearance and the enigmatic nature of human experience that often lies beneath the surface. The first incident focuses on the gross reality of the unwieldy, prolonged, frustrating, and uncomfortable aspects of postoperative recovery after a serious illness or internal injury. In post-op, the patient becomes aware that the body is a living organism, a metamorphic system of fluids that are pumped in and out of the body as food and waste: "He had ulcers, and was there for two months because something had gone wrong after the operation. A clear plastic tube was inserted through each nostril to drain the blood from the operation and prevent infection. The tubes emptied into a bottle that looked like a five gallon pickle jar"(75). As in the urinal that Duchamp found with its signature of "R. Mutt," as with Winsor's *Interior Sphere Piece*, which enables the viewer to "enter [without] fully knowing their interior spaces and hidden dimensions" (49), and as with Johns's *Flag*, a "cobbled together" object that expresses the entropic nature of the body, Bouton is a bionic contraption of tubes, bottles, and fluids, a metamorphic organism. By paying attention to the internal organs—the guts—the part that most people don't like to think about when imagining themselves, Yau goes beneath the surface that Warhol concentrated on in *Marilyn's Lips*, and in his image of the female profile after a "nose job" in *Before and After*. As in Duchamp's *Fountain* (urinal), Yau does not repress the continuously changing inner workings of the body—the "plumbing"—as immensely complex organisms.

In the second image, Bouton, under the effect of pain killers, expresses another (this time psychological, rather than physical) aspect of his inner self by trying to enlist Yau in a desire to fulfill a wild dream of adolescent excess: "He was given Demerol, a slightly milder pain killer than morphine. He once got out of bed and began dragging it and the bottle across the floor. I remember waking up and hearing him say: "Let's go to town, get two quarts of LSD and some girls" (76). The passage suggests how Kristeva's "semiotic" realm of the language of dream life and the "amniotic deep" of

the baby within the maternal body has replaced the normative text of the symbolic realm. The "semiotic" aspects of Bouton's dream life have uneasily coexisted with the superficial description of him as a symbol of mainstream America: *the thirty-two-year-old tree surgeon with five children and a wife whom he married when both were in high school.* Bouton is a family man, but he is also a biological form, a bionic sack of tubes and pickle jars filled with various bodily fluids. And he is also a contradictory figure of freedom and restraint. He has accepted normative definitions of male subjectivity as father, husband, and wage earner. He has also rebelled by desiring to reach a state of oblivion (two quarts of LSD and some girls) that would cancel out the initial description of him as a family man with a job and the full plate of middle- class concerns that have probably contributed to his ulcer.

Yau remains interested in Bouton's story after their hospitalization, and he has kept in touch with Bouton, at first by chance, and later in imagination. "Two years later, I would bump into him in the Grand Union in Rhinebeck, New York. He still had his quiet smile, and it still frightened me, since he seemed more desperate than he was letting on. Recently, I was reminded of him when a friend read a line from Auden about not giving a gun to a melancholic bore" (76). The projection of meaning onto Bouton's smile may reflect the speaker's own memories of the hospital, but it also speaks to Yau's unwillingness to accept surface appearances as the definitive way to interpret what he sees. For Yau, the act of seeing is only partially revealed through the act of looking. Seeing, as opposed to looking, is a creative activity that involves an intimate, silent dialogue between the seer and the seen. Seeing cannot be isolated to a specific moment of looking at the expression on the face of a man wheeling a cart in a supermarket. Instead, what one sees, and how one interprets what one sees, are conditioned by a history that is shared by the seer (in this case Yau) and the seen (in this case Bouton and his enigmatic smile). Knowing what Yau does about Bouton's life as a family man by day and a wild man when he dreams and desires, Bouton as a shopper pushing his cart in Grand Union and Bouton as a family man with ulcers, Yau cannot accept the "quiet smile" as reflective of an interior life. From experience, Yau knows that the smile means something other than what could be understood by someone passing Bouton in a supermarket aisle. (It seems especially appropriate that the chance meeting takes place in the Grand Union supermarket, the Warholian space par excellence of

consumerism, the location of the Brillo boxes, Mott's apple juice boxes, and Heinz ketchup bottles.) The supermarket is a place where a "Grand Union" takes place between two sensibilities, Bouton's and Yau's, as these two injured men have witnessed each other in hallucinatory states when identity has been disfigured and reconstructed in the most intimate of public settings. The fact that Yau's concern for Bouton extends beyond one chance supermarket encounter is evident in the final re-mark he makes about thinking of Bouton when a friend reads the line from a poem by W. H. Auden about not giving a gun to a melancholic bore. Bouton does not seem to be a "melancholic bore," judging from his occupation, his personal conflicts, his mysterious smile, and his way-out desires, but the line does suggest the potential explosiveness that may lurk beneath tranquil surface appearances.

A bit player in Yau's drama of accident, mourning, and recovery, Bouton remains an enigmatic participant in the author's reflections about life and death after leaving the hospital. In evaluating the significance of Bouton's story on Yau's self-portrait, it is useful to remember that Yau is writing about an event that happened when he was a twenty-one-year-old. In his early thirties, Bouton must have been an especially perplexing figure for Yau, who in 1971 was on the cusp between late adolescence and early adulthood. If Bouton represents Yau's projection of what early middle age might have in store for him in a few years, Art Blauvelt, the "third roommate," and the man with heart trouble in his fifties, must have presented Yau with a disturbing model of the body in later maturity and, literally, with a figure of the "Death of Art."

In *In the Realm of Appearances,* Yau criticizes Warhol for enabling the viewer to "take a kind of childish glee in knowing that he or she is a by-stander untouched by what has occurred" (75). In the prose poems, Yau challenges the boundary between spectator and participant by addressing his reader as a "you." The "you" is a shifting pronominal marker in any text, but in Yau's case the "you" is an especially complex marker that refers to a range of persons situated inside and outside the immediate event. In "The Telephone Call," the "you" signifies the listener or reader, but also a friend or lover, the specific person in Yau's life who is a character in the story.[2]

"The Telephone Call" is an account of the phone conversation that occurs when "Art's death"—a phrase that must relate to Yau's critique of

the modernist disposition to distinguish between "art" and "life"—takes
place, but goes unexpressed by Yau, and a second phone call to the same
interlocutor. The second call relates news about the first call in which
Yau experiences the roommate's death in real time but does not tell the
person on the line with him what is transpiring.

> I remember telling you my roommate died while we were talking on the
> phone. I hadn't said anything at the time, though I could hear Art plead-
> ing with his wife to get the nurses, because there was nothing you could
> do. I was surprised when I said that to you, because, up until that moment,
> I hadn't been conscious of what it was I was thinking when I picked up the
> phone and dialed, except that I hoped you were there. (78)

In terms of Yau's stress on the relationship between author and audi-
ence, the passage is significant because the referent to the "you" is en-
gaged with the construction of the story in such direct and yet complex
ways. The "you" is Yau's telephone correspondent, but "you" is also Art
speaking about his wife's inability to save him from heart failure, and the
"you" is the reader who Yau has tried to reach through the communica-
tion of "The Telephone Call," a story he first told orally to the "you" at
the college bar who, years later, insisted Yau write down what happened
as a piece of literary art.

Yau presents the response of "you" to narratives as a Bakhtinian act of
"live-entering" into the experience of another person through a text. He
does not suggest that the "you" he phoned could have saved Art's life: "I
hadn't said anything at the time, though I could hear Art pleading with
his wife to get the nurses, because there was nothing you could do." At
the same time, Yau describes his impulse to contact the "you" as an inex-
plicable, but urgent, communication. The communication expresses a
wish to make a personal connection that exceeds the information that is
transmitted: "I hadn't been conscious of what it was I was thinking when
I picked up the phone and dialed, except that I hoped you were there."

Yau's recollection of the first phone conversation reveals the relation-
ship between memory, narration, and real event. The information about
Art Blauvelt unfolds through so many layers of discourse that representa-
tion becomes part of the "thing itself," an attitude that was apparent in
Johns's palimpsestic compositions. Telling Art's story, which is really the
narrative of Yau's shifting relationship between "art" and "story," be-
comes part of the event's significance because what is compelling about

Yau's first phone call was that he omitted, apparently out of a sense of shock and helplessness, mentioning that Art was dying in front of his eyes as the call took place. By telling a story about "Art/art" that refers to the transmission of an event that is significant because the immediate disclosure is omitted, Yau represents writers and readers as responsible for the significance of an "art" event for which there is no prior text, no direct and immediate account. Art's death is missing from the layers of discourse that surround the unsayable "real" event that led to the need for speaking and then writing about it as symbolic acts of consolation and recuperation.

Jasper Johns constructed a recognizable image of the flag of the United States through his involvement with the apparently unrelated materials of his art. "Johns overturns the hierarchy separating art from life. Neither, he repeatedly shows us, is more important than the other, because neither can escape time" (1996, 11). Like Johns, Yau is involved in a meditation and a mediation about how identity is constructed out of the complex negotiations between the artist or writer, the materials of representation, and the physical experiences of human beings whose bodies change according to the ravages of time and chance. In Yau's case, the materials of art consist of a variety of discursive methods: the scene at the Bard bar of two friends talking, the telephone conversations, the prose poem that links disparate moments in Yau's experience by way of iconic imagery, "The Electric Drill." The poem is the fallible and partial means by which an event is seen and unseen.

Accidents

In a decision that proved consequential for the rest of his career, Warhol, who had between 1960 and 1962 hedged his bets on the direction of American painting by doing mechanical and painterly versions of Coca-Cola bottles and storm door pictures, decided, in Donna De Salvo's words, "to erase the telltale brushwork that characterized his first hand-painted version of 'Before and After.'" Warhol did, after 1962, "reveal the means by which he created his paintings" by emphasizing the "inconsistency of the screen process" in the multiple and repeated images of figures such as Marilyn Monroe. He did so, however, to show that the art-making process was overtly mechanical, and not to reveal the hand of

the artist, any trace of artistic "presence," or to assert a relationship between artist and his material or his subject matter (Schimmel, 49).

Warhol's decision in 1962 to showcase the mechanical, rather than the painterly, versions of his early art prints, is relevant to my ongoing discussion about the semantics of form. In contrast to Warhol, the artists of the "School of Johns" and Yau's prose poems represent composition as bound to accidents that occur in the course of producing the representation. Yau and Johns perceive their art as a controlled accident. Unlike Warhol's version of crash victims who appear to belong to a perpetual state of afterward, and unlike Warhol's suppression of the painterly versions of his early art, Yau and Johns make the uncontrollable, or accidental, aspects of living coincide with the unpredictable act of producing a painting or writing a poem. Warhol treats the subject matter of the car crash as a visual pun on the abstract painter's focus on artistic "accidents," such as random spills, as signs of spontaneity and the role played by the unconscious in art. It is difficult for me not to interpret his repeated depictions of a car crash as something other than a comment on the death of Jackson Pollock, whose car crashed into a clump of trees and overturned in East Hampton, Long Island, on August 11, 1956.

By contrast to Warhol, Yau, with inspiration from Johns, Van Vliet, Cote, and the other artists Yau has discovered to be an "active stimulus" to his own explorations of the self, has accepted the accidental features of composition as no inside joke, but as an undeniable aspect of life and of making art. According to Johns, accidents were a deliberate aspect of composition if the artist chose to accept drips and mistakes as parts of his process, if he chose not to erase the messy aspects of composition: "There are no accidents in my work," Johns wrote (Schimmel, 40). "It sometimes happens that something unexpected occurs—the paint may run—then I see that it has happened, and I have the choice to paint it again or not. And if I don't, then the appearance of that element in the painting is no accident" (Schimmel, 42). In his prose poems, Yau connects the subject matter (car accidents) to Johns's foregrounding of accidents such as drips or unfinished strips of canvas left exposed in his compositions. He creates a coincidence of style and subject matter by writing an accident poem that is performed in the logic of Johns's exploitation of the accidental nature of art.

3

Charles Simic's Self-Portraits

With someone else's art as the starting point to his contribution, Charles Simic has transformed visual objects ranging from boots he wore as a boy in Eastern Europe during World War II to the collages of Joseph Cornell into locations for writings that convey the self as a fluid construct subject to constant change. In self-portraits that take the form of poetry, memoir, and art writings, Simic recovers traumatic episodes from his childhood that he could not access without reference to modernist visual culture as a guiding inspiration. As with Yau on Johns, however, Simic interprets quintessentially modernist artifacts from a postmodern perspective with the intent of inhabiting and investigating the grim and painful history of his own struggle to survive war and displacement in the 1940s and 1950s. Craig Owens has written that postmodernism "was specifically a reaction to the hegemony of formalist theory, which had claimed or appropriated the term modernism. Modernism meant what Clement Greenberg said it meant. The definition therefore excluded things like Duchamp, dada, surrealism; things that were not part

of high modernism" (299). By recovering Cornell, an artist who combined Duchamp, dada, and surrealism in his collages, Simic elaborates on modernism's counterdiscourse, one that remains relevant to the poet's sense of contemporary life.

Shoes and the Narrative of Mourning: "In the Beginning . . ."

A Pulitzer Prize winner in poetry in 1990 for *The World Doesn't End*, Simic has focused on memoir since that time. Besides the sixty fragments on Cornell collected as *Dime-Store Alchemy*, he has published memoirs in five volumes of the University of Michigan's Poets on Poetry series, including "In the Beginning . . ." from *Wonderful Words, Silent Truth* (1990), and "The Necessity of Poetry" from *The Unemployed Fortune-Teller* (1994). By juxtaposing a close reading of a Simic poem based on an object associated with World War II, "My Shoes," with remarks he made about his childhood in writings including *Dime-Store Alchemy*, I will explore how he has transformed fragmentary images associated with modernity into a meaningful fiction of the postmodern self.

In "My Shoes," Simic finds in the personal item most near in view— the broken and discarded shoes—a minimal starting point (or speculum) that leads him to the subsequent prose memoirs:

> My whole reason for doing the object poems came out of the realization that the things that I truly knew, and had profound emotions about, were things around my house, not the house I was living in, but the house of my childhood in Chicago. And thinking back to that place, the objects, I realized, contained stories. I think of people *through* the objects. (1985, 34)

Because "object poems define [his] consciousness," Simic interprets his task as "establish[ing] a kind of contact with these minimals"(Simic 1985, 14, 15). By creating a personal meaning for the "minimals," he orients himself to the contemporary world: "we are part of the same whole, the same organism" (Simic 1985, 15). In the poem, he imagines that the shoes incarnate memories that are linked in *Dime-Store Alchemy* with his survival of the bombing of Belgrade in 1944.

Born in Belgrade, Serbia, on May 9, 1938, Simic has said he had a "typical Eastern European education" in which "Hitler and Stalin taught us the basics" (1985, 68). Simic's childhood coincided with the war, a

time during which his family evacuated their home to escape indiscriminate bombing raids, first by the Germans when Simic was three years old, and then by American and English planes that were attempting to end the German occupation there in 1944:

> The building we lived in was in the very center of the city on a small side street near the main post office and parliament. A dangerous place to be. That's what we realized in the spring of 1944 when the English and the Americans started bombing Belgrade. . . . My mother was all for leaving immediately; my father was for staying. She prevailed. . . . The roads out of the city were full of refugees. The planes kept returning. We approved of the American and the English bombing of the Germans. I never heard anyone complain. They were our allies. We loved them. Still, with their miserable marksmanship, it was dangerous to remain in the city.
> (1990b, 5–6)

Beginning in the fall of 1945, Simic and his mother, Helen, embarked on a series of risky attempts at illegal border crossings. Forced by English army border authorities to turn back to Belgrade because they lacked passports, Helen and Charles eventually crossed the mountains of Austria as war refugees (Johnson, 400). When Simic was fifteen his mother arranged for the family to travel to Paris, where he studied English at night and sporadically attended a French public school during the day. After one year in Paris, the mother and son sailed for the United States. Entering at New York City, they moved to Chicago, where Simic's father, an engineer named George, had gone after he escaped from an Italian prison camp to avoid persecution by the German Gestapo on charges of spying. In Chicago as a high school student, Simic, who says he "was never at any point capable of writing a poem in Serbian," began writing poetry in English. By combining what he calls the "throw everything in" attitude toward imagery found in Vachel Lindsay with the lyrical resources of Hart Crane, these first poems in English predict Simic's fascination with artists such as Joseph Cornell and the photographer Holly Wright. Like Simic, these artists visualize the magical and reverential dimensions of Crane, but by paying attention to the imagery of everyday life and the body that influenced Lindsay (Simic 1985, 72). In "Secret Maps: Holly Wright's Photographs of Hands," Simic notices how she plays darkness against light in erotic, close-up images of naked hands to "restore wonder to our lives" and to suggest "the visible against the hidden" (1996, 27).

During the period of hunger, violence, poverty, and cultural nomadism after the bombing of Belgrade, Simic writes that shoes remained among the few commodity items available in what had become a precapitalist barter economy. After the bombs hit, he learned to value basic objects such as shoes as instruments of personal survival:

> Since we didn't have any money, we'd barter. A pair of my father's black patent leather dancing shoes went for a chicken. Sometimes these yokels couldn't make up their minds about what they wanted in exchange. We'd let them look around. They'd walk from room to room with us in tow, looking things over, shaking their heads when we suggested a particular item. They were hard to please. Carpets, clocks, armchairs, fancy vases were exchanged for various yard animals over the years. (1990b, 22)

Domestic items—clocks, chairs, vases, shoes—were, in effect, consumed as food, a desperate kind of exchange that connected the body to its needs and to the inanimate objects that surrounded it. Simic learned to transform a visual object into food through bartering, but he also became sensitive to the language of objects as vocal agents of warning: "Toward dusk we heard steps. A wild-looking man with blood on his face told us, without even stopping, that the Germans were coming this way and killing everybody in sight. There was nothing else to do but hurry back to the grandfather's house. The old woman stayed behind. We were back on that empty road lined with poplars" (1990b, 8–9). Sensitivity to the relationships between objects and the sounds of the world around him have, I would argue, continued to inform his poetics.

Simic grew up in an environment where it was ordinary for children to witness the human body in various states of disfigurement and fragmentation. "The river was close by but we only went to dip our feet. There were corpses in it. Every few days they'd fish one out" (1990b, 7). Shoes were symbols of death, of bodies vanishing into murky water, but in a literal sense, they were also instruments of hope, a way to escape to safer territory. His focus in poetry from the 1970s on utensils, on shoes, and on shirts, as well as his affection for Cornellian collages that are filled with objects such as alarm clocks, suggest the influence of a childhood that he realized could be extended into adulthood by reviving debris. In *Dime-Store Alchemy*, it is as if Simic recovers the lost objects of his own childhood in the work of another artist, working in another medium, and in a different period, modernism. Through Cornell's exquisite handling, objects

that Simic associates with his childhood are magically restored to a meaningful existence in a newly imagined context.

For Simic and Cornell, aesthetic constructs become a medium to revive in adulthood the secret life that objects seemed to possess in childhood. Along the way, the objects serve the function of breaking down "either/or" ways of thinking about culture as Cornell and Simic contest the border between high and low art, verbal and visual art, art that is "made" and that is "found" as well as between the present and the past. Both translate debris into a system of another kind through an imaginative method of exchange, metaphor. They also apply the poetic figure of metonymy by associating an abandoned piece of a prior world with the significance of the lost world as a whole. The translation of the utensil or garment into language that signifies objecthood recuperates the value of the thing even as it displaces the object's realm of existence from the real to the symbolic. For the poet, ironically, transforming the object into poetry can secure its existence in forms that are sufficiently distinguished to be sought after by cultural institutions in the United States that possess wealth and prestige. Poems such as "My Shoes" and "Fork" have brought to Simic a full professorship at the University of New Hampshire, a Pulitzer Prize, and in 1983, a lucrative MacArthur Fellowship. Even if such rewards were not Simic's primary motivation for writing poetry, they are nonetheless an ironic outcome of his efforts. This process is a symptom of a commodity culture that will consume and revalue all things—including poems about junk—that threaten its fiscal evaluation of aesthetic worth. Indeed, Simic's shoes, like Cornell's collages, have become iconic figures of American culture and entered into a sign value economy almost in spite of themselves.

Besides helping Simic to survive the war through the indirect means of the barter exchange, shoes were the garment of escape to the mountains of Austria, where he and his mother hid out with relatives before reaching France. Paris became his site of instruction into the intimate world of craftsmanship, illustrated by the cobbler, another type of object-worker, who, working on the edge of industrial capitalism, transforms broken items by his own handiwork into usable ones. "I knew every corner [in Paris], every store window in that city. I can still see clearly each dusty item in a poor shoe-repairer's window on a street in a quiet, residential neighborhood. I would stop by every time I was in the area and

examine that window with the leisure of someone who has nothing else to do" (1990b, 28). Wandering the streets as a truant in Paris because he could neither read nor write in French, Simic perceives the cobbler as a figure engaged in meaningful work with another kind of language, the objects that had been traded, lost, or destroyed during the war years in Belgrade. Like Cornell, the cobbler becomes for Simic an appealing popular artist, one whose occupation is to mend worn objects, the language he associates with childhood trauma and estrangement.

In the memoirs, however, shoes remain linked in his mind with war trauma, with disfiguration, hunger, and death. There are images of one-legged victims of bomb explosions and of the grim work of front-line surgeons performing triage. "Belgrade was a city of the wounded. One saw people on crutches on every corner. They walked slowly, at times carrying a mess kit with their daily ration" (1990b, 11). In "Great Infirmities" (1980), a lyric Simic wrote contemporaneously with his prose memoirs, he reports that "everyone has only one leg." In "Begotten of the Spleen," another poem from 1980, he speaks of "the Virgin Mother [who] walked barefoot among the land mines" and of "the old men [who] had two stumps for legs" (1990a, 144, 148). In a 1984 interview, he was "still haunted by images of that war" (1985, 74). The image of shoes as embodiments of human survival and as specters of death are both at play in a discussion of "My Shoes" once they are connected with Simic's later writings such as "In the Beginning" or the art writings on Cornell.

By comparison with descriptions of his childhood in writings since about 1980, Simic repressed the ongoing significance of his past in interviews conducted when *Dismantling the Silence*, the volume containing "My Shoes," was published. The response he gave to an interviewer's request to have "the poet give us a sketch of his life up to the present time" suggests he was not ready to come to terms with the war trauma. "No, I hate biographies. What matters ought to be in the poems. The rest is boredom—dates, jobs, schools. If I tried, I would have to reduce it to trivia. Each time I'm forced to do just that I experience an immense sadness. So please forgive me if I can't bring myself to do it" (1985, 3). In 1972, Simic did not believe that he could write about "dates, jobs, schools" without reducing their significance to trivia. "In the Beginning . . ." (1990), however, dealt with mundane experiences related to the war

such as attending grade school as a refugee. In Paris, Simic was placed in a classroom where the teacher assumed that all the students, including the young Serb, could speak and write French. The account he gives of the school in "In the Beginning . . ." illustrates how tattered garments marked his status as a refugee of war:

> We were poor, I realized. That first evening strolling along the Champs-Elysees, and many times afterwards, I became aware that our clothes were ugly. People stared at us. My pants were too short. My jacket was of an absurd cut. Waiters in cafes approached us cautiously. . . . After a couple of weeks in France, I knew I had a new identity. I was a suspicious foreigner from now on. (1990b, 32)

In 1972, Simic felt he could not discuss such events without trivializing them. The repression was unfortunate because it disabled him from connecting the semiotics of clothing to the pain of class stigmatization and of uncovering the relationships between clothing, immigrant experience, and identity in a way that becomes evident in later writings such as *Wonderful Words*.

Prior to 1980, Simic denied experiencing "any traumas" from the war, as his comment in 1975 to the poet George Starbuck suggests:

> I don't wish to come out and say "I've seen this and that." I've seen terrifying sights. But on the other hand, I wasn't very unique in that. Everyone else was there. They saw the same thing. . . . There was a church which had a large yard, and there were dead German soldiers there and so we'd go over there, and we'd take from the German soldiers the belts, the ammo-belts, helmets, war-junk such as kids can play with. We wouldn't pay attention to things like watches or the valuable things. We were interested in the—well, weapons were usually taken by then, but there were a lot of ammo and war-junk. *I don't have any nightmares about it. It was all part of this wonderful game we had. And I don't think I have any traumas that I can recognize as a result of it.* (1985, 35, italics mine)

In spite of his claim that no "traumas that I can recognize" were related to the war, the uncanny repetition of images Simic associates with his childhood suggests otherwise. It is as if the poet had awoken from what Dominick LaCapra refers to as a period of "resistance to remembering, mourning and working through trauma in an open reckoning with specific events" that is characteristic of survivors of war (9). In prose fragments written between 1987 and 1993 that appear together in *The*

Unemployed Fortune-Teller as "The Necessity of Poetry," Simic records how objects from the past "contained stories" and how they also provided a medium through which he could "think of people" (1985, 34).

"The Necessity of Poetry" consists of a series of nightmarish vignettes. Among the images are those of an old woman with amputated legs, a blond little girl curtsying while surrounded by the "high boots of the [fascist] dignitaries," dead German soldiers whose "boots were gone," boys tiptoeing around war victims, and a grandfather with "one leg cut off at the knee"(1994, 58, 64, 59, 62). "The Necessity of Poetry" also contains images of survival, nurturance, and escape. There is, for example, a poor woman mending stockings, Simic's father escaping from a Milan prison camp after removing his shoes and tiptoeing to freedom, and his father after the war "studying a pair of brown suede Italian shoes" on Madison Avenue in New York City (1994, 60, 63, 68). In the "Necessity of Poetry," Simic interprets shoes as figures of construal and deconstrual. The ambivalent imagery is relevant to his recollection of war trauma in "My Shoes." By referring obliquely to the catastrophe in the restrained form of the lyric, "My Shoes" reenacts the wound, but it also conceals the wound through displacement.

"My Shoes": Poetry as Speculum

Other critics have placed Simic's poetry into an eclectic variety of literary and philosophical traditions that have enriched American poetics since 1960. These influences include Walt Whitman's "Out of the Cradle Endlessly Rocking" (see Peter Schmidt), Heidegger (see Kevin Hart), Stephane Mallarmé (see Ileana Orlich), the Eastern European folk-style poetry of Vasko Popa (see David Kirby), and the "deep image" and Yeatsian poetry of Robert Bly and James Wright (see Geoffrey Thurley). I place Simic in his historical context as an author engaged in an act of personal recollection that reflects a wider cultural wound. The poem turns an image associated with childhood trauma into what Yau calls "a locus for the writer both to inhabit and investigate" (Yau 2000a, 45).

In "My Shoes," the objects become something that not only has given him "perspectives that he would not otherwise have had, but what those perspectives might be" (Yau 2000a, 45).

MY SHOES

Shoes, secret face of my inner life:
Two gaping toothless mouths,
Two partly decomposed animal skins
Smelling of mice nests.

My brother and sister who died at birth
Continuing their existence in you,
Guiding my life
Toward their incomprehensible innocence.

What use are books to me
When in you it is possible to read
The Gospel of my life on earth
And still beyond, of things to come?

I want to proclaim the religion
I have designed for your perfect humility
And the strange church I am building
With you as the altar.

Ascetic and maternal, you endure:
Kin to oxen, to Saints, to condemned men,
With your mute patience, forming
The only true likeness of myself.

 (Simic 1990a, 38)

The speaker makes a courageous statement by claiming that from his address to a lost part of himself he can build a cosmic structure, divined in the "strange church" of the poem with old shoes as the "altar." Simic has spoken of silence as "a myth of origins" and of language as "a minor ripple on the great pool of wordless silence" (1985, 77). In the apostrophe to the eponymous object in "My Shoes," the speaker is unsure about the world he calls to mind by forming lines on a white page that represents absence as the speaker's environment. He breathes in air (inspires) and then expires by breathing out air that has passed through his mouth and lungs. Literally an act of rejuvenation and inspiration, the speaker transforms the dead, or expired, air into meaning-bearing signs. Simic has said the poem is con-

cerned with breaking silence. "It's an attempt, again, to get to that border-line which divides silence and language—the miracle of that single word that comes out of an inability to speak. You're struck by an experience. You find yourself speechless, right? And then out of that inability just this one word comes. And there is the sheer awe at the presence of that word" (1985, 53). "My Shoes" claims that by disturbing the silence inscribed as whiteness around the poem, a self and its relationship to an object that is in the process of "forming / The only true likeness of myself" will be revealed.

Where is the stress of the reader's attention placed when he (or she) utters "My Shoes," a world-making syllabic foot that exists by itself in the title? I do not hear a trochee (strong/weak) in this first metrical foot. The stress is not to my ear on the self-referentiality of a capitalist who possesses objects to confirm his place in the world through ownership. It is not *My* (strong) / shoes (weak). The stress is on the object. The iambic foot registers in prosodic form the speaker's comfort at stumbling on the form to fill the void with human sounds that reflect a world made intelligible through language. With the object as starting point, the poet tells a story that extends outward and into a world conditioned as human through speech. My (weak) / *Shoes* (strong). I hear the whisper of expectation and the relief of discovery in the long vowel sound made by the shoes. The title refers to the author's relief at discovering how to revise the self through a dialogue with an object that recalls the wonder and terror of childhood. The speaker's address also suggests the bewilderment of reading such as John Keats experienced when he first set eyes on Chapman's Homer or when Emily Dickinson described how she first read the poetry of "that Foreign Lady" (Elizabeth Barrett Browning) in Poem #593 and then "The Dark—felt beautiful—" (Poem #593).

When the poem begins, the shoes, and not the authorial self, occupy a distinguished position in terms of their relationship to the traditional syntax of poetry. Shoes are positioned as the impersonal source of poetic empowerment. As in classic examples of poetic initiation in the West such as in the first two words of *The Iliad* (translated into English as "Sing Muse . . ."), the shoes are nothing less than the inhuman source (Mnemosyne, the rememberer) that authorizes the poet to call forth the inhuman energies of the cosmos prior to his management of them into a personal utterance. The first position in a poem is by tradition reserved for the name of the source of literary power external to the speaker that contains what

Yeats called "Great Mind." Such a source for inspiration has been under-
stood by poets from Homer to Yeats to Simic to be necessary to produce
images of the person and to set the grounds for poetic speech. In Homer,
and in a displaced and delightfully subversive way, in Simic, the will toward
ontological security becomes available to the singer through a projection
outside the self and onto what is not human. In Simic's case, however, the
inhuman thing is a humble and discarded artifact, an inanimate object
that was "something in my own life that I understood very well and felt pas-
sionately about, something that surrounded me, something that was right
in front of my nose, so to speak" (Bellamy, 208).

As the first word, *shoes* exists at the margin between the not-human
realm signified by white space and a world being negotiated as human
through a common object (shoes). The supreme fiction of "My Shoes" is
that the inhuman source of personal recuperation and theological mys-
tery is known by the poet to be an inanimate object manufactured by
persons. Simic accepts a linguistic surrogate for the absent signifier of
transcendence. The shoes, which rhyme with the muse for which they
substitute, are located between an address to the beloved (the broken,
foul-smelling shoes no one else but Simic could love) and a source of lit-
erary power. To a degree that is almost farcical, but at the same time is
appropriate to his predicament, "shoes" are displaced and immanent vehi-
cles for transcendence and inspiration. The shoes are incidental (Simic's
old shoes) and archetypal (the shoes that reflect a whole world).

In a later poem, "My Weariness of Epic Proportions" (1982), Simic sati-
rizes the tragic logic of representation in *The Iliad*. The speaker is weary of
reading about how the life of one great warrior after the other—Patrokles,
Hector, and Achilles—is snuffed out on the ancient battlefield of recogni-
tion to be exchanged for memorable lines in an epic. For Homer to sus-
tain the narrative over twenty-four books, Achilles and countless other
Greek and Trojan warriors must fall like autumn leaves before the poem's
action is resolved. The speaker of "My Weariness of Epic Proportions"
prefers the pastoral imagery of a bird singing and of a daughter asking her
mother "whether she can go to the well" to a destructive history where
characters, many of whom lack even the dignity of their admission into the
poem by name, are "expertly slaughtered" in *The Iliad* (1990a, 222).

Compare the catastrophic outcome to "Sing Muse" in *The Iliad* as Simic
characterizes it in "My Weariness of Epic Proportions" to his production of

a cosmos from the ground up in twenty lines by looking down at his shoes. I am not saying that "My Shoes" avoids resonances of the tragic economy of representation that Simic figures most prominently in his satire of *The Iliad*. The speaker in "My Shoes" relates the shoes to figures that have been sacrificed or who have sacrificed their experience in order to permit a relationship between a community and its God or gods: "Kin to oxen, to Saints, to condemned men." In "My Shoes," however, Simic does not orient the world through the violent exchange of the body for its representation in poetry. He provides a humble example of how contemporary literature might encourage personal survival without the exchange of being for meaning characteristic of poetry in the West. In the first three stanzas of "My Shoes," Simic invokes a nonhuman spirit that is related to human dwelling. The shoes, or the ghosts in the object, and not the poet, are active agents in these first three stanzas. The shoes, rather than the poet, act in the gerund ("ing") or processual form of the verb. They are "gaping," they are "guiding my life," they are "smelling of mice nests," and they contain the ghosts that are "continuing their existence in you." Dialogue with the object creates an "altar" that places the speaker between earth and sky.

By imagining the poem as a vehicle for transcendence in a religious ceremony, Simic connects himself to the romantic aspirations found in modern long poems such as *The Bridge* and *The Waste Land*. Through the apostrophe to the shoes, the speaker believes he can obtain knowledge concerning eschatological mysteries. The shoes, like saints, priests, or Christ as the shepherd, are presented as "Guiding my life / Toward their incomprehensible innocence." They bear messages of the resurrection of the "brother and sister" who are innocent because they, paradoxically, "died at birth." Unlike the brother and sister, the shoes are all too human in the way they appear and begin to disappear and decompose. Their silence triggers the speaker's involuntary memory, revising the object into a language "forming / The only true likeness of myself." The poem is formed when the speaker releases to the object the authority to form personal identity. Where the first three stanzas involved calling a world to mind, the last two stanzas contain this inhuman energy once it is released. Simic invokes the metaphor of a house of worship to speak about his poem as an extraordinary discursive formation: "strange church I am building / With you as the altar."

The shoes are humble, and yet they are regarded as a religious struc-
ture. The shoes are the "altar" upon which the priest (the maker) stands.
The altar is a medium between the incidental life of the person and the
archetypal life of what was and what will be: ". . . my life on earth / And
still beyond, of things to come . . ." A poet with a comic imagination,
Simic's inspiration for "My Shoes" occurs from what is beneath us. He is
also a comic poet because "My Shoes" concludes happily with a type of
sacred marriage involving the earth, the human world, and the sky. A secu-
lar priest, the poet makes the world visible in language. The poem is a
heightened (because additionally restrained) form of discourse that points
toward but is not itself a holy utterance. Shoes have the common purpose
of enabling persons to move safely on ground that was not made to adhere
to human feet. Like poems, shoes are set at the edge or crisis point where
the person is vulnerable to the pain of a world that he or she also must
encounter. "My Shoes" exists between a vast silence that is indifferent to
human sounds, and a series of objects that might, if seen in a new way, con-
tain information that reflects human meanings and values. When Simic
titles the poem "My Shoes," he is comparing the comfort his poem offers
to readers to the protection shoes provide in negotiating ground.

Like the poet with his boots, words, and the prosodic structures of stan-
za and line, the priest stands before an altar to perform his communion
service through the Gospel of the Book. The altar is contained within and
made meaningful by its placement within the environment of worship that
contains the altar. In "My Shoes" the larger environment is the poetic
frame. The poem is a heightened form of discourse just as the church is an
exotic space of habitation. The sacred house of worship, which is related
to the extraordinary form of discourse called poetry, is made with special
care to contain energies that are addressed as if they were not of human
origin. "My Shoes" is "small" and "humble" when compared to the discur-
sive systems produced by ambitious American modernists. At the same
time, "My Shoes" is carefully organized in its features when compared to
prose. There are five quatrains, twenty lines. Each stanza is a sustained
grammatical unit ending on a marker coterminous with the conclusion of
one imaginative thought about the shoes. "My Shoes" cannot be measured
according to an accentual syllabic pattern. The poem alternates between a
lyric that approximates the lines of social formation (the line of ten and,
to a lesser extent, the line of eight) and the more communal (polyvocal)

ballad measure that pivots between three-and-two-beat and four-and-three-beat lines. Simic's poem alternates between the line of ten, which the poet Mary Oliver says "most nearly matches the breath capacity of our English lungs," and the anonymous public form of the folk ballad and low church religious hymn (40). In its prosody the poem registers the ambivalent relationship between "high" and "low" cultural models that informs his admiration of Joseph Cornell's brand of modernism.

After the shoes appear in the first three stanzas, the lyric "I" appears as agent three times in stanza four.

> I want to proclaim the religion
> I have devised for your perfect humility
> And the strange church I am building
> With you as the altar.

This "I," in collaboration with the object as co-worker, produces in relationship both self and other, self through other, and other through self. The gerund form of the verb that once was associated with the shoes is transferred to the speaker. "I am building / With you" means the poet, through dialogue, gains authority to officiate at the service of a new faith in the world based in metaphors of the self. He shifts his address from the sole of the shoe to the souls of his siblings.

Simic suggests an ineffable realm by attending to a visual object that might otherwise have seemed trivial to be worthy of attention. "In my poetry images think," Simic has said. "My best images are smarter than I am" (1985, 77). The shoes, therefore, offer a paradoxical "perfect humility." By "perfect humility," Simic honors a Heideggerean earthiness because humility contains the word for earth while rendering the Good Speech (The Gospel) that tells the story of what is "still beyond, of things to come." Like Whitman in *Leaves of Grass*, Simic combines the book of the body with the book of the soul. Whether it is "My Shoes," "In the Beginning," or *Dime-Store Alchemy*, Simic represents objects that trace the dream work of an author who shapes his character in the parallel act of authoring his life in narrative form. *Dime-Store Alchemy* extends the autobiography Simic began in "My Shoes" in 1972. In *Dime-Store Alchemy*, he produces a "self-portrait," but in the guise of writing about Joseph Cornell, whose enigmatic visual assemblages Simic hopes his study will revive.

4

Responsible Viewing

Charles Simic's *Dime-Store Alchemy: The Art of Joseph Cornell*

Since the eighteenth century, writers and artists have tried to combine all the senses. In France, for example, Louis-Bertrand Castel, with his "ocular harpsichord," attempted to make sound visible (Gessinger, 50). Simultaneously, the limit to Castel's experiment at cross-genre fertilization was being articulated by Lessing, who in *Laocoön: An Essay on the Limits of Painting and Poetry* (1766) questioned how poetry could combine the features of sculpture and painting on one side, of music on the other. Disputing the absolute boundary between genres established by Lessing and, in the modern period, by Greenberg in "Toward a Newer *Laocoön*" (1940), Charles Simic demonstrates in *Dime-Store Alchemy: The Art of Joseph Cornell* (1992) that visual designs and verbal narrations are related but distinct strategies for personal disclosure, imaginative reverie, and interpersonal communication. Extending Cornell's shadow boxes into a collage of sixty prose poems without translating them into his own discourse, Simic destabilizes the line between generic identifications. In the act of transforming spectatorship into a creative endeavor and statement

of shared citizenship in New York City, Simic explores his own poetics while revising the visual text of an iconoclastic American modernist who died in 1972.

Using ideas that the Russian narrative theorist Mikhail Bakhtin derived primarily from verbal discourse to analyze Simic's relationship to visuality, I follow an argument that Bakhtin developed in *Toward a Philosophy of the Act* to consider *Dime-Store Alchemy* as an event that Simic, metaphorically, "coauthors" with Cornell.[1] I read *Dime-Store Alchemy* as a "creative under-standing," a hybrid text that Simic refers to as the "third image" (1992, 60). In *Toward a Philosophy of the Act*, Bakhtin argues that "creative under-standing" differs from a "live-entering" of the reader's viewpoint into the author's imagination. For Bakhtin, such an empathetic identification between reader and writer, while a necessary step toward "creative under-standing," removes the relational and, therefore, the critical aspects of reading as a form of authorship: "If I actually lost myself in the other (instead of two participants there would be one—an impoverishment of Being), i.e., if I ceased to be unique, then this moment of my not-being could never become a moment of my consciousness" (Bakhtin, 16).[2]

For Bakhtin, "creative understanding" through close reading involves "live-entering" (identification) *and* the "moment of separation" (disidenti-fication) that establishes the reader's identity as an imaginative horizon. The interaction between reader and writer produces what Bakhtin calls a "surplus of seeing" that posits the reader's stake in the creation of textual meaning, and by implication, the reader's responsibility for sharing in the author's construction.[3] As Deborah J. Haynes writes in *Bakhtin and the Visual Arts*, "If visual art is ever to have social or political efficacy, the critic or viewer must practice this kind of living-into *and* separation" (68).

Joseph Cornell lacked art school training, but his place outside the academy did not prevent him from designing collages in his spare time in the basement of a modest house on Utopia Parkway, Bayside, Queens, where he lived for many years as a bachelor with his widowed mother and a chronically ill brother. His creative enterprise is a modern example of outsider art, as it primarily consisted of finding interesting objects, and then moving these items into a realm of his own fashioning. He places in small, homemade wooden boxes abandoned or ignored items such as dolls, twigs, thimbles, maps, cut-out pictures of birds from cheap paperbacks, photographs of movie stars such as Lauren Bacall, dice,

Cordial glasses, rubber balls, and Ping-Pong balls that appear to have fallen off the surface of a slotted game board that functions according to obscure rules. As John Ashbery has written of one of the "hotel" boxes that depicts an out-of-season French resort, Cornell's art does not require empirical verification to testify to its authenticity. "The secret of his eloquence: he does not re-create the country itself but the impression we have of it before going there" (Ashbery, 15). Ashbery reads into Cornell's art an expression of modernist escapism. Cornell is a surrealist who invents a utopian fantasy through an act of pure imagination ("the impression we have . . . before going there").

By contrast to Ashbery, Simic revises the meaning of Cornell's relationship to modernism by reading his rummage work of abandoned objects as a metonym for the fragmented and isolated history of an immigrant's experience in New York City. "He sets out from his home on Utopia Parkway without knowing what he is looking for or what he will find. Today it could be something as ordinary and interesting as an old thimble. Years may pass before it has company. In the meantime, Cornell walks and looks. The city has an infinite number of interesting objects in an infinite number of unlikely places" (1992, 14). Simic fastens Cornell's art to his quotidian existence of Utopia Parkway, not a utopian fantasy of a faraway resort hotel in France. Cornell's art reflected the material life of Queens, New York, during modernity, but he made the familiar strange by altering the context for the stuff he discovered in five-and-dime stores, used bookstores, and the photo collection housed in the basement of the New York Public Library at Forty-second Street and Fifth Avenue. These sites are comparable to the "secondhand" places that Simic frequented on arriving in New York City around 1960 after his mother, Helen, had taken him from Belgrade to escape the war. Interpreting Cornell's art, Simic visualizes his own poetics, social views, and his experience as a displaced person, an urban immigrant, and war refugee. "For a long time I wanted to approximate his method, make poems from found bits of language," he writes (xiii). Discussing Simic's poetics, the poet Bruce Weigl has noted "his habit of setting the spectacular alongside the mundane, the comic in bed with the tragic, and a powerful sense of the brute forces of history and nature intruding on the reality of the poems" (2). In poems such as "My Shoes," "Fork," and "Ax," Simic, like Cornell, grants to ob-jects what Weigl calls a "rich new life" (3).

Reconfiguring art criticism, Simic disrupts linear narratives of art history that emphasize specific genres or periods. By contrast to writers of traditional art history, Simic discusses the influence of European and American arts and letters on Cornell aesthetics, and, therefore, connects the visual arts to his own poetics (1992, xiii). Cornell's "rummage work" becomes a metaphor for a method of composition that contructs a usable past without relying on faith in what Harold Bloom calls "the American religion" of artistic originality to compensate for the "pressures of reality," as Wallace Stevens had sought to do in his poetry. At the same time, Simic notes that Cornell did not try to develop a new idiom to represent modern life—the project of nativist American poets such as William Carlos Williams—so much as he sought to revive the aesthetic potential in the fragments of the "Old World": "A pile of Greek 78 records with one Marika Papagika singing; a rubber-doll face of uncertain origin with teeth marks of a child or a small dog; sepia postcards of an unknown city covered with greasy fingerprints; . . . a menu from a hotel in Palermo serving octopus" (1992, 17). Cornell could not draw, paint, or sculpt, but Simic considers him to be an artist whose vision enables his own desire to recover aspects of the culturally and financially impoverished experience of European immigrants in the United States. "America is a place where the Old World shipwrecked. Flea markets and garage sales cover the land. Here's everything the immigrants carried in their suitcases and bundles to these shores and their descendants threw out with the trash" (1992, 17). Simic places Cornell's art, and by extension, his own poetry, in relation to the "found" and "low" cultures of "flea markets and garage sales." He also places Cornell in relation to an "other" verbal and visual endowment of modernist collaborations by connecting him to dadaist and surrealist *writers* in France such as André Breton, who "found" material in overlooked places, as well as to the bohemian "walker in the city" figured in the prose poetry of Charles Baudelaire. Simic notices how these and other European modernists influenced representation in New York City, where many of them had fled to escape fascism in the 1930s: "The history of that idea [that poetry and art are everywhere] is familiar and so are its heroes, Picasso, Arp, Duchamp, Schwitters, Ernst—to name only a few. You don't make art, you find it. You accept everything as its material. Schwitters collected scraps of conversation, newspaper cuttings for his poems" (1992, 18).

By placing Cornell in relation to the counterdiscourse of European and American modernists who chose to "accept everything" as elements of culture, Simic extends the national boundaries, as well as the generic affiliations, of his art. He also challenges gender affinities by placing Cornell in the context of male as well as female voices in nineteenth-century American poetry, Walt Whitman and Emily Dickinson. Stating that "both in the end are unknowable," he compares Cornell's enigmatic but psychologically revealing collages to Dickinson's use of the riddle form to express the surprise of life and the mystery of death in poems such as "It was not Death, for I stood up" (1862), and to Whitman, who celebrated urban dynamism in poems such as "Crossing Brooklyn Ferry" (1856). "Whitman, too, saw poetry everywhere," Simic writes (1992, 73, 18).

In its form, *Dime-Store Alchemy* is a hybrid text that mirrors Cornell's challenge to definitions of modernism that favor one class of cultural phenomenon over another. In Simic's view, even the paradigmatic texts of high modernism, *The Waste Land* and *The Cantos*, are "collages," part of the "accept everything" aesthetic that he finds in Cornell. Itself a textual "collage," or garage sale version of *The Waste Land*, *Dime-Store Alchemy* is divided into sixty sections, each with its own title. The poet Edward Hirsch has accurately described these individual entries as "diverse 'illuminations,' notebook entries arranged in associative rather than linear fashion, paragraphs put together in tonal blocks that accrue into an homage and a portrait" (Hirsch 1992, 131). Simic's prismatic assemblage of sixty ways of looking at Cornell is open ended. It graphically reproduces the content: multiple interpretations of "beautiful but not sayable" boxes (Simic 1992, 54).

As Cornell's art bears affinities to modernist verbal collages by Pound and Eliot, Simic's graphic renderings of Cornell resemble the form of modernist texts by authors such as Eliot. As in *Four Quartets* (1943), Simic divides *Dime-Store Alchemy* into primary areas that suggest his desire for structure, categorization, and coherence: "Medici Slot Machines," "The Little Box," and "Imaginary Hotels." As Irving Malin points out, these units, which are then condensed and subdivided into the sixty "box" sections, become a literal "*reflection* . . . of Cornell's constructions" (Malin, 267). The multiple "takes" on Cornell nonetheless represent a challenge to the modernist impulse to construct interpretative metanarratives for beguiling texts. Eliot offers an example in his "*Ulysses*, Order, and Myth" (1923), in which he claims that Joyce's novel *Ulysses* follows the "mythical

method." Unlike Eliot's metanarrative, which was designed to contain
the play of language in *Ulysses*, Simic's critical "boxes" allow Cornell's art
to emerge before the reader/spectator in an ambivalent state where lan-
guage and images are at play, a state between concealment and revela-
tion, seeing and knowing, legibility and the illegible.

Simic addresses Cornell from many social, cultural, and aesthetic per-
spectives. In addition, meditating on art provides him with stimulating
metaphors to assess his own poetic process, religious sensibility, and auto-
biographical impulses as a poor, immigrant writer living in New York City
and Chicago after World War II. As Helen Vendler has written, "No other
book by Simic transmits so strongly as *Dime-Store Alchemy* what New York
must have meant to him when he first arrived from Europe" (1992, 97).
Simic establishes his fascination with Cornell by extending the genre of
art criticism to include moments of reverie usually reserved for lyrical
poetry or dream diary.

In the preface, Simic records a dream where he meets Cornell as his
double, a fellow wandering isolate haunting a New York City street:

> I have a dream in which Joseph Cornell and I pass each other on the
> street. This is not beyond the realm of possibility. I walked the same
> streets he did. In the years 1958–1970, I subsisted by working at various
> jobs in mid-Manhattan, or I was out of work spending my days in the
> Public Library on Forty-second Street, which he frequented himself. I
> don't remember when it was that I first saw his art, or even where it was.
> I was interested in surrealism in those days, so it's likely that I came across
> his name and the reproduction of his work that way. He made me think
> I should be doing something like that myself, but for a long time I wasn't
> very clear about what it was Cornell was really doing. (xiii)

Dime-Store Alchemy is the theater of speculation where the imaginative but
improbable meeting between Simic and Cornell, whose gaze affirms the
author's presence, takes place in a belated textual form. Mystified about
the artist's intentions ("I wasn't very clear about what [he] was really
doing"), Simic is nonetheless inspired by Cornell to create his own
graphic art: "He made me think I should be doing something like that
myself." The posthumous vision of Cornell also enables Simic to recover
his own past by revisiting New York City circa 1960. He associates the
artist's journeys from Queens to Manhattan with his own strategy of cop-
ing with isolation and despair by imaginatively re-creating the past, and
thereby protecting himself through poetry, film, and art.

In "Chessboard of the Soul," Simic equates Cornell's isolated existence with his own immigrant experience of alienation, poverty, and loneliness. He represents Cornell as a life-long bachelor who sold "woolen samples door to door in the manufacturing district in lower Manhattan" and who lived with his mother, Helen, and invalid brother, Robert, as an autodidact (xv). Shut off from the art scene in Manhattan except for occasional visits to the Julien Levy gallery, which first showcased his art in 1932, Cornell controls and even momentarily transcends his monotonous existence in Queens by juxtaposing miniature objects in his art:

> Around the boxes I can still hear Cornell mumble to himself. In the basement of the quiet house on Utopia Parkway he's passing the hours by changing the positions of a few items, setting them in new positions relative to one another in a box. At times the move is no more than a tenth of an inch. At other times, he picks the object, as one would a chess figure, and remains long motionless, lost in complicated deliberation. (42)

As with "My Shoes," Simic makes images speak to relieve isolation: "Around the boxes I can still hear Cornell mumble." He also matches Cornell's artistry to a chess master playing an endgame when few pieces remain on the board, and, therefore, when the value of each movement of each piece accrues. Simic's account of Cornell's dependence on art to survive alienation is comparable to how Ashbery has imagined Cornell's life: "One imagines that his day-to-day existence in Queens must be as outwardly routine and as inwardly fabulous as Kant's in Koenigsberg" (15). Simic would not have selected Kant, the philosopher who influenced Greenberg by claiming that an object may be beautiful only when it pleases "apart from all interest," as his example of a man who lived inside himself (Kant quoted in Golub, 28). He does, however, represent Cornell as someone who, "lost in complicated deliberation," adjusted minuscule aspects of art to convey his inner life. A key moment of dialogue between author and artist, Simic's analogy of Cornell's art with that of a chess master playing blindfolded refers back to a narrative poem about young Simic's initiation into poetic vision. As in "Chessboard of the Soul," Simic, in "Prodigy" (1977), represents chess as a metaphor for metaphor, a scene of instruction in how creativity may enable the child to resist trauma through displacement.

Simic begins "Prodigy" by stating: "I grew up bent over / a chessboard. / I loved the word *endgame*" (1990a, 138). He reports how he

learned chess from a retired professor of astronomy when "Planes and tanks / shook [the] windowpanes." He also recalls playing chess with an incomplete set of broken pieces: "the paint had almost chipped off / the black pieces" and "The white King was missing / and had to be substituted for" (1990a, 138). At the end of the poem, he transforms playing chess during the war into a narrative that combines the image of the blind chess player with a story about how his mother shielded his eyes as a man is hanged:

> I remember my mother
> blindfolding me a lot.
> She had a way of tucking my head
> suddenly under her overcoat.
>
> In chess, too, the professor told me,
> the masters play blindfolded,
> the great ones on several boards
> at the same time. (1990a, 139)

By interpreting art as a playhouse, Simic suggests how the mature writer may come to terms through representation with experiences that were beyond his control as a child. "Prodigy" is a poem about trauma because the speaker remembers an episode from the remote past that he never claimed to have initially witnessed—he was blindfolded by his mother. By remembering how he learned chess from the blind master, poetic insight becomes contingent on experiential deprivation. Like the chess master whose gifts are enhanced by blindness, Simic was shielded by his mother from witnessing a hanging, but his need for artistic control is a consequence of the sensory loss. The traumatic episode possesses talismanic power over him because it was never witnessed and, therefore, never worked through, never mourned. In "Secret Maps," his essay on the photographs of hands by Holly Wright, he states that her work "teaches us a new kind of trompe l'oeil. We can see ourselves reflected in them only if we close our eyes" (26). The paradox involving blindness and insight, as well as the relationships between memory, imagination, and desire are at play in "Prodigy" as the poet can now revise what happened in poetry as a reflection of his mind's eye. In terms set forth by the poet Alan Shapiro,

Simic "transform[s] into pleasure experiences that otherwise would ter-rify or repel" (184). Playing chess while blindfolded in "Prodigy" is com-parable to Cornell's art as a visionary compensation for experiential loss, a kind of blindness. It is also a gloss on the classic image of the blind singer found in Homer, Sophocles, and Milton, as well as in the African American blues tradition, much admired by Simic, in the figures of Blind Lemon Jefferson, The Reverend Gary Davis, Ray Charles, and Stevie Wonder.

In "O Fading Memory!" Simic challenges the relationship he set up between Cornell's playful art and his own childhood gamesmanship dur-ing the war. He compares his memory of playing with toys to protect himself from fear to Cornell's art *as* a form of theatricality. "My own the-ater did not come from a store. It consisted of a few broken toy soldiers made of clay and an assortment of small wooden blocks, corks, and other unidentifiable objects which, in my imagination, had acquired anthropo-morphic properties. My stage was under the table" (1992, 49). Identify-ing with these game boards and playhouses, Simic also distances himself from them by stating that his childhood involved a level of poverty and danger that stemmed from life in a war zone. Where most of Cornell's images came "from a store," Simic's "broken toy soldiers" were directly related to the war scenario that raged around him. Cornell's boxes recall childhood play in Belgrade, but they cannot approach the terrifying experiences that sent Simic "under the table," where he created a private theater with fragmented art objects, the clay soldiers, as props. "My fig-ures enacted what could only be described as an endless saga of the Wild West. There was a hero, his best friend, the bad guy, the Indians, but I don't remember the heroine. I was seven or eight years old. The war was just over. There was little to do but imagine"(1992, 49). As with the chess board, the war game turns into a theater of preservation, a space to con-vert the "little to do" in Belgrade into imaginative gain, an "endless saga" where he was the general in charge of the troops. Simic's narrative sug-gests that as a boy he perceived art as a safe haven, protecting him from loss, fear, and isolation.

Dime-Store Alchemy is not the only place where Simic imagines scenes that insist on the promise of art as a form of personal reparation after traumatic loss. We may recall that in "In the Beginning," he remembers playing hooky in Paris and then gazing inside a window to observe the

cobbler reconditioning damaged objects. Similarly, in *Dime-Store Alchemy*, Simic perceives Cornell's miniature, glass-enclosed boxes as sites where broken objects are revived as meaningful artifacts. The "art of reassembling fragments of preexisting images in such a way as to form a new image, is the most important innovation in the art of this century," Simic writes in "We Comprehend by Awe" (1992, 18). In his poetry and in the book on Cornell's art, abjected and apparently dead things seem, uncannily, to spring to life, but in a context in which prior meanings are, if not erased, then not entirely restored to public disclosure.

Through the reflections on childhood during the war, *Dime-Store Alchemy* becomes an event of identification with Cornell, a "live-entering" into the artist's creative process. Simic, however, also distinguishes himself from Cornell by focusing on his own life story in the course of his visual analysis. Describing Cornell's "Medici Slot Machine" (1942), which contains a reproduction of a renaissance portrait of a Medici princeling set in the "magic" districts of vice in Times Square in Manhattan, Simic recovers his own sensual experience of New York circa 1960:

> The boy has the face of one lost in reverie who is about to press his forehead against a windowpane. He has no friends. In the subway there are panhandlers, small-time hustlers, drunks, sailors on leave, teen-aged whores loitering about. The air smells of frying oil, popcorn, and urine. The boy-prince studies the Latin classics and prepares himself for the affairs of the state. He is stubborn and cruel. He already has secret vices. At night he cries himself to sleep. Outside the street is lined with movie palaces showing films noir. One is called *Dark Mirror*, another *Asphalt Jungle*. In them, too, the faces are often in shadow. (1992, 26)

Like all grotesque art, Cornell's boxes and Simic's poems fuse the perishable realm of the body with the imperishable realm of the human spirit.[4] For Simic, collage registers temporality and decay, but it also is a still life that suggests the permanence of art. A three-dimensional artifact, collage recuperates disappearing pieces of actuality by placing them inside an enclosed realm that is designed to attract spectators. Simic's reading of "Medici Slot Machine" suggests that even as he detects mystery in streets strewn with garbage, Cornell does not erase the profane aspects of city life and of popular culture ("movie palaces showing films noir"), sites that for him are the residences of sublimity as well as the erotic. As Cornell's biographer has written, "In the luminous flicker of moving pictures, he found the promise of eternal life" (Solomon, 77).

Simic and Cornell practice what I think of as a "poetics of conver-
sion." Even though Cornell finds his material in an urban environment,
the shadow boxes are not a visual equivalent to William Carlos Williams's
industrial image of poems as Ford-era machines made out of words.
Instead, the boxes are sites for magic operations. They are alchemical "slot
machines." As in his reading of Cornell's art as an iconic self-portrait, "a
totem of the self" (1992, 62), Simic likewise positions himself in "My
Shoes" in the cosmos through an imaginative dialogue with a pair of beat-
en shoes that "smell . . . of mice nests." Perceiving the shoes with an unusu-
al degree of attention and personal identification, the speaker represents
them as "the only true likeness of my self." In fact, the speaker claims that
from his apostrophe to an abjected part of his surroundings he can build a
cosmic structure, divined in the "strange church" of the poem with the
image of old shoes as the "altar." As in Cornell, who combined the renais-
sance portrait of a Medici princeling with images that belong to a mid-
twentieth-century urban pinball arcade, Simic juxtaposes sacred and pro-
fane objects, the world of spirit and of body, of libido and of a transcendence
of ego, of what Simic refers to as a "good-tasting homemade stew of angel
and beast" (1994, 103).[5] In "Street-Corner Theology," Simic directly ad-
dresses Cornell as "a religious artist" (1992, 70). "He makes only icons. He
proves that one needs to believe in angels and demons even in a modern
world in order to make sense of it" (1992, 70). Even if Simic and Cornell
express religious impulses, both are grounded in the human body that
experiences desire in an urban setting of impurity, sexuality, and risk.

In "Vaudeville de Luxe," Simic imagines Cornell's art as a transforma-
tional space where the boxes are "like witch doctors' concoctions" that
contain objects possessing magical properties (1992, 40). They are "a lit-
tle voodoo temple with an altar" (1992, 40). In churches, the altar is the
table, or, in Latin, the "high place." Traditionally, the altar is used for
sacred acts such as the celebration of Eucharis. In "My Shoes" and in
Simic's reading of Cornell, however, the altar is not an elevated place in a
church, but a discarded or broken object through which the poet or artist
makes the familiar world seem strange. Each man revises the significance
of objects in an unorthodox structure such as the short lyric poem or the
sixteen-inch wooden box filled with debris. In "My Shoes," Simic repairs
aspects of his personal, cultural, and familial past. In Cornell's case, art
enhances the sensation of New York City as a humane but wild environ-

ment where private associations, once hidden from view, become available to others for speculation and enjoyment. As in his reading of Cornell, Simic in "My Shoes" employs cultural leftovers to produce unauthorized ("strange") versions of a ceremony figured as "magic" or "witchcraft." By reading Cornell's boxes as profane vehicles that enable him to access a sacred environment associated with metamorphosis, Simic visualizes his own poetics and suggests an unorthodox spirituality.

Cornell strove to recuperate a sense of belonging among leftover items that did not exist together prior to his imaginative engagement with them. "Somewhere in the city of New York there are four or five still-unknown objects that belong together. Once together they'll make a work of art. That's Cornell's premise, his metaphysics, and his religion, which I wish to understand" (1992, 14). By displaying a hidden unity among discarded objects, Cornell anticipates a major aspect of Simic's belief system as well as a formal principle that informs his poetics. In describing his own creative process in "Notes on Poetry and Philosophy" (1989), Simic relates his poems to the ensemble of unlike things found in Cornell. "My poems (in the beginning) are like a table on which one places interesting things one has found on one's walks: a pebble, a rusty nail, a strangely shaped root, the corner of a torn photograph, etc. . . . where after months of looking at them and thinking about them daily, certain surprising relationships, which hint at meanings, begin to appear" (1990b, 64). As in "My Shoes," where "meanings begin to appear" as the poet gazes into the existence of objects, Cornell revises the meaning of things without facilitating a nostalgic return to an unmediated sensation of presence. Neither man suggests that he can return to an original "groundedness in being" in an Old World community of agrarian workers, as is the case in Martin Heidegger's description in "The Origin of the Work of Art" (1935–36) of Vincent Van Gogh's painting *Old Boots with Laces* (1886–87).

Describing Van Gogh's painting, Heidegger emphasizes the artist's sentimental identification with the peasant woman who, through the shoes, is linked to the primordial experience of fieldwork disclosed in art:

> When she takes off her shoes late in the evening, in deep but healthy fatigue, and reaches out for them again in the still dim dawn, or passes them by on the day of rest, she knows all this without noticing or reflecting. . . . By virtue of [the shoes'] reliability the peasant woman is made privy to the silent call of

the earth; by virtue of this reliability of the equipment she is sure of her world. (Heidegger, 262)

Through "reliable equipment" that mediates nature and culture, Heidegger establishes the peasant's connection to the earth, community, and the seasons of an agrarian economy. For Heidegger, Van Gogh's painting reveals "the equipmental being of the shoes, that which is as a whole—world and earth in their counterplay—attains to unconcealedness" (277). I mention Van Gogh's painting because it represents an icon of Simic's poetry, but also because Heidegger believes it reflects the experience of an active culture, not a lost world. By contrast, Simic and Cornell are closer to Derrida's reading of Van Gogh's boots as unattributable objects, as they imagine on formal (aesthetic, associative) terms the meaning of fragments of vanished life worlds. The shoes and the other objects found in Simic's poems and Cornell's shadow boxes are irrelevant without the aesthetic performance of their significance. By revisiting objects and then sharing the outcomes of their perceptions with spectators, Simic and Cornell affirm their unique visions while establishing a community of interpretation.

In *Dime-Store Alchemy*, Simic defines poetry as "three mismatched shoes at the entrance of a dark alley" (21). In his iconoclastic definition of poetry, the shoes are uncanny artifacts that mark the threshold between familiar and strange places. Like Cornell's art as a combination of realism and surrealism, the shoes mediate between the waking world of the city street and a dreamscape, the labyrinthine city within the city that might resemble urban imagery as depicted by Balthus and De Chirico. Simic's metaphor for poetry also implies the image of the poet as a voyager who explores a dangerous environment, risks bodily deformation, and like the owners of the "three mismatched shoes," courts disappearance. Reading Simic's metaphor for poetry, I pause to ask myself: Who has discarded the three shoes near an alley? Is one citizen walking around the city with only one shoe? Is another barefooted altogether? Or did three people deposit the shoes and is each of them hobbling around the city, one shoe on, one shoe off, in search of their lost shoes? Why three shoes and not four? Or, if there were THREE PAIRS of shoes, as the statement that they were "mismatched" implies, where are the other three shoes?

As with Simic's search in the preface to *Dime-Store Alchemy* for Cornell as his double or lost twin, and as with his description of Cornell's art as the detection of how "still-unknown objects that belong together" may form a

company, the "mismatched" shoes in the metaphor for poetry await their companion, their pairing, their lost twin. And yet Simic states that the "mismatched" shoes are *the* poetic object, not a part of a poetic artifact that remains to be completed once the other shoe is located. Simic's metaphor for poetry calls to mind an array of narrative reflections, but my projection of a story about missing persons has trespassed on the objects' beguiling quality. Defying narrative speculations, the companionship the "mismatched shoes" require is from the reader/spectator who resists interpreting the "mismatched" pair as possessing a narrative dimension.

The image of mismatched objects suggests presence and absence, traces of human meaning and the cosmic randomness that inform Cornell's task of gathering the objects that he finds along the way. The image is the "thing itself," but it is also a symbol at the gateway to a realm inhabited by dreams and darkness, order and disorder, symmetry and asymmetry. The image is like the Cornellian assemblages that Simic has described as "beautiful but not sayable" (1992, 54). As I have illustrated through my own narrative intervention, and as we have seen throughout *Dime-Store Alchemy*, it is difficult for spectators to resist a verbal translation of the images. In "The Gaze We Knew as a Child," Simic addresses the paradoxical aspects of his linguistic response to "not sayable" art: "One [way of seeing] is to look and admire the elegance and other visual properties of the composition as a craft, and the other is to make up stories about what one sees. Neither one by itself is sufficient. It's that mingling of the two that makes up the third image" (1992, 60). Working in the form of cross-genre fertilization known as ekphrasis, in which an iconic poem is written with a visual representation in mind as subject matter, Simic projects language onto what he *sees* when he *looks* at the boxes. He creates what Bakhtin calls a "third image," a verbal and visual collage that illustrates Bakhtin's theory of interpretation as an act of "creative understanding" or "co-authoring" of texts, an act that involves "live-entering" (identification) and the "moment of separation" (differentiation). Simic admits his narratives are based as much on his *inner* visions—his desires, memories, and projections—as on his view of the material of Cornell's boxes. In Bakhtin's terms, Simic's admission about the sources of his narrative speculations confirm his identity in a "moment of separation" from Cornell.

Like Warhol, Cornell was an obsessive collector. Yau, for example, points out that the posthumous catalog of Warhol's warehouse required

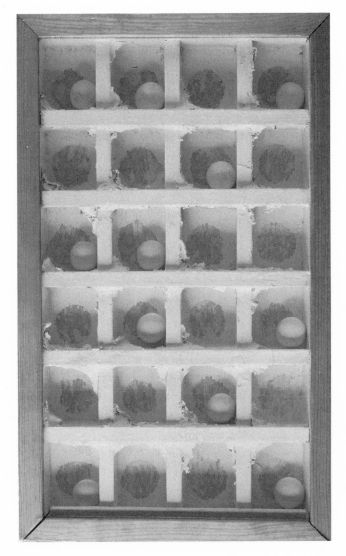

Figure 4. Joseph Cornell, *Untitled (Compartmented Box)* (ca. 1958). Box construction, 17 x 10 1/4 x 2 3/8in.

six books in a boxed set. The auction was described by one journalist as the world's greatest garage sale. Warhol and Cornell were collectors, but the meaning of Cornell's reconstructions of junk shop material and Warhol's catalog could hardly have been more different. In "The Warhol Effect," Simon Watney writes that Warhol's indiscriminate strategy of collecting

"only further undermines the notion of a coherent Self, a person to be found in his possessions." For he collected anything and everything, without regard to classification. Hence, by extension, he "collected" nothing, for his collection is indiscriminate—as void of central purpose or subject as the Andy Warhol persona. He made an art of shopping (Watney, 120–121). By contrast, for Cornell, reclassifying "junk" as personally significant aspects of a homemade art enabled him to reflect on his childhood and his relations to people whom he loved, admired, and wished to please with his art. As Dickran Tashjian in *Joseph Cornell: Gifts of Desire* (1992) and Deborah Solomon in *Utopia Parkway* (1997) have shown, he often designed boxes as gifts for specific audiences, such as the poet Marianne Moore, the screen actress Lauren Bacall, the painter Robert Motherwell, and the critic Susan Sontag. Arthur C. Danto has described the gift box to Motherwell as a portrait of the recipient. "Cornell once gave to Robert Motherwell . . . a box in which poster paint was spattered onto newspaper and cardboard. And in this case, as in the other gift-works, it is a kind of portrait of the recipient. Perhaps all true gifts embody the essence of those who are to receive them" (Danto 1992, 62). However obscure the boxes must have seemed to their primary audiences, Cornell intended his art as gifts to his special friends, fellow artists, and to the objects of his fantasies and desires. The boxes were designed to attract the attention of persons he admired, most often from afar. They were constructed with relationships in mind, or else they were compensations for relationships that Cornell only wished he could have developed. The boxes are veiled autobiographies because they define Cornell's identity as an infatuated and repressed lover who lived in isolation from other artists, but who craved their attention, admiration, and companionship. The personality of intended audience members (Bacall, Moore, Motherwell) is also construed through Cornell's awareness of their sensibility. His desire for their presence is apparent in his iconoclastic image of them. Because Cornell understood his boxes as directed toward someone else whom he loved, it is reasonable to claim that the identity of the receiver influenced the design of the boxes. In that sense, the intended audience was in part responsible for constructing the box. Simic responds to Cornell in *Dime-Store Alchemy* as if he were giving voice to one receiver of the visual gift. By so doing, Simic imagines the persona of the receiver, whose interests were made visible in the boxes.

The Trauma of Style in Ann Beattie and Alex Katz

By reading the attention Alex Katz places on aesthetic form as a way for him to suppress the interior dimension of his sitters, Ann Beattie confronts the wider issues found in the relationships between violence, representation, and the tenets of modernist criticism. She focuses on how style, when considered to be a good in and of itself, interferes with the implicit dialogue between painter and sitter, a communication, related to the recovery of human identity in art, that Yau and Simic had anticipated in their writings on Johns and Cornell.

In regard to the semantics of form, Katz and Beattie have much in common. Both represent fashionable (often young, white, upper middle class, East Coast) characters in bucolic settings while simultaneously making the beholder aware of how self-fashionings are a traumatic site, concealing as well as revealing information about the deep self. In her short fiction, Beattie narrates the disturbing implications to the lessons she has learned about representing persons from Katz's pictures. Like his portraits, her

characters lose themselves, rather than recover their identity, *as a consequence* of their entrance into the symbolic order. The iconic countenances they display seem unrelated to the deep self, which remains outside the page or canvas, introverted, unimaginable, but also uncontestable. In her short stories, characters lose touch with their memories *as a consequence* of their entrance into the metafiction. Similarly, Beattie teaches us to see the human figures in Katz's paintings as the residue of stylistic choices, as writing onto the body of the sitters, and a symptom of their disturbing entrance into the symbolic realm.

Alex Katz by Ann Beattie

Like many other late modern artists of his generation—Ellsworth Kelly, Frank Stella, and Donald Judd come to mind—Alex Katz, who was born in Sheepshead Bay, Brooklyn, in 1927, has been celebrated (and reviled) by critics for the sheer pleasure he has taken in aesthetics, and especially in rendering flat washes of vibrant colorful surfaces and for the way light falls on the monumental shapes of his dramatically reductive art. Roberta Smith of the *New York Times* is typical when she describes his achievement as "stylish billboardlike close-ups of faces, stiffly posed couples and psychologically distant group portraits (Smith, B40). Katz's art has been cited as "trend-setting." To many younger artists, writers, and fashion photographers at work in the late 1990s, his style represented the innocent "look" of the 1970s, a period that Carol Oditz, a movie costume designer, has said was noted for "great style, pure design . . . the high road, the boldness." The ubiquitous portraits of Ada, the artist's wife of more than forty years, whom Katz has described as "a perfect model—a classic European face and all-American beauty," and the sunny landscapes of the unspoiled reaches of Maine have been identified as the inspiration for a fashion shoot in *Italian Vogue* by Steven Meisel, who the *New York Times* identifies as "his generation's most trend-setting fashion photographer" (172 Art News). Katz's work has also served as the visual inspiration for production designer Mark Friedberg's creation of the "period look of waterbeds amid a Philip Johnson–style glasshouse" for Ang Lee's *The Ice Storm* (1997), a film based on a 1994 novel by Rick Moody about adulterous parents and jaded teenagers that was set in upper-middle-class New Canaan, Connecticut, in 1973.

Beattie reads Katz as a belated modernist who struggles to glimpse an interior dimension of those who have fashioned themselves into models before he has a chance to paint them. Her interpretation seems counter-intuitive, especially when juxtaposed to signs of Katz's relevance to post-modernism in the 1990s, and to other critical assessments that suppose his severe and reductive compositions pursue a conceptual (rather than a three-dimensional, realistic) agenda. Katz's flat planes, smoothly flow-ing lines, and delicate spread of tones have led Carter Ratcliff to agree with the artist's own impression that "he is not interested in psychologi-cal matters, only in strong images" (Ratcliff, 11): "The end point comes when you feel that you have gotten the image as an image—a sharply focused presence that makes an immediate, unambiguous, public kind of sense" (Ratcliff, 12).

To Ratcliff, Katz's paintings diverge from the painterly (impastoed), vulgar, and psychologically driven later self-portraits of an artist such as Philip Guston (1913–1980), who ushered in a return to human figura-tion *as well as* psychological depth in the wake of pop, op, and minimalist art movements of the 1960s and 1970s. In bizarre, cartoonish paintings such as *Untitled (Head)* (1980), Guston, who reinvented himself and his art in personal terms in the 1970s, unveils a self-portrait that turns out to be an Emersonian eyeball of the subjective historian of the self. By virtue of late paintings such as *Head*, Irving Sandler has credited Guston with influencing such younger, neoexpressionist painters as Susan Rothenberg, Elizabeth Murray, Eric Fischl, and Francesco Clemente. It would be a mistake to argue that Katz's decorative paintings open up the individuals he portrays to the wildness, emotionalism, and political outrage captured by a painter such as Guston. Beattie, however, does suggest how Katz goes beneath "the image as an image" to convey his models' stifled long-ings for connection with the other iconic figures who surround them with-out sharing existence *with* them.

Often compared by literary critics to a photographer or else, when she is labeled a neorealist, minimalist, or mannerist, to painters of her gener-ation, Beattie is a most appropriate subject for a study about contempo-rary American authors who have turned to modern visual art to discuss the semantics of form from a postmodern perspective.[1] Her critics have often noted her acute eye for visual detailing and her attention to sur-face appearances, often at the exclusion of a psychological-depth model

of the self in the short fiction. "Her stories may best be regarded as a collection of photos in an album: each records a situation, revises a memory, and redeems nothing," writes Pico Iyer (69). In "Weekend" (1978), the paradigmatic story that I discuss in this chapter, Beattie glimpses, but does not explore, the sources of irretrievable loss that have precipitated the scenarios of separation, psychic numbing, and traumatic displacements that her main characters, Lenore and George, act out in the present tense of the narration.

As she does with the characters in her short fiction, Beattie examines Katz's sitters and concludes that Katz achieves insight into his sitters through portraits that the spectator might assume visualize an unrepresentable human presence. Implicit in these portraits is what Mark Poster, writing on Jean Baudrillard, refers to as the "pessimistic implications" of a "world constructed out of models or simulacra which have no referent or ground in any 'reality' except their own" (6). In her art monograph, Beattie suggests that Katz challenges postmodern skepticism, in part by contesting the high modern shibboleth that attention to aesthetics signifies the artist's disinterest in natural life outside the pictorial frame of reference. Beattie argues that Katz encourages the spectator to enter into a dialogue with the pictures, and more important, to create narratives that suggest dimensions of the self that exist *in excess* of what any artist can portray in a three-dimensional, realistic artifact. "We are shown over and over that externals are extraneous, and that [Ada's] demeanor is a constant" (1987, 38).

Yau and Simic perceived representation as a method of self-reparation after childhood trauma. In her reading of a double portrait by Katz entitled *John and Rollins* (1981), Beattie challenges their hope of recovering a mediated version of identity through figuration in art:

> If nothing else, *John and Rollins* shows us that surfaces do not define the individual, and neither do they provide a forum for interaction. The suits are only a surface link, the well-groomed appearances only a custom, and not much of anything can be known about the individual lives of Rollins and John except that the painter has interpreted for us that their lives, at the moment of the painting, do not coincide. (1987, 91)

Katz represents each model in a theatrical setting where characterization is contingent on deferring presence through masked appearance and staged gestures. Beattie regards the paintings as narratives of selves in the act of a performance, but the story line has been arrested at the

point of visual composition. Further, she implies that Katz's extreme version of modernist stylistics has contributed to his sitters' alienation from other personages through the freezing of further narrative possibilities. "[H]e has painted people failing to connect; he has painted them in the act of fiercely pulling away from one another; he has chronicled the end of relationships that have not yet officially ended. Quite often, the light Katz is so interested in falls beautifully on a world of alienation, sadness and conflict" (1987, 25). Beattie regards *John and Rollins* as an emblem of representation as disfiguration, of art as a traumatic symptom. The modern artist's attention to surface beauty becomes a painful type of concealment of identity, a block to interpersonal contact. By bestowing the beautiful "light" of representation on "a world of alienation, sadness and conflict," Beattie addresses a paradox in Katz's art. For the models to become legible, to become apparent to one another, they must assert their identity through a composition that denies presence. "They seem to have evolved in some direction before the moment in which they were painted, to already have worked out some particular dynamic. These are not people in a state of change, but in stasis" (1987, 12). Katz art is not so much a site of personal reparation as it is the site of loss, dissociation, arrested development, and stasis.[2]

Katz's freeze-frame style implies the completion of his sitter's history, but Beattie contests this reading by opening up narrative possibilities that extend the scope of Katz's art in new directions. Her analysis of *Ada and Flowers* (1980), for example, leaves room for the representational potential and temporal dimensions to his art. "Ada might be an icon at an altar, history having passed, so that now what we see represents something; the present implies a past" (1987, 16). An author of a novel about a photographer, entitled *Picturing Will*, whose stories are self-consciously modeled after films by auteur directors of the French "New Wave" such as Jean-Luc Goddard in *Weekend* and Francoise Truffaut in *Jules and Jim*, and whose own novel, *Chilly Scenes of Winter*, was turned into a cult movie, *Head over Heels*, Beattie revises *Ada and Flowers* by imagining it to be part of a moving picture, that is, a single shot in a film sequence that begins and ends in a reality that exists outside the frame. "We have grown used to examining things by staring: freeze-frames, instant replays, evaluations quickly arrived at within the fallacious concept of stopped time. . . . [W]e all must wonder each day how much detail defines us and how much

complicates unnecessarily" (1987, 10). Noting how Katz "implies a past," she writes that he develops suspense by *omitting* the details necessary for the beholder to interpret the painting as a story line. Instead of denying the narrative of a portrait that possesses "some kinetic energy we can almost feel; something there to discover," Beattie reads *Ada and Flowers* as a caricature that exposes, by virtue of its exclusion of "unnecessary" details, the opacity of Ada's deep self (1987, 51).

By disputing the claim that Katz's surfaces *are all there is to see and know about the person*, Beattie distinguishes her version of Katz from that of critics such as Ratcliff, who interprets the paintings as unequivocal in their meaning:

> The difference between recognizability and legibility does, in fact, vanish. Looking becomes reading. . . . Seeing one of his compressed images for the first time, we seem to read it as quickly as a corporate logo or a word in flashing, neon letters. A first glance leads to more. One can study a Katzian image for a long time and never see it question itself. No ambiguities appear. The longer one looks, the more details one finds. Some are miniscule; all of them support and amplify one's first impression. (1987, 14)

To Ratcliff, Katz negates ambiguity by eliding the difference between "looking" and "reading" as responses to a human face. By contrast, Beattie argues that spectators must distinguish between *seeing* a face in passing and *concentrating* on it with a curiosity that implies communication and empathetic identification. Noting the difference between *seeing* and *looking*, she believes that Katz expresses interiority in the wake of telemediation and stimulating (as well as simulating) appearances theorized by Baudrillard. Instead of considering Katz to be a neorealist painter whose narratives are accessible to spectators at first glance, Beattie claims his type of minimalism subverts the lucidity of his representations as "freeze frames." Ironically, she reads his style, indebted to billboard art and to advertising displays on television ("an Arrow shirt ad translated into the gravity of a Coptic funerary portrait" writes Bill Berkson), as Katz's way to withdraw painting from consumerism (Berkson, 171). Through his attention to style, he confirms art as a matter of artistic control.[3]

Katz's aesthetics are not based on immediate perception, as in Monet's impressionism or in the transmission of images through the electronic media "eye" of the television camera. Like Cezanne's modernism, his compositions suggest extreme processes of selection that assert the

artist's control over the arrangement of subject matter. "Katz is a stylist, but he is a stylist who believes in paring down," Beattie writes. Focusing on the semantics of form, she confronts the violence of art by describing it as a cutting activity based in metonyms and synecdochial practices in which the partial appearance of the subject is substituted for the whole image of the person. In Katz's *Joan* (1984), she calls attention to the fingers on one of her hands, which appear to be cut-off at the tips for the sake of compositional order and to make a striking visual effect. "[Joan's] hand [is] painted as if the fingers incomprehensibly and shockingly disappear into her hair with impossible regularity; the line of demarcation might as well have been drawn with a ruler—or scissors might have been used to snip off the fingertips" (1987, 15).

Beattie cannot decide if Katz has painted an unthreatening image of Joan running a hand through her flowing hair on a windy day, or a more disturbing image that implies mutilation, imperfection, and disability. Her reading focuses on the play between external and internal features of how Katz represents women as models. Ratcliff has stated that in Katz "space is manipulated according to the dictates of the design": "The picture itself is often clipped and cut to a kinetic fragment. Katz uses cropping not only to dramatize an image, but also to sharpen its contemporary 'look'" (Coffey, 10). Following Ratcliff's observations about the role of design in Katz, but drawing different conclusions about *Joan*, Beattie challenges the ethics of Katz's aesthetics of cropping. His gesture of transferring the female image into a pattern, she argues, disturbs the demand viewers have for maintaining the integrity of the body in the act of partially configuring it to produce a pleasing aesthetic effect.

By attending to the relation between the female body and Katz's rendering of it through a "paring" technique in *Joan*, Beattie emphasizes her specific position as a female observer who is especially interested in connecting formal art to an analysis of the ethics of representing the body. Her critique is based on the root meaning of the word *style*, which is etymologically related to the Latin word *stylus*, an instrument such as was used by the ancients in writing on waxed tablets. An instrument used for marking by puncturing or disturbing a surface, a stylet can be many things: a pen, a graver, an etching needle, a phonograph needle, a pin, a gnomon, or a dial. In medical technology, the stylet is a surgical probe for examining wounds. All of these instruments supply visibility, vocality, or

are involved with the healing of internal injury. They are effective, however, by cutting, piercing, disfiguring the material—the skin, the paper, the plastic disk on which musical recordings are inscribed—they act upon. The paradox of the stylus is that it benefits the person by allowing an image to be engraved, but through an instrument of disfiguration.

As a contemporary female author interested in the relationship between representation and violence, Beattie addresses the ambivalent meanings of style in *Joan*. By representing *Joan* as a work of art that differs from an immediate response to her visual appearance, such as is supposed to occur in telemediated representation, Katz asserts his own presence as the controlling agent in a composition that converts, or passes, a living subject into a disfigured object.[4] Katz resists the assumption, held by artists who were influenced by Warhol, such as Frank Stella and Jeff Koons, that what is seen on the surface of art is easily deciphered by spectators. ("What you see is what you see," Stella has famously remarked). By contrast, Beattie demonstrates that to interpret *Joan*, spectators must consider a variety of possible meanings:

> We are reminded of the arbitrary exactitude of art, that the painter is there, present as a trickster. Yet the half-hand does not really work as a joke, but as a disturbing image, a hand and not a hand. What should we believe? That the eye will fill in what is missing? That everything is all right? That the fingers' disappearance has no connotations that pertain to the whole? It is a discordant enough presentation to make us uneasy. (1987, 15)

Katz is a critic, as well as an agent, of his transmission of the person from the real to the symbolic. His image of *Joan* displays a postmodern aesthetic in the terms supplied by Shari Benstock and Suzanne Ferriss in *On Fashion*, where representations "exhibit the logic of postmodernism, for they both expose and uphold forces of dominance" (10). Like the post-1960 photographs by Diane Arbus, once a prominent New York magazine photographer who then attended to fashionably attired transvestites in artistic images that comment on her "own early role in upholding fashion's false fabrications," Katz achieves fashionable effects through painful exclusions and hyper-stylization (Benstock and Ferriss, 11).

According to two of his models, the painters Rackstraw Downes and Jon Loring, Katz's self-conscious reflection on the transference of the body into the painted image of *Joan* is commensurate with their experi-

ence of being transformed into objects in the course of his composition. According to Downes: "You are not posing for Alex other than as a dancer. I was not a person. You are in some role where you are taking some visual position for him: a body position. . . . I never felt my personality remotely at stake" (Beattie 1987, 16–17). According to Loring: "I'm a springboard for what he [Alex] wants to do. . . . Alex is going to leap off and do what he's going to do" (Beattie 1987, 17). A third sitter, the art critic Lucy Lippard, has commented on how Katz turned her into a statuesque object: "It's a funny relationship, painter and subject. Pygmalion in reverse. You feel yourself becoming an object" (Lippard, 3). In an interview with Mark Strand, Katz stated his awareness that when painting his focus is on "style and appearance." "Style and appearance are the things that I'm more concerned about than what something means. I'd like to have style take the place of content, or the style be the content. It doesn't have to be beefed up by meaning. In fact, I prefer to be emptied of meaning, emptied of content" (1983, 124, 129).

Katz intends to focus on aesthetics, not on "meaning" or "content." In the interview with Strand, however, he admits that style reveals the artist's presence as well as the personality of his sitter through attention to fashion. "I think of style as being a conscious choice. Everything you do in your life ends up the next day with your making a choice. It's one thing built right on the next. One's behavior is determined by one's previous behaviors. I think that has to do with style" (1983, 129). Katz illustrates the relationship between fashion and identity in *The Gray Dress* (1982). In the painting, each model's identity is based on her decision to wear different gray dresses, a late afternoon dress, a barer dress with spaghetti straps, and a less provocative dress. Beattie suggests that the third dress "would be as useful to wear when selecting vegetables in the store as standing around with a cocktail glass" (Beattie 1987, 52). A triptych composed of three models whose dresses signify different attitudes toward social forms and customs, spectators are encouraged to derive information about each woman through decisions they made *prior to* Katz's performance in *The Gray Dress.*[5] By casting the models in fashions that project an image in theatrical settings, Katz *represents representation* (including self-representation in the nonart context of social life) as a screen, obstacle, or concealment of a person's deep self.

David Cohen is correct to observe that Katz "loves to paint what are

already painted things in the world, such as made-up faces, painted lips and eyebrows" (Cohen, 105). Following Beattie's analysis of *John and Rollins*, however, I want to adjust Cohen's observation by noting that the conversion of the self into an object of visual contemplation interferes with the coincidental image of the sitter as an introverted subject longing to communicate with other masked personae. Katz creates masklike countenances that veil inner worlds, but his art is uncanny because he also *unmakes* (or unmasks) the choices his models have made about how to construct their own images prior to sitting with Katz. "People come packaged in their own images and conceits and [in the course of being painted by Katz] leave unwrapped," writes Lucy Lippard in "Alex Katz Is Painting a Poet" (Lippard, 3). Beattie's reaction to Katz's attention to his characters' "images and conceits" in order to "unwrap" their personae is one aspect of her response to his art that points toward personal reparation. By reading his paintings as "unmakings" of his sitters' prior self-constructions, a viewer can interpret Katz's portraits as figures of resistance to the "fatal strategy" of objectification of the person that was discussed by Baudrillard. Offering a "style of writing [that] highlights surface behavior and neglects etiology," Beattie argues that Katz witnesses the sublimated (unrepresentable) residue of a modernist's devotion to intimacy, subjectivity, and psychological introspection (Schneiderman, 311). Paying attention to how Katz defines his identity as an artist through a style that deforms the subjects he composes, Beattie visualizes a crisis in representation that she incorporates into her best-known short stories. Her attention to Katz's art as a violation of the model's appearance is comparable to her exploration of the connection between style, character, and traumatic disfiguration in "The Lawn Party" and "Weekend," characteristic stories from the 1970s.

"The Lawn Party" and "Weekend": Ann Beattie by Alex Katz

As in *Alex Katz by Ann Beattie*, in "The Lawn Party," Beattie considers representation as a traumatic event when the author or character within the fiction places attention on style as a good in itself. In her short story, characters behave like storytellers who erase their own presence by repeating experience as a narrative that conceals, rather than reveals, the pain of events that remain evident in their experience like a text writ-

ten on the body. "The Lawn Party" may directly refer to a painting by Katz, a billboardish group portrait "cut-out" called *The Lawn Party* (1965). Like *Joan*, Katz's *The Lawn Party* achieves its effects through cropping. According to Dean Swanson, the group portrait of two-dimensional figures violates the integrity of some of their bodies through excisions and exclusions. "In [*The Lawn Party*] only parts of the figures appear, the severely cropped foreground figures concealing those who stand behind them" (52–53).

In "The Lawn Party," the protagonist's amputated arm is related to Beattie's characterization of him as a metafictional figure and trauma victim. The reader is invited to consider the man's lost limb in the story as related to an event that was erased from his memory because he never "owned" the experience outside of a prior mediation, Truffaut's *Jules and Jim* (1962). A film set in France around World War I that was based on the novel written by a friend of Pablo Picasso's, Henri-Pierre Roche, *Jules and Jim* ends with a suicidal crash reminiscent of the car accident in Beattie's story. Like Katz's *The Lawn Party*, Beattie *represents representation* as a displacement of experience that interferes with the man's ability to remember his past or to interact with family members closely connected to that past in a contemporary setting.

In "The Lawn Party," the protagonist in the first-person narration of an Independence Day family gathering held at a Connecticut country estate is a thirty-two-year-old art professor. He is on leave from his teaching post because of an injury he suffered while a passenger in a car driven by Patricia, sister of Mary, the man's ex-wife. He has reason to believe the accident was really no accident, but Patricia's successful attempt at suicide because she was heartbroken after his decision to wed her sister, Mary, even as he still claimed to love Patricia. In recounting this melodrama to a visitor named Banks, his former art student, as the family party transpires on the lawn while the man remains in the upstairs bedroom of his childhood, it is surprising when he fails to remember the impact of the car wreck on his body or his psyche. Instead, he *remembers remembering* a similar event that occurred at the end of *Jules and Jim*. In the aftermath to the wreck, he also filters his experience through other modernist representations, such as Hemingway's *The Sun Also Rises*, and a painting by Hopper.

In the following exchange with Banks, the man is aware that he sounds like he is repeating a Hemingway dialogue:

"I got drunk," Banks says on the phone, "and I felt sorry for you."

"The hell with that, Banks," I say, and reflect that I sound like someone talking in *The Sun Also Rises*.

"Forget it, old Banks," I say, enjoying the part.

"You're not loaded too, are you?" Banks says.

"No, Banks," I say. (Beattie 1983, 206)

In one of a number of intertextual moments in a story that hinges on the way representation displaces presence in traumatic situations, Beattie parodies Hemingway's laconic and affected style of representing conversation. She is also haunted by the specter of Hemingway's representation of his characters' strategy of compensating for irreparable loss (sexual dysfunction, abandonment by lovers, the failure to connect with others, war trauma) by understanding human life as a theatrical performance that involves behaving according to elaborate "codes." In the passage above, the man knows he speaks to Banks as if he were participating in a modernist novel, which suggests, in Derridean terms, how language sabotages actual experience by converting it into a linguistic performance.

Later in the same passage, he connects representation to aphasia and to bodily disfiguration when telling Banks about the wreck that killed Patricia and led to the loss of his arm:

"Do you remember your accident?" he says.

"No," I say.

"Excuse me," Banks says.

"I remember thinking of *Jules and Jim.*"

"Where she drove off the cliff?" Banks says, very excited.

"Ummm."

"When did you think that?"

"As it was happening."

"Wow," Banks says. "I wonder if anybody else flashed on that before you?"

"I couldn't say." (1983, 209).

In *Unclaimed Experience* (1996), the narrative theorist Cathy Caruth interprets the relationship between trauma and the representation of public history and private life. She can connect storytelling to trauma because, like the psychic disturbance, narrative may repeat an actual event that was not initially experienced, or in her term, "owned," by the narrator on a conscious level. "The historical power of the trauma is not just that the experience is repeated after its forgetting, but that it is only in and through its inherent forgetting that it is first experienced at all. . . . Forgetting is indeed a necessary part of understanding" (Caruth, 16, 32).

Anticipating Caruth's theory of trauma in her analysis of the style Katz uses to paint friends and family members, Beattie troubles the hope that the self can be restored through art. In her theory of trauma and narration, Caruth, using as her examples a variety of literary and cultural sources ranging from the story of Moses in the Old Testament to *Hiroshima Mon Amour* by Alain Resnais, argues that historical narratives erase the prior "real moment" of violence in the process of the telling. Anticipating Caruth's theory of narrative as a displacement of a repressed event, the man's recollection of the accident as a scene from *Jules and Jim* becomes a residual symptom of the trauma as it surfaces in the act of telling. Narrating the event to Banks, an empathetic listener, becomes an episode of mourning as the man acts out and, potentially, works through the loss of Patricia and the professional and personal frustrations due to his disability. But telling his story through a film equivalent, *Jules and Jim*, suggests that his narrative erases the memory that he attempts to recover with Banks. Beattie represents the man's exchange of memory for its film equivalent as indelibly bound to the trauma. His narration illustrates Dominick LaCapra's observation that "trauma is precisely the gap, the open wound, in the past that resists being entirely filled in, healed, or harmonized in the present. In a sense it is a nothing that remains unnamable" (109).

As in "The Lawn Party," the plot of Truffaut's film involves an unresolved love triangle between self-consciously theatrical characters, the two best friends who fought on opposite sides during World War I, Jules and Jim, and Jules's wife, Catherine. The romantic conflict leads Catherine to drive a car off the end of a ruined bridge, killing herself, her lover Jim, and leaving her husband, Jules, to mourn their loss and to care for their child, Sabine. Relating the man's experience of Patricia's suicidal drive *before it occurs* to a film that reflects his own decision to marry one sister while remaining in love with the other, Beattie suggests that the man's perception of experience as represented by another visual artist erases his access to his own past. This is true to the degree that representation is itself the trauma that blocks his experience of experience. The car accident and its representations become the events in the man's life when a confusion of the difference between real life and the symbolic order takes place. The violation of the difference between the insignificance of life in its rich ongoingness and the significance of life when rendered still in art leaves the man without the symbol of the ability to act in

the world after the accident. This symbol is his lost arm, which he main-
tains as "air," an absence that reminds him of the missing part of the
body associated with the experience of the sensual world. At the end of
the story, the "air" where the arm once existed signifies his psychic and
physical detachment from the world of interpersonal relations.

After Truffaut's film replaces the man's recollection of the accident, he
lives as a specter. Besides his experience of the absent limb, which the psy-
choanalytic critic Leo Schneiderman describes as "the outward emblem
of his poorly integrated self," he is estranged from his prior life through
his divorce from his wife, Mary (324). He has also lost custody of his
child, Lorna; he is on a disability pension from the college; he does not
make art; and he no longer wants to leave the room upstairs—the bed-
room of his childhood—during the family gathering on the ironic day of
freedom but also of isolation, Independence Day. As Schneiderman has
said, "The embittered protagonist deliberately insults everyone present at
[the] reunion, including his 10-year-old daughter" (324).

"The Lawn Party" can be framed as a story that Beattie has collected in
Secrets and Surprises, and as an immediate record of the man's first-person
present narrative account of his experience. These two versions of author-
ship merge at the conclusion of the tale, suggesting no difference exists
between reality as construed by Beattie and its internal representation in
the voice of the main character. In the final image from the story, the
man discusses how he admires his brother's wife, Danielle, a beautiful
French woman who he has desired throughout the story, at one point
even impulsively kissing her bare toes when she comes upstairs for a brief
visit. In the final scene, he gazes out the bedroom window as she dances
drunkenly by herself on the lawn and undresses her mentally. "Banks is
here. He is sitting next to me as it gets dark. I am watching Danielle out
on the lawn" (1983, 208). As with the plots of *Jules and Jim* and the ill-
starred romantic triangle between the man and the two sisters, Patricia
and Mary, Beattie's fiction concludes with his fixation on another sister-in-
law, Danielle. The final scene, therefore, creates a compositional circle as
it returns him to the initial situation of a familial love triangle, the type of
complication that he had not resolved prior to his narration of the acci-
dent to Banks via Truffaut's film. Failing to experience his initial trauma
as an event he owned, but having displaced it onto its film equivalent, the
man appears to be on the verge of repeating the love triangle with

Danielle, his wife's sister, a type of love affair that he has forgotten he has already experienced in the act of telling Banks about it.

In "Weekend," as in "The Lawn Party," Lenore and George, the two main characters, interpret their experience by relating to different types of visual culture. In this story, the connection between self-characterization and visuality occurs through a contrast between two classes of visual artifact. On the one hand, there are George's photographic self-portraits, which reveal his distressed psychological state to Lenore when she happens on them. On the other hand, there are mannerist artifacts—shells, colorful stones, and small paintings—that George openly displays to visitors in his living room to represent himself in a social setting as a well-adjusted bon vivant.

Beattie presents the story through a third-person account of Lenore's perspective as she narrates the disturbing events that take place during a weekend visit to her country home by two young women, Julie and Sarah, both George's former students at a nearby college. Lenore, formerly one of George's mistresses, has now lapsed into being his common-law wife. They live with their two children in a quaint, fixed-up country house. George, twice Lenore's age, is a fifty-five-year-old failed English professor and aging roué. As Schneiderman has correctly observed, "Lenore feels excluded from his life and sees daily evidence of the man's self-absorption and indifference to her needs. . . . Her brother has urged her for years to leave the older man, but in vain, partly because the woman feels pity for her lover, having seen a number of agonized facial photos that he took of himself and then concealed" (1983, 321). Privately disgusted about being denied tenure at the college and careless about how he treats Lenore, whom he defines as "simple" and as somehow deserving verbal abuse for staying with him, George represents himself to visitors as being, in his words, "in touch" with nature, silence, and other nonmaterialistic values, especially during the weekend visit by the two attractive female students.

In contrast to George's perception of himself as an art connoisseur, home builder, and nature lover, his actions during the weekend reveal that his depression, anger, and narcissistic behavior have taken over. Far from a well-adjusted outdoorsman, he is an alcoholic who has misused his knowledge of art to repress his rage, but who finally cannot control his wild emotions or erratic actions. Drunk on brandy after a hike in the rain with Sarah near the end of the story, he proclaims his love for her in

a "scene" played out in front of Lenore that causes Sarah to burst into tears and then to flee the country home. As with Katz's characterizations of Ada and *John and Rollins*, whose self-fashionings are shown to interfere with their coincidental desire to disclose aspects of interiority, "Weekend" disturbs perceptions of visuality as enhancing personal knowledge or fostering intimacy in social relations.

George represents himself to weekend visitors as an art lover and man at peace with himself in his bucolic surroundings. Lenore represents herself, in George's term, as a "simple" woman who is unaware of her common-law husband's philandering. Events during the weekend, however, reveal that both images are false fronts. Lenore is aware that his tortured photographic self-portraits are tied to her decision to stay with him. Her interpretation of his photographs, however, does not imply that she will use her knowledge of his distress to alter her relationship to George, to urge him to seek help, or to leave him. Instead, her awareness of his persona that veils the disturbing implications of the photographs becomes her motivation for staying with George as a protector. George and Lenore, like the self-fashioned figures in Katz's paintings, are living in fictions of their own creations. As with Katz in *Ada and Flowers* and *The Green Dress*, Beattie *represents how characters represent themselves to others* through self-fashionings that are really forms of self-deception and a massive denial of psychic pain. George's art is designed to conceal the deeper understanding of his inner world that his photographs illustrate, but that he does not wish to confront. At the same time, as with Katz, Beattie reveals glimpses of her characters' psychological lives even as they attempt to conceal their pain from visitors and from themselves. As with Katz, Beattie allows vestiges of the modernist self in her fiction, but these exist uncomfortably and in excess of how her characters' appear to visitors through the false perspective of the first glance. Julie and Sarah, the two students, believe that Lenore is naive and foolish because she pretends not to know that George has a sexual interest in them. Lenore also refrains from participating in dinner conversations between George and the students, and she remains silent when she attends to household chores. Appearing to be uncommunicative because she is dull and has nothing to contribute, Lenore is shown to possess insight. Perhaps more than George himself, she understands that his persona is designed to promote his sexual desires and to quiet his fears and professional disappointments. She also

understands why she stays with George even if her reasons for not leaving him are tied to her low self-esteem as well as to her belief that couples often stay together for mysterious reasons. In contrast to Lenore's perceptiveness, which is keen but for the most part left hidden from public view, George, who boasts that he is in touch with his own emotions, is, ironically, cultivated but shallow. Unlike Lenore, he is selfish, petty, and reckless in how he treats his most valuable love relationships.

Lenore knows that art and the art of self-fashioning are what block his ability to confront his loss of professional status, his fears about aging that emerge as vanity about his clothing and hair style, his desire to impress the former students, and his alcoholism: "She could never get him to admit that what he said or did was sometimes false. Once, long ago, when he asked if he was still the man of her dreams, she said, 'We don't get along well anymore.' Don't talk about it,' he said—no denial, no protest. At best, she could say things and get away with them; she could never get him to continue such conversation" (1983, 128). Because she has consciously or unconsciously stumbled on the photographs that George had suppressed by hiding them in his dark room, Lenore knows that George displays to visitors a false self that conceals his turbulent psyche. His repression of self-disgust as expressed in the photographs, however, eventually leads him to act out his pain through inappropriate behavior, such as declaring his love for Sarah in a drunken rage in front of Lenore.

Even as George is invested in art as a method of concealment, Lenore has, like him, repressed contradictions in their relationship. She is perceptive about George's lies, but misrepresents herself as a "simple" woman who looks at things while pretending that she doesn't know what they mean. Lenore and George are a perfect pair in that both are postmodernists who replace art as a means of psychological revelation and self expression—figured in George's photographs that Lenore has discovered—with other arts and crafts such as bread baking and shell collecting that display homey comforts, personal stability, and a countrified good taste. Beattie's narrative, however, demonstrates the inadequacy of George's mannerist art and Lenore's folksy manners as ways to conceal personal turmoil and interpersonal crisis.

Describing a scene around the fireplace with Sarah and Julie after a Saturday night dinner, for example, the narrator (Lenore) uncovers George's

motivations for displaying the quaint "found" collages and other art
objects in his living room:

> The acorn caps, the shiny turquoise and amethyst stones—those are there,
> she knows, because George likes the effect they have on visitors; it is an ex-
> pected unconventionality, really. He has also acquired a few small framed
> pictures, which he points out to guests who are more important than wor-
> shipful students—tiny oil paintings of fruit, prints with small details from
> the unicorn tapestries. He pretends to like small, elegant things. Actually,
> when they visit museums in New York he goes first to El Grecos and big
> Mark Rothko canvases. (1983, 128)

Lenore understands that George's possessions of fine art and good taste
are related to his desire to shield from view his deeper impulse to create
art and respond to paintings from earlier periods, when art expressed the
ecstasy and anxiety of a passionate spiritual life. El Greco's and Rothko's
paintings are stylized artifacts, but we also know that painting was part of
a spiritual quest for El Greco and that Rothko believed that painting was
a dramatic activity in which he confronted extreme psychological and
emotional states of being in the course of revealing the expressive possi-
bilities of zones of equal chromatic intensity. A tortured individual who
committed suicide in 1970, Rothko interpreted painting as a private ritual
made visible. In his devotion to Rothko and El Greco, Jewish and Catholic
painters who expressed religious mystery with intense personal feeling,
George reveals an interest in spiritual art. His private taste, however, con-
tradicts the deceptive image he projects to the female visitors as a cool
mannerist who admires shells and stones.

The narrator interprets George's self-representation through the living
room art and through his dress style as part of a "pretend" life that repress-
es his psychological rage. "He subscribes to *National Geographic* (although
she rarely sees him looking at it)" (1983, 129); "he pretends not to care
about his looks, but he does. He shaves carefully, scraping slowly down
each side of his goatee" (1983, 123); "he pretends to have no feeling for
clothing, but actually he cares so strongly about his turtlenecks and shirts
(a few are Italian silk) and shoes that he will have no others" (1983, 123).
The list reveals that although they are acts of bad faith, George's preten-
sion toward living without affect is also the fiction that enables him to sur-
vive the pain of aging, the loss of his professional status, and his psychic
desperation. In this sense, George's stylish mask is a meaningful fiction

that allows him to survive the hard facts in his life. His posturing, however, blocks a type of expression that might have provided consolation instead of the alcoholism, emotional violations, childish rage, and affairs that constitute George's method of acting out trauma in "Weekend."

Unlike Rothko and El Greco, the type of art that George displays on his living room walls discourages viewers from experiencing strong emotions, spiritual longings, or a desire to upset the status quo. In fact, George designed the living room to distance himself from the emotionalism, religious struggle, and the angst he associates with Rothko and El Greco. If his strategy of using mannerist art to conceal his chaotic feelings was successful, we could read "Weekend" as Beattie's sanction of a postmodern aesthetic that favors surface appearance while denying the power of art to reveal the artist's psychology. George's attempt to seduce Sarah at the end of the story reveals that his aesthetic sublimation has proven to be an unsatisfactory method of acting out his psychic life. His statement to Lenore at the end of the story that "he wouldn't care if [Sarah and Julie's] car went off the road" (1983, 136) when they leave the cottage and his description of Sarah as "that damn bitch" and "a stupid little girl" (1983, 135) are evidence that he has not worked through the fear and rage that he reveals and conceals in the photographs he hides in his darkroom.

Besides his interest in the intense art of Rothko and El Greco, George developed close-up photos of his face that suggest his interest in expressionism. The photos reveal the pain, rage, anger, and madness that he acts out with Sarah at the end of the weekend visit. Unlike the images he displays in the living room, the photos are tortured revelations of his private night studio and, except for the fact that Lenore has happened on them, he intended them to remain hidden in his dark room. After discovering the photos when putting contact prints back in the dark room that George had left in their bedroom (a sign that he may have wanted them to be discovered), Lenore shows the pictures to Julie as evidence for why she stays with a man who is unfaithful and verbally abusive:

> They are high-contrast photographs of George's face. In all of them he looks very serious and very dead; in some of them his eyes seem to be narrowed in pain. In one, his mouth is open. It is an excellent photograph of a man in agony, a man about to scream.
>
> "What are they?" Julie whispers.
>
> "Pictures he took of himself," Lenore says. She shrugs. "So I stay," she says.

Julie nods. Lenore nods, taking the pictures back. Lenore has not thought until this minute that this may be why she stays. In fact, it is not the only reason. It is just a very demonstrable, impressive reason. When she first saw the pictures, her own face had become as distorted as George's. She had simply not known what to do. She had been frightened and ashamed. Finally she put them in an empty box, and put the box behind another box. She did not even want him to see the horrible pictures again. She does not know if he has ever found them, pushed back against the wall in that other box. As George says, there can be too much communication between people. (1983, 133)

Art that expresses George's pain is the abjected form of representation in this fiction. When Beattie admits such art into the story as a form of personal disclosure, what the representation expresses becomes desublimated in the course of George's mistreatment of Sarah and in Lenore's disclosure of the pictures to Julie. Lenore appears to be a simple person in other parts of the story, but she scrutinizes the connection between George's photos and why she stays with him. Lenore, however, does not even accept the "simple" reading of her own motivations for staying with George, which is that she is a "protective woman" who feels too much empathy to leave a man she knows from the photographic evidence to be tortured and probably suicidal. By reconsidering her own interpretation of why she stays with George to be a fiction that primarily serves as a plausible response to Julie's questions, Lenore challenges her own interpretation of experience as a reasonable response. She does not sympathize with George so much as she empathizes with him. Besides wanting to protect *him* from the pain revealed in the pictures, she sees a reflection of her own face in his countenance when she notices that "her own face had become as distorted as George's" (133). George denies the emotional state figured in the self-portraits, but Lenore, too, is escaping from the implications of his art. The photographs have so disturbed Lenore that she does not even want George to see them again.

Lenore and George conspire to deny the existence of the photographs by "push[ing them] back against the wall in that other box," but in "Weekend" Beattie discloses the contents of the box of photographs, exposing the images George and Lenore had attempted to conceal through her narration. By substituting one set of images (the mannerist assemblages in the living room) with another set of images (the expressive photographs),

Beattie disturbs the calm surface appearance of the living room and replaces it with a story line that disrupts the arranged weekend visit as George had composed it. When Lenore clings to George at the end of "Weekend," she wishes "he could protect her from the awful things he has wished into being" (1983, 136). She is referring not only to the events of the weekend, but to the photographs, those "awful things he has wished into being" that represent the difference between an art of concealment and an art that must be concealed if the couple is to stay together without altering their relationship to each other, as well as changing their relationship to the aesthetic objects that reveal and conceal the disturbance in their lives (1983, 136).

Beattie is skeptical about the idea that representation is a form of psychotherapy, but she does interpret Katz as a metaphysician whose paintings recover the mystery of human identity even as his models appear to deny the interior aspects of the hidden self. For Beattie, Katz's style registers his distrust of the pictorial realm as a reliable medium to express the disappointments evident in the wistful facial expressions of his characters. Instead of indicating that the beautiful clothing, unblemished complexions, and country, beach, or SoHo loft party settings are indicative of the quality of his models' experiences, Katz discredits the significance of visual information as revealing the models' inner worlds:

> The truth is that Katz, who has been criticized for presenting innocuously well-groomed people, wants them so attired not because it is his notion of conventional good style, but because he conceives of clothes as uniforms that do not deflect attention from the important things that need to be noticed. People miss the point when they talk about Katz painting surfaces; actually, he distrusts surfaces so much that he will not allow them to provide easy definitions of his subjects. (1983, 27)

As in her fictional portrayal of characters such as George from "Weekend," who wishes to define himself according to the display of objets d'art in his living room, Beattie notices that in Katz portraits such as *The Gray Dress* the desire for individuation is expressed through the depiction of visual objects that connote style and good taste. "Katz is not interested solely in fashion . . . but rather in the attitude with which we display ourselves and create an atmosphere that defines some world. A mood is created by the presentation of the three gray dresses" (52). As in her own analysis of character in "Weekend," Beattie also shows that Katz analyzes

character by addressing the sensibility, taste, or attitude of his sitters. For example, she discusses the ironic wit of Katz's wife, Ada, in the portrait of her wearing a kitsch Parrot Jungle sweatshirt while she reclines on a Victorian sofa:

> When you consider the way she reclines on the Victorian sofa, her hair painted so that it appears that there is a confluence between hair and sofa, a link is forged between the rather silly, commercial world represented by Parrot Jungle and history. . . . The forties fabric she rests her head on is another textual incongruity. But again, in spite of the context in which we see her . . . , we know something about Ada, but we cannot say we know Ada. Her gaze is lovely, but the information we have to read into that only takes us far enough to say that this is a person in a particular moment, who is perhaps consciously parodying herself (or adult notions). (1983, 38)

Even as "Weekend" and *Alex Katz by Ann Beattie* associate individualism with aesthetic choices, the comment that spectator's *know something about* Ada without the accompanying feeling that the spectator also *knows* her through her funny choice of clothing, hair style, and through the "textual incongruity" of the souvenir sweatshirt, "forties fabric," and type of sofa suggests Beattie's awareness of the unreliability of surface appearances and consumer tastes.

Katz's aesthetics and Beattie's poetics have been said to be reliable codes to reading their analysis of character. Blanche H. Gelfant, for example, has compared Beattie's "esthetic problem" to the creation of "significant stories out of the trivia which surface in our time, surface without depths except for the empty abyss of nothingness" (Gelfant, 25). By contrast, I have demonstrated that figural significance in Katz and Beattie is, paradoxically, shown to be sublimated into the region described by Lyotard as the unrepresentable. As will be the case for the next subject of my inquiry, Mark Strand, for Katz and Beattie to depict a character's appearance, to take up volume in a representation, is also to display an absence, a lack, a "missing." As in Lacanian psychoanalytic theories of the uncanny and as in Lyotard's interpretation of the modern sublime as "the unpresentable . . . put forward only as the missing contents," the figure in a Katz painting or the characterization in a Beattie short story such as "Weekend" is represented as an obstacle that prevents the beholder from recognizing inner worlds. As visual representation, the paintings of Ada by Katz reveal to Beattie the concealed: what is shown is also "what is missing" (Lyotard, 81).

Stranded Objects and Saying Things

The Art Writings of Mark Strand

Harold Bloom has interpreted Mark Strand's poetry as sustaining, rather than qualifying, the totalizing impulses and narcissistic strains evident in modernist forebears such as Wallace Stevens, who wrote in "Tea at the Palaz of Hoon":

> I was the world in which I walked, and what I saw
> Or heard or felt came not but from myself;
> And there I found myself more truly and more strange.
> (Bloom, 64)

As in his reading of Stevens, Bloom describes Strand's main re-source as "the transformations of the self as it dodges a proleptic [or anticipatory] consciousness of its own death in an outward world that somehow seems not to exist" (151). Following Bloom, Strand has contributed to the treatment of his poetry as an exclusively literary event in "Views of the Mysterious Hill: The Appearance of Parnassus in American Poetry." In

that essay, he performs a Bloomian reading of his own poem, "The Hill," by interpreting its sublimated topic as the poet's relationship to literary tradition, to Parnassus, the classical site that registers a poet's level of accomplishment in relation to the canon.

Solipsism and Self-Effacement in the Early Poems

In returning Strand's art writings on Edward Hopper and William Bailey toward the reception of his poetry, I want to suggest that he turns modernist formalism against itself by attending to design as a block that checks the author's libidinal desire to project meanings onto paintings through narrative. His analysis of painting enables him to revise his relationship to modernist forebears such as Stevens, but more important, he is able to imagine encounters in a nonart context that are not contingent on the disappearance of the authorial self, as in a poem such as "Keeping Things Whole," or on the solipsistic declarations expressed by Stevens. In "Tea at the Palaz of Hoon," Stevens was pleased to discover that poetry enables him to experience sublimity (truth and strangeness) as an aspect of identity. By contrast, Strand registers embarrassment and guilt over his possession of the perspectival domination of space in his best-known early poems.

The most prominent example from Strand's early poetry of his strategy of linguistic appearance through self-effacement and spatial disfiguration occurs in "Keeping Things Whole" (1964):

> In a field
> I am the absence
> of field.
> This is
> always the case.
> Wherever I am
> I am what is missing.
>
> When I walk
> I part the air
> and always
> the air moves in

> to fill the spaces
> where my body's been.
>
> We all have reasons
> for moving.
> I move
> to keep things whole.
> (1980, 10)

In an interview, Strand has interpreted the slender lyric as expressing his concern that authorial "presence" as a speaker is contingent on "disturbing" the "world" that envelops the poem as white space: "In the end . . . the world can get along very well without me, and in fact that my being there is . . . an interruption. The presence of consciousness is altering, disturbing, isolating" (Cooper, 2). As Strand suggests, the speaker appears as a lyric subject by erasing (as well as absorbing into the self) all other personal referents and objects in his visual "field" (Wherever I am/ I am what is missing"). In "A Poet's Alphabet," the ambitious poet imagines language as a manifestation of a "vacancy," or the presence of an absence, but in order to displace a void that he can then occupy: "*S* is for something that supplies a vacancy, which I might kill. It has a verbal presence that my own immediate appetite or ambition subverts, misreads, or makes an appealing voice, a space only I can elaborate on (13)." As in the relationship between language, emptiness, and the authorial voice in "A Poet's Alphabet," self-inscription enacts the violent ("parting") motion of the speaker through enjambment in "Keeping Things Whole": "When I walk / I part the air." Even as the speaker claims that he moves to "keep things whole," the reliance on enjambment disrupts the "wholeness" of the visual field.

Strand's construction of a border between the authorial self and other persons in the speaker's territory becomes a source of confusion, guilt, and paranoia in many other poems from *Sleeping with One Eye Open* (1964) and *Reasons for Moving* (1968), his first two volumes. In "The Tunnel," he dramatizes the shifting relations between self and other as he imagines the self as abject, or the self as other to itself. The poem describes the unstable border that exists between a male voyeur and a paranoid man who, believing he is being shadowed by a stranger, abandons his home, and walls himself inside a neighbor's household:

When he seems unmoved
I decide to dig a tunnel
to a neighboring yard.
I seal the basement off
from the upstairs with
a brick wall. I dig hard
and in no time the tunnel
is done. Leaving my pick
and shovel below,

The poem suggests that the predatory figure, who has "been standing / in front of my house / for days," might also be a projection of the speaker's belief that he is under surveillance:

I come out in front of a house
and stand there too tired to
move or even speak, hoping
someone will help me.
I feel I'm being watched
and sometimes I hear
a man's voice,
but nothing is done
and I have been waiting for days.
(1980, 14)

In "The Way It Is," Strand enacts the erotic nature of the unrestrained gaze of the male spectator. In the narrative, the observer transgresses on the boundary between public acts of seeing and the private space of his neighbors' realm of desire as he, in imagination at least, participates in their sexual drama by peering into the living room through a window that frames the scene as if it were a painting or a film screen:

My neighbor's wife comes home.
She walks into the living room,
takes off her clothes, her hair fall down her back.
She seems to wake

through long flat rivers of shade.
The soles of her feet are black.

> She kisses her husband's neck
> and puts her hands inside his pants
>
> (1980, 79–80)

In "The Way It Is," he expressed the relationship between self and other as the spectator's imaginary entanglement in the neighbors' sexual drama. In "The Tunnel," he represented the issue of marking the boundary between self and other in terms of personal identity as the splitting of a man's sense of himself into halves, a private figure trapped inside a house and a shadow self that waits on the front lawn. Like "The Tunnel," "The Man in the Mirror" displays the self *as other to itself* in a retrospective lyric that expresses the speaker's wish for (as well as fear of) healing the divided self. The poem contrasts perspectives on the self that hover between identity as a zone of consciousness and an understanding of the self as an object of visual attention, a mirrored image that signifies abjection, not wholeness:

> I remember how we used to stand
> wishing the glass
> would dissolve between us,
> and how we watched our words
>
> cloud that bland, innocent surface,
> and when our faces blurred
> how scared we were
>
> (1980, 24)

In Strand's poetry, boundaries are set up to establish distinctions between subjects and objects in a visual field, but, as feminist theorists of the male gaze such as Laura Mulvey would predict, the male's desire to see and then to possess what he has seen disrupts these boundaries. In "Fantasia on the Relations between Poetry and Photography," Strand remarks that the pose of the sitter in a formal photograph can act as a "defense against the candor of family photographs" (Strand 2000b, 22). Photographic compositions are a way for the sitter to control the image of the self for public consumption, and to protect the viewer from feelings of sadness over the passing of time. The compositions of poems and photographs are designed to assist persons as they negotiate human relations by marking the difference, for example, between public and private spaces, but Strand represents the speaker's desire for appearance as contingent upon invading, erasing, or

disrupting boundaries in all four early lyrics. Because he ignores the bound-
aries that create identity by assigning difference, the self can only be figured
as an absence that appears by disregarding other selves as other absences.

In the early lyrics, Strand portrays his speaker as reacting with hysteria
to his own relationship to modernism, which is to say, he displays his wish
to hold dominion over the cultural imaginary. In "The Dirty Hand," the
speaker states that "My hand is dirty / I must cut it off." The poet refers to
the hand that writes poems and that interacts with the world of sensations
as a displacement for the phallus. In "The Dirty Hand," the authorial self
must, paradoxically, return to the symbolic arena to castrate the hand-as-
phallus to reduce the speaker's guilt at authorizing the text that erases
other persons. In "The Mailman," the author perceives his survival as con-
tingent on disfiguring other bodies: "You shall live / by inflicting pain."

In a 1990 interview, Strand interpreted the terse style of *Reasons for
Moving* (1968), the second book of poems that borrows its title from a
line in "Keeping Things Whole," as his formal response to an experience
of personal disorientation. "I think the style is rather plain (although
there is rhyme and there are some measured poems in that book or in the
previous book) because I was holding on for dear life, even rhetorically.
My sentences had to be simple for me to stay in control of them. My lines
had to be short for me to be able to gauge their musicality" (Kellen, 65).
Strand connects his literary *style* to his desire for personal orientation in a
real world context. The link he makes between art and life suggests his
general interpretation of poetry as a medium of social negotiation.[1] Un-
like modern formalists, Strand does not attend to poetic design as a medi-
ation for its own sake—he says he did not focus on rhyme and meter only
to "gauge their musicality." Instead, he attempts to organize his experi-
ence through a structure that reduces the difference between art and life:
shortening the line, simplifying the syntax, and making his rhetoric as
unobtrusive as possible. Strand's attempt to manage his life by simplifying
line and diction resonates with the postures of self-effacement, resigna-
tion, and guilt experienced by speakers in his early poetry, for whom, as
David Kirby writes, "the best action is no action at all" (1990, 23).

In art writings from the 1980s and 1990s on Bailey and Hopper,
Strand reconfigures his relation to other persons, to other worlds besides
his own, and to the libidinal aspects of perception by regarding the
semantics of form. By locating meaningful borders between his writings

and the visual realm on which he rests his gaze, he refrains from inter-preting his appearance as contingent on the economics of scarcity that he displayed in the early lyrics, where the self was figured as the outcome to a zero-sum game of authorial power. By attending to the duality of fig-urative painting as subject depiction and as formal design, Strand discov-ers a visual basis to interpret aesthetics as a principle of interpersonal negotiation outside the domain of poetry or painting. By reading ab-straction as a figurative check against the mistaking of the internal realm of art for realistic representation, he places formalism into a social catego-ry that respects personal differences. Attention to the opacity of form— a high modernist conception—enables him to resist the desire to perceive art as a transparent construct available to his projection of meaning onto it through the language of interpretation.

Art of the Real

Besides *Hopper*, Strand has published one other monograph on an indi-vidual American painter—the still life and portrait artist William Bailey —but his initial book-length encounter with American artists occurred in the interviews he conducted, edited, and collected as *Art of the Real: Nine American Figurative Painters* (1983), which appeared with photographs of the artists by Timothy Greenfield-Sanders. In *Art of the Real*, Strand's characteristic poetic trope of self-divestment as unlimited self-fashioning is reinstated in the form of his art writing.

I said that the negative freedom of self-assertion through personal era-sure was Strand's characteristic response to spatial distribution in the early poetry. Self divestment was figured in the title of the poem "Giving Myself Up," in the lines "Wherever I am / I am what is missing," and, in "Poem":

> First, my toenails
> will be clipped, then my toes
> and so on until
> nothing is left of me.
> (1980, 15)

In these poems, Strand's passive response on behalf of other persons in a face-to-face encounter disguised a wish for unlimited appearance, not of the other person, but of the authorial self. As in his massive disappearing

act in poetry, *Art of the Real* dissolves the boundary between self and other in a performance of modernist appropriation. Disregarding the relatively minor role of interviewer, Strand ventriloquizes the statements of the nine painters through his own voice. In *Art of the Real*, as in the early poetry, Strand, writing under the sign of personal erasure, becomes the omnipresent supervising agent of a visual realm by reconceiving the voice of the other person as subject to the domain of the authorial self, even as that self only exists as an absence.

Given the subject matter of *Art of the Real*, and given the trajectory of Strand's history of creative endeavors since that time, I read the interviews as virtual autobiographies of careers as an artist that Strand did not fulfill in his early adulthood. A Canadian-born author who has achieved the rank of poet laureate of the United States, Strand had first conceived of himself as a painter, not a poet. "I was told that I was gifted as an artist. No one ever told me I was gifted in language," Strand recalled in an interview with his teacher at Antioch College, Nolan Miller (1981, 109). Enrolled as an art student at Yale after graduating from Antioch, Strand's creative interests shifted toward poetry and away from an adolescent perception of himself, fostered by his parents, as a painter who lacked literary talent. Strand recalls that it was at Yale, while studying with the color theorist Josef Albers, that he realized "I was never a very good painter . . . for a student I was a pretty good painter or draftsman, but I never developed" (1981, 115). Distinguished members of the English Department such as Robert Penn Warren, Gordon Haight, and Cleanth Brooks, by contrast, admired his poetry. "All those people were terrifically nice to me," Strand has said (1981, 115). His decision as editor of *Art of the Real* to place his contemporary, William Bailey (b. 1930), who, like Strand, received a degree in art from Yale where he, too, studied with Albers, as his initial subject is one indication of the book's autobiographical dimension.

Art of the Real is a peculiar transcription of the interviews Strand conducted with painters such as Bailey, Neil Welliver, Alex Katz, Fairfield Porter, and Jane Freilicher because the author's identity is effaced throughout the text. Unlike the interviews Strand has published with Richard Vine and Robert von Hallberg (1977), David Brooks (1978), Cristina Bacchilega (1981), Nolan Miller (1981), and Leslie Kelen (1990) where he is interviewed about his poetry, Strand's perspective is deleted

except for the introduction to *Art of the Real.* Instead of a dialogue format, the discussions appear in a first-person autobiographical narrative, but one *shaped and written by Strand, not by the artist.* As editor, Strand has revised the interviews into "the casual autobiographical format" to allow the artists to "speak for themselves about their work and careers" (1983, 11). As in "Keeping Things Whole," his presence as an author who has projected his story onto artists such as Bailey is felt more keenly in his absence than if he had adhered to the interview format. Strand's interviews, I am arguing, are symptomatic of the emergency, figured in "The Dirty Hand," of his appearance in representation as contingent on effacing himself, erasing others, or violating borders that are designed to maintain differences between self and other in a social environment. In *Art of the Real,* he furthered the modernist project of appropriation and control by merging the voices of the author and the artist into aspects of one voice in one unified text that has been "shaped and clarified" by the editor. "Because it seemed best to have the artists speak for themselves about their work and careers, and to have them do so in a unified, uninterrupted series of disclosures, there was no need to retain the editor's questions. The editor's job was to shape and clarify the responses of the painter's so that they could be read with maximum pleasure" (1983, 11).

In spite of this sublimated power play, Strand's introduction does address features, common to all nine artists, that will inform the theory of aesthetics as a principle of interpersonal negotiation that respects boundaries in his subsequent writings on Bailey and Hopper. In a statement that proved to be influential to Strand's concept of realism in the later art monographs, William Bailey interprets the term *figurative* in conceptual and perceptual contexts: "One meaning has to do with painting figures of objects; the other is more literary, having to do with the metaphorical rather than literal character of what is painted. I think of my still lives in architectural terms. My paintings are like imagined towns, not real ones. They are places for me, painting places" (1983, 32). Extending Bailey's observations to the other artists he discusses in the introduction, Strand links representational and textural aspects of realism when he views each painter as "committed . . . to figuration as a mode that holds its own value; they respect the formal considerations of modernism and are drawn to the painterly conventions of abstract expressionism" (1983, 10). Paradoxically, he admires *realist* work that is also "a mode that holds its

own value." By so doing, he makes the counterintuitive point that by pivoting between illusionism and abstraction, the nine artists offer a model of social relations based on maintaining a degree of opacity between interlocutors. Each artist *represents representation* as a site that both is and is not a part of the real world beyond the picture plane. "They pursue—in their concerns with, and restoration of, illusionistic space—an objectivity that not only recognizes the world around them but also depends on it. Their paintings are not projections of self-discovery so much as evidence of a varied and on-going engagement with the world" (1983, 10).

Thomas Crow and T. J. Clark have uncovered the leftist political motivations behind the New York critics' decision to embrace abstraction as a response to a nascent consumer society and the abuse of aesthetics to further the political agendas of fascist and totalitarian regimes before World War II. Like the "Eliotic Trotskyists" in Clark's definition of modernist criticism, Strand follows contemporary realist painters who retain the integrity of the painted surface as an act of resistance to the usual assumption that realistic art is an unmediated reflection of actual life. Where Greenberg followed Lessing in separating the arts from one other and by perceiving advanced painting as an oasis from everyday concerns, however, Strand interprets aesthetics as a meaningful frame that is relevant to the negotiation of social relations outside of art. Form is meaningful as an opaque, rather than an optical, medium, because the physicality of art blocks an interpretative and narrative impulse that has caused social differences and differences between abstraction and realism to be ignored in writings about art.

In his analysis of Hopper and Bailey, Strand argues for the recuperation of aesthetic detachment, a position that John Yau criticized in his reading of Warhol's *Death and Disaster* series as an act of denial of the relationship between art and the human body in all of its vibrancy and vulnerability. Yau interpreted the grids, repetitions, and color makeovers as formal decisions that enabled Warhol to repress the temporality of life, and the eventual fact of death. Warhol desired to maintain a commercially driven fantasy of a realm of "elsewhere of after that can be obtained" (Yau 1993, 45). By contrast to Yau on Warhol, Strand attends to design in Bailey and Hopper to map out differences between persons that he dissolved or ignored in his early lyrics and in *Art of the Real*. For Strand, form is a meaningful frame because it produces the self by limiting the author's desire to

impose narration upon a visual realm that is unresponsive to his calling.

William Bailey

Strand's attempt to narrate the comparative representational content of paintings by Bailey and Hopper abides by the usual expectations we have for interpreting realist painting as an immediate reflection on natural life. For Strand to translate a painting into a story line, however, he must suppress his awareness that art is also a formal construct defined by a painter's stylistic choices, not by the author's desire for mastery over the silent medium. By attending to aesthetic design as a limit to the power of projection by the viewer, Strand's criticism leans toward what W. J. T. Mitchell describes as "the moment of resistance or counterdesire that occurs when we sense that the difference between the verbal and visual representation might collapse and the figurative, imaginary desire of ekphrasis might be realized literally and actually" (1994, 154): "It is the moment in aesthetics when the difference between verbal and visual mediation becomes a moral, aesthetic imperative rather than . . . a natural fact that can be relied on" (1994, 154–155).[2] Spectators experience "ekphrastic fear" when they perceive the confusion of genres in terms of an unrestrained intersubjective encounter—a "dangerous promiscuity"— in a nonart context. As in Bakhtin's treatment of conversation as a coproduction of personal identity, spectators may perceive the disruption of the border between genres as an opportunity for interpersonal contact, but also as an illustration of the loss of autonomy. In Mitchell's interpretation, the observer's translation of the visual realm into the verbal replicates the merger of self and other in a system of social relations based on the establishment of differences between persons. From the perspective of "ekphrastic fear," narration compromises the integrity of art, and by so doing, it is analogous to the erasure of distinctions between the "me" and the "not me" in the sphere of social relations.[3] In *Hopper* and *William Bailey*, Strand replaces the model of conversation as the merger of self and other found in *Art of the Real*.

Strand chose a "super real" still life by William Bailey of bowls and cups set on a wooden table as the cover art for the second edition of *Selected Poems*. Bailey's painting replaced a black-and-white photograph by Lilo Raymond of Strand seated on a stool against a blank wall that

appeared on the cover of the first edition of *Selected Poems* (1980). *Dark Harbor* (1993) also borrows its title from the Bailey painting that appears on the cover of that volume of poetry. In 1987, Strand expressed his continuing identification with Bailey by selecting him as the subject of his first monograph on an individual American painter. By addressing how Bailey negotiates social relations through art forms, Strand reads still life paintings and female nudes as expressions of his own ambivalent relationship to representation. Interpreting Bailey, Strand reflects on issues of personal construal that involve absence and presence, and the author's desire for control over space and the relinquishing of that control to something else or someone else.

William Bailey is known for his transcendent arrangements and immaculate renditions of common household items and kitchen utensils. His marmoreal versions of coffee pots, eggs, mixing bowls, cups, and potato mashers appear to be perceived from a telescopic point of view. The images are rendered with an exquisite level of detail that suggests a close-up view, but the items from the kitchen pantry and dinner table seem alien and to have been withdrawn from bodily need and everyday life. His dinnerware never appears to have come into contact with the body in the form of lips that touch cups, or fingers and hands that leave prints when they hold the bowl, crack the eggs, or mash the potatoes. Could any spectator imagine that the eggs Bailey paints will ever be cracked to make an omelet, becoming empty shells? Strand doesn't think so. He imagines that Bailey arranges objects on a bare tabletop so they might be interpreted by spectators, not as common domestic items, but as strange places, parts of exotic landscapes, such as the skyline of an Italian city when viewed by a tourist approaching from a distance. Strand experiences tension in reading Bailey paintings as remote landscapes because they "look like real objects but, of course, are not real" (9). Like Strand's own poetry, which chronicles a divestment of the self from social encounters, Bailey excludes images of persons from the realm of the domestic objects that he paints with a tenderness that verges on an act of mourning for a world that no longer exists.

Strand distinguishes aesthetic rule from representational impulse in Bailey's art, in part by following Eliot, Bloom, and Fried in examining art historical influences ranging from Chardin and Ingres, to De Chirico and Balthus. "Almost all Bailey's figure paintings bear certain resemblances to the work of others," he writes (1987, 42). He focuses on how Bailey, a

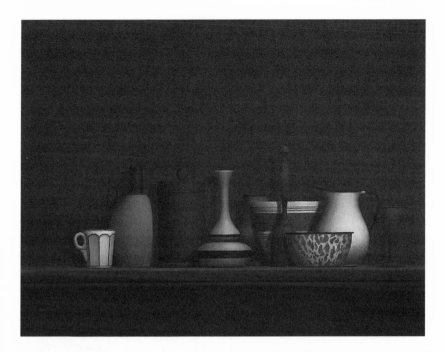

Figure 5. William Bailey. *Mercatale Still Life* (1981). Oil and wax on canvas, 30 x 40 in. (76.2 x 101.6 cm). The Museum of Modern Art, New York. Blanchette Rockefeller Fund. Photograph © 2001, The Museum of Modern Art.

Platonist, whose "reality transcends our common experience," manipulates objects by reconfiguring their shape and size (50). He then shows how Bailey juxtaposes cups, bowls, and pitchers on a table top so that what Strand calls the "figurational order" of the composition suggests a village skyline, as in *Still Life Pisa,* or an American city skyline as in *Manhattan Still Life* (34). Strand's reading of the immaculate version of the pitchers and cups suggests that, as for Bailey, aesthetics enables him to see things at a distance and to resist the desire to ignore the difference between representation and conceptual content. Strand also reads form as a way to resist experiencing anxiety about the "nothing" contained within the pots and bowls:

> They look like real objects but, of course, are not real. They have no life other than in the painting. They are not used to remind us of their utility in the real world. We don't see tabletops like those in Bailey's paintings, with the objects on them so painstakingly placed. . . . In Bailey's work, each

ordering forms a resistance to the representation of reality. (1987, 90)

From the perspective of a cultural analyst who is interested in establishing the relationship between art and nonart contexts, there are disturbing implications to Strand's comment about what he goes on to call the "terminal arrangement" of Bailey paintings that suggest touristic landscapes. Representing the viewpoint of a privileged white male artist who finds kitchen tools such as potato mashers to be objects of a fascination that verges on the uncanny, Bailey lends credence to a paternalistic attitude toward domestic labor. Defamiliarizing the image of kitchen tools as utensils necessary to perform valuable work, Bailey's fastidious versions of eggs and potato mashers become associated in the viewer's imagination with a leisure activity, such as might be found in a tourist's sentimental vision of what is happening in an Italian village as it is approached from a distance. Strand observes that for the conventional male artist, kitchen utensils such as a potato masher would be unfamiliar, and, therefore, available to an uncanny aesthetic speculation. "For Bailey, they have existed in passing, in those brief encounters a man has with household objects whose importance for him is not mediated by their utility. Bailey sees them solely in terms of their potential for paintings. Such an abstract, metaphorical existence is far removed from, say, the kitchen" (1987, 27–28).

Bailey can be interpreted as a descendent of modernism as practiced by Duchamp, but Strand criticizes his still life art precisely *because* of Bailey's devotion to the beauty of commonplace objects such as eggs, pitchers, mixing bowls, and potato mashers. Besides deleting the agents of domestic labor from the picture, Bailey's sublime paintings erase the continuously changing bodies that consume the food and drink contained in the exquisitely painted vessels. Bailey's objects seem, like those in the "Ode to a Grecian Urn" by Keats, to suggest the permanence of art, rather than the metamorphic quality of human experience that such art wishes to repress.

Strand critiques Bailey for erasing the images of persons in his domestic scenes, but he also argues for the social values of the unlikeness of his art. Especially in his reading of how Bailey paints a female nude in N (1964), Strand describes the play between mimesis—the sense that the painting is "caressable flesh that is soft and warm"—and an analysis that regards N as "cold and marmoreal," that is, as a sculptural design unavailable to the caress of the spectator (1987, 40). Strand places the contradictory "temperatures" of the painting—the "warm" or "realistic" illusion of a lifelike repre-

sentation, and the "cold" or figural (in a design sense of the term) artistry, the living body and the still life—into the context of the male spectator who witnesses the naked female body. Strand describes the painting as a "formal rendering of erotic possibility and denial, an abstraction" (1987, 40). Bailey's attention to "the formal issues raised by the disposition of a complex figure in space," Strand writes, suggests the sitter's "particular presence" (1987, 45, 46): "It is a different kind of attention being paid. It is related to the delicate, detailed engagement of his drawings with the female figure, but less investigatory, less a form of interrogation" (1987, 46).

Bailey's formalism reduces the violational (voyeuristic, libidinal, and appropriative) aspects of male spectatorship of the female body. "Engagement" implies a dialogic interaction between the sitter's "particular presence" and the artist's skill in rendering her image. "Engagement" also replaces the rhetoric of invasion (interrogation, investigation, and interpellation), which suggests the artist's uninvited entrance into her private world. Bailey may have drawn information by observing life when painting, but Strand's focus is squarely on art as an opaque medium of restraint

Figure 6. William Bailey. *"N" (Female Nude)* (ca. 1965). Oil on canvas, 48 x 72 in. (121.9 x 182.9 cm). Collection of Whitney Museum of American Art, New York. Gift of Mrs. Louis Sosland, 76.39. Photograph © 2001, Whitney Museum of Art.

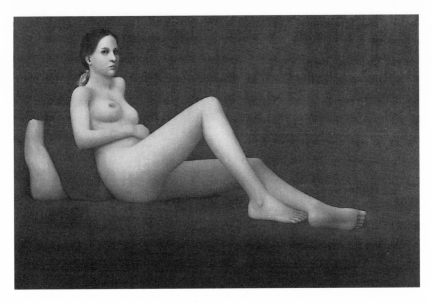

that differs from life. Regarding painting as a "terminal arrangement, a monument to itself," Strand registers the artist's disinterested relationship to domestic labor in his still life paintings. Yet it is also evident that Bailey's response to figuration as aesthetic form *and* as a reflection of an actual object can limit the assumption, held by many spectators of realist portraits such as *N*, that the images are being offered as objects of consumption. Paradoxically, Bailey limits (male) spectators from understanding their act of beholding art as a means of possessing the objects they have seen as (female) subjects.

Nighthawks*: What We Are Talking about When We Talk about Hopper*

Gail Levin has testified to the tradition of narrating Hopper by editing *The Poetry of Silence* (1995), an anthology of lyrics based on his paintings. Along with Deborah Lyons's *Hopper and the American Imagination,* an anthology of writing inspired by Hopper's art that also served as the catalog for a show at the Whitney Museum of American Art, Levin demonstrates that Hopper has stimulated what the poet William Carpenter calls "the image that demands completion in the other [verbal] medium." In *Hopper,* Strand questions the "demand" for "completion" through verbal narration that is noted by Carpenter, and that has been enacted by many contemporary authors. Strand's treatment of Hopper, for example, differs from literary adaptations of *Nighthawks* in a poem by Joyce Carol Oates and of *Early Sunday Morning* in a poem by John Hollander. Unlike Oates's and Hollander's unrestrained lyrical impulses, Strand suggests that the material of art represents an obstacle that limits narration by contradicting the manifest content, or depictive "subject" matter, of the paintings.[4]

By calling attention to the semantics of Hopper's form as an act that subverts narrative meaning, Strand questions the project of writers who respond to Hopper by, in Hollander's words, "superimpos[ing] an actual street scene from . . . childhood . . . onto the Hopper . . . street scene" (11). Strand offers a commentary about Hopper's paintings, but the dialogue between art and writing *is not* like that between Hollander's recollection of "actual street scenes" from his childhood and *Early Sunday Morning* (1930), the painting on which Hollander, in a poem entitled "Sunday A.M. Not in Manhattan," projects images of how the city looked to him as a child growing up on Flatbush Avenue in Brooklyn. Instead,

dialogue exists in Strand's monograph between the manifest content of *Early Sunday Morning* and the contradictory meanings that are "silently announced" by the conceptual aspects of Hopper's formal display. In reading *Nighthawks*, Strand distinguishes between perceptual and conceptual realms of experience. He shows that Hopper maintains what the poet Allen Grossman calls "the rules of the construction of the human image—the *likeness*... not the thing itself" (1990, 273).

Especially in regard to the classic images of urban ennui, such as *Nighthawks*, on display at the Art Institute of Chicago, it has become so easy for us to forget that what we are looking at when we see a Hopper painting is an example of figuration as realism, but also what Strand calls "figuration as a mode that holds its own value" (1983, 10):

> The diner is an island of light distracting whoever might be walking by—
> in this case, ourselves—from journey's end. This distraction might be con-
> strued as salvation. For a vanishing point is not just where converging lines
> meet, it is also where we cease to be, the end of each of our individual
> journeys. Looking at *Nighthawks*, we are suspended between contradictory
> imperatives—one, governed by the trapezoid, that urges us forward, and
> the other, governed by the image of a light place in a dark city, that urges
> us to stay. (1994, 6–7)

Hopper's art is an expression of human concerns, but it is the form of *Nighthawks* that enacts the characters' existential predicament. Strand perceives the contradictory and yet coexistent wish for a transcendence of place, the wish for movement and escape from conventional social arrangements, and the wish for an embrace of the quotidian in the company of other persons as a stay against the fear of unknown places signified by cut-off horizontal planes that point toward, but defer access to, the area beyond the picture plane. Through his attention to form as an expression of the anxiety of urban social life in modernity, Hopper admits, but finally rejects, the desire to explore the sublime (unrepresentable) realm beyond the picture plane. Strand has described the situation of the characters in *Nighthawks* in the poem called "The Door" as "Nobody wants / To Leave, nobody wants to stay behind" (1980, 46).

Like those of abstract and color-field painters such as Mark Rothko, Helen Frankenthaler, and Ellsworth Kelly, Hopper's paintings approach sublimity. In *Nighthawks*, however, Hopper resists placing exclusive attention on the vanishing point—the state of no difference (or "all overness")—through what Strand calls the "distraction" of the urban landscape. "The

Figure 7. Edward Hopper. *Nighthawks* (1942). Oil on canvas, 84.1 x 152.4 cm. Friends of American Art Collection, 1942.51. Photograph © 2000, The Art Institute of Chicago. All rights reserved.

diner is an island of light distracting whoever might be walking by—in this case, ourselves—from journey's end," he writes. Hopper defers the viewer's admission toward the state of no difference by establishing the appearance of a figurative blockage—the brightly lit café—that occupies a transitional space in between the conception of the painting as realist (figuration as realistic representation) and the purity of abstraction (figuration as design).

In his analysis of *Nighthawks*, Strand registers the concurrent feelings of salvation and cessation, claustrophobia and agoraphobia, quotidianism and sublimity, and the idea of figuration as depiction and figuration as design. He points toward emotional effects through a discussion of vanishing points, lines, and trapezoids, rather than by projecting narratives onto the somber images of the men and the woman seated in the café. Hopper conveys tonal information to viewers through the geometric and planar elements of the canvas, and through the horizontal bands of color that are cut off from reaching a vanishing point by vertical blocks. "For a vanishing point is not just where converging lines meet, it is also where we cease to be, the end of each or our individual journeys," he writes.

By contrast to Strand's resistance to imposing a narrative onto the

painting, Joyce Carol Oates, in a poem entitled "Edward Hopper, 'Night-hawks' (1942)," superimposes her interest as a fiction writer onto the fig-ures in *Nighthawks*. Describing the subvocal discourse of the woman with red hair at the café's counter, for example, Oates imagines her thoughts and feelings about the man in the fedora hat seated beside her:

> . . . she's contemplating
> a cigarette in her right hand thinking
> her companion has finally left his wife but
> can she trust him?
>
> (1995b, 16)

Oates imagines the wishes, fears, and even the "smells of guilt" experi-enced by characters that consider their futures in a private discourse:

> [she is] damned good-looking
> and she guesses she knows it but what exactly
> has it gotten her so far, and where?—he'll start
> to feel guilty in a few days, she knows
> the signs, an actual smell, sweaty, rancid, like
> dirty socks, he'll slip away to make telephone calls
> and she swears she isn't going to go through that
> again, isn't going to break down crying or begging
> nor is she going to scream at him, she's finished
> with all that and he's silent beside her
> not the kind to talk much but he's thinking
> thank God he made the right move at last.
>
> (17)

Oates, of course, is best known as a novelist, and not as a poet, and so it might seem unfair to use her poem as the negative example of an unre-strained type of narrative intrusion. I do, however, feel that her inatten-tion to poetry *as an abstract pattern*, rather than as a forum for an un-mediated reflection on character and plot, is the significant trouble with her response to *Nighthawks*. This is especially true in terms of my overall thesis that Strand is, unlike Oates, interested in Hopper's painting as a check against the hope of translating the visual into the verbal.

Oates's disinterest in the line as a signifier of poetry's difference from the rhythms of natural language is analogous to her disregard for perceiv-

ing *Nighthawks* as a painting that displays figuration as an example of depiction *and* as design. Her discourse is, of course, recognizable as a poem because it is written in lines of relatively stable length, but the lines are not semantically justified. Enjambment seems arbitrary in " 'Nighthawks,' (1942)," and even as the lines approximate the ten positions of social formation, their rhythm and meter do not superimpose a meaningful pattern on the speaker's natural voicing of a social dilemma. Oates disregards poetic form as a principle of regulation that checks the reader's desire to mistake artifact and referent. Her formal disregard is understandable because her primary discursive mode is narrative prose and because, as a female author, Oates may be more interested in establishing "voice" than in constructing the physical structure of verse. But her inattention to form, either in her own poem's lineation or in her analysis of *Nighthawks*, suggests her disinterest in the semantics of form in Hopper's painting.[5]

From the poem's opening line, "The three men are fully clothed, long sleeves," Oates is drawn toward the dramatic center of *Nighthawks*. She is not observing the margins, as Strand does when he interprets the significance of blocked vanishing points as revelatory of the painter's ambivalence toward reaching a sublime realm in which individuality as well as human relations, however trying, will be extinguished at the moment of liberation from the café's social world. For Oates, the café's glass window, which for Strand represents a screen that both reveals and conceals human behavior, does not exist as an obstacle to her speculations. Similarly, the canvas for Oates is a window open to a social world that reflects on her understanding of human relations. In other art writings such as *George Bellows: American Artist*, where she discusses the implication of the spectator in the performance of scenes of violence in the boxing ring, Oates respects the boundary between forms of representation. In the case of Hopper, however, Oates seems unable to resist finishing the painting in other words.

In Strand's view, Hopper suggests the mysteries and fears that viewers experience when they imagine what lies beyond the claustrophobic realm of community inside the café or, in *Gas*, where they might travel once they leave the filling station and enter the dark wood. Hopper's paintings represent a stay against the death drive, or the desire to transcend human meanings and relations, even as the forms that specify human interactions seem inhibiting, unsatisfying. Strand does not represent dialogue in *Nighthawks* by inventing a plot or by examining charac-

ter relations. He does, however, maintain the dialogic aspect of the paint-
ing through the semantic interpretation of form, which often exists in
contradiction to the visually realistic content.

Hope and Fear in A Woman in the Sun

In the preface to *Hopper*, Strand defines his motive to write on the para-
digmatic American painter of modernist apprehension as an act of cul-
tural reconfiguration. He reports that he wanted to "correct what I per-
ceived to be misconceptions advanced by other critics of his paintings"
(xiii). From this new modernist, or "cultural reconfiguration," stand-
point on his motivation to write on art, Strand wishes to defend Hopper
against "misguided readings," such as the following analysis by Deborah
Lyons. "It is Hopper's spareness, along with his progressive tendency to
clear out detail and incident, which allows us to project the details of our
own lives into his painted world, to see the lives projected on canvas as
standing for all lives" (Lyons, x–xi). Lyons suggests that Hopper disallows
the aesthetic realm that intrigued other modernists to interrupt specta-
tors from projecting their experiences onto his art. To counteract the
"natural attitude" tradition that has dominated Hopper criticism, and
that has led to a consensus about his significance in the popular imagina-
tion, Strand suggests that representation should be contextualized in
terms of form. In his analysis of *A Woman in the Sun*, Strand, however, at
first reacts to the painting as if he were not an art critic paying attention
to a formal design, but a detective, perhaps one in a film noir, who needs
to solve a mystery: "One feels that the first thing she was moved to do
upon waking was to appease the flesh, but one also feels that her momen-
tary indulgence is compensatory. That she is not a woman who padded
about in her 'jammies' and slippers before nodding off is obvious. The
high-heeled pumps beside the bed suggest that she retired with haste"
(1994, 36). A desiring male spectator who gazes on a naked woman, but
who cannot be observed in the room in which she stands, Strand begins
his analysis in a speculative and equivocal manner, and yet I would
describe his voice as confident and impersonal ("one feels"). Sounding
like Oates in her noirlike conversation about *Nighthawks*, Strand at first
responds to *A Woman in the Sun* with the hope that he can translate its
meaning in his own words. Basing his narrative as much on his own intui-

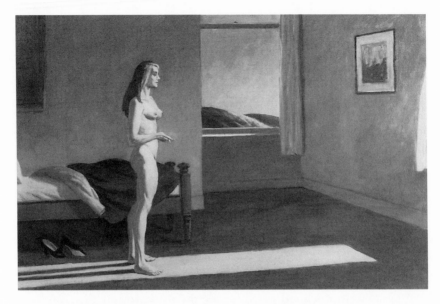

Figure 8. Edward Hopper. *A Woman in the Sun* (1961). Oil on canvas,
40 1/8 x 61 1/4 in. (101.9 x 155.6 cm). Collection of Whitney Museum of
American Art, New York. Fiftieth Anniversary Gift of Mr. and Mrs. Albert
Hackett in honor of Edith and Lloyd Goodrich, 84.31. Photograph
© 2001, Whitney Museum of Art.

tions—she is not the kind of woman who wears "jammies"; she undressed
in "haste"—as on the visual information Hopper has provided, Strand is,
at first, willing to gauge which causes are proximate and which are re-
mote for placing her in the motel room. Deciphering "clues" such as the
black pumps, he translates Hopper's art into a narration that makes sense
in terms of cause and effect.

Strand's initial move is to disrupt the boundary Hopper establishes
between spectatorship, narrative, and the mediational value of the paint-
ing as a physical artifact. His interpretative gesture is figured as an ac-
count of unrestrained heterosexual male desire as he pursues informa-
tion that will lead him to solve a mystery, but the unsolved case involves
the woman's appearance, rather than, as in detective fiction, the mystery
of a disappearance. As in a poem such as "Keeping Things Whole," how-
ever, where Strand writes that "wherever I am / I am what is missing,"
appearance and disappearance are contingent on each other. To appear,

to take up volume in a representation, as the woman does in Hopper's painting, is also to display an absence, a lack, a "missing." As in Lacanian psychoanalytic theories of the uncanny and as in Lyotard's interpretation of the modern sublime as "the unpresentable . . . put forward only as the missing contents," the figure in the painting is an obstacle that prevents the beholder from recognizing internal significance. What the painting reveals on a perceptual level can also be said to be that which is concealed, that which is shown is also "what is missing" (Lyotard, 81).

Strand wants to possess the model as a sexual object, but the painting's opacity repels the fulfillment of his erotic wish for control over a visual arena that does not belong to him. At the conclusion of his interpretation, he releases the painting from his prior assessment of its availability to him through narrative projection: "It is pointless, however, to speculate further on what her present pensiveness has to do with or what preceded her falling to sleep. Her past, like the back of her body, is left in shadow" (1994, 36). In the end, he follows Fried in stressing the absorption of the depictive content of the painting back into its own materiality. He moves away from what Norman Bryson calls a "natural attitude" toward reading art by contending that Hopper's use of chiaroscuro disrupts the credibility of any interpretation of the plot of *A Woman in the Sun*. If there is a solution to the mystery of Hopper paintings, Strand suggests, it is one that allows the spectator to observe how illusionistic effects, which display scenes of desire, can be dissolved into the formal qualities of the painting. "What Hopper had to do as an illustrator—idealize the figure—he chose not to do as a painter. His woman are no more beautiful than the painting themselves and belong entirely to the formal imperatives that have given them their existence" (1994, 36).

Strand's art writings are metacritical speculations concerning the ethics of the author's interpretative impulse to structure human experience—what he calls life's "rich ongoingness"—into a pattern that makes sense in terms of narrative cause and effect. In a recent commentary on how a poem by Rilke based on a fading photograph of his father as a young man in martial uniform "assumes the burden of carrying on, for a while, the image of Rilke's father," Strand suggests that writing about an image can be an ethical activity. In the case of Rilke's poem about the photograph of his father in a uniform, the act of writing recovers the value of the image of a person who is on the verge of disappearance as

the picture fades from view (2000a, 26). At other times, such as in the commentaries on female nudes by Bailey and by Hopper, Strand suggests that the art forms provide obstacles instead of *an inherent base* on which to construct narratives as meaningful frames.

The Wish to Make Pictures Speak

If Strand's reading of Hopper was merely a critique of interarts collaboration in which hope is not tempered with fear, his study would be an extension of the modernist assumption that verbal and visual realms are absolutely distinct entities. He would then be maintaining the philosophy that art should be valued as a quasi-spiritual realm that is separate from quotidian concerns and social relations. Given Strand's resistance to projecting autobiographical experiences onto the paintings, however, a surprise in reading *Hopper* is to realize that Strand *does* want to make "pictures speak" about his childhood. Besides the public motivation of cultural reconfiguration, Strand admits that his twenty-year fascination with Hopper stems from a personal identification with images that recall his childhood in Summerside, Prince Edward Island, Canada, in the 1940s:

> I often feel that the scenes in Edward Hopper's paintings are scenes from my
> own past. It may be because I was a child in the 1940s and the world I saw was
> pretty much the one I see when I look at Hoppers today. It may be because
> the adult world that surrounded me seemed as remote as the one that flour-
> ishes in his work. . . . It was a world glimpsed in passing. It was still. It had its
> own life and did not know or care that I happened by at a particular time.
> Like the world of Hopper's paintings, it did not return my gaze. (1994, 3)

Comparing his childhood in Canada with his reading of Hopper's paintings returns Strand to a theoretical discussion of *a crisis of visual interpretation* that pivots between hope and fear. His willingness to supply narrative speculations and personal anecdotes onto Hopper's art presents Strand with a paradox, especially given his critique of Levin for providing biographical information about Hopper's marriage to Jo Nivison as a context to read the work. Similarly, the autobiographical dimension of *Hopper* puts in question his critique of Lyons's appreciation of how Hopper enables viewers to "project the details of our own lives" onto his paintings. Finally, his vision of the Canadian landscape appears to compromise his critique of stories and poems based on Hopper paintings that Strand says "have little to do with the work itself" (1994, 30).

How, then, to account for Strand's imposition of his autobiography

onto Hopper, especially in light of comments about a short story based on *New York Movie* (1939), where Strand criticizes Leonard Michaels for "leav[ing] the painting behind as [the story] pursues its own imperatives and becomes a story in which the usherette of the painting is invested with the narrator's own adolescent uncertainty" (1994, 31)? Is Strand's description of his boyhood in Canada another version of applying "the narrator's own adolescent uncertainty" onto Hopper's art? And, if so, how can readers distinguish between his childhood story from projections by the authors whose poems and stories are found in the Hopper anthologies edited by Levin and Lyons? How can Strand resist hypocrisy when he claims, as he does throughout *Hopper* and in his *New Republic* review, that the autobiographical impulse "diminishes [Hopper's] work" (1994, 31)? Strand cannot deny that Hopper's paintings call forth the narrative impulse, but the reason he has perceived Hopper as a formalist has been to provide a physical check against his narrative expectations in a way that makes his own desire to tell stories seem "sentimental and beside the point" (1994, 23).

I want to suggest that what Strand remembers about his visual experience as a child in Canada is related to the narrative frustration that he confronts as an adult when engaged in an analysis of Hopper paintings. In addressing Hopper, he has returned to a crisis of meaning that is reminiscent of the childhood exposure to adult experiences of intimacy with which he could not fully interact, and, although able to glimpse and overhear, that he could not comprehend. "Like the world of Hopper's paintings, [the world of my childhood] did not return my gaze" (1994, 3). Trying to narrate Hopper paintings, Strand returns to landscapes from his childhood. But more than the reminder of a setting, a quality of light, or a type of architecture that he remembers seeing as a boy in the 1940s station wagon, Strand is reminded of what it felt like to be at an interpretative deficit in relationship to the world of visual stimulation. Writing on the mysterious relationship between form and content in Hopper returns Strand to a place and time when he could perceive the world in passing, a situation when the world did not return his gaze, the type of world Strand described in "Taking a Walk with You" as one in which "we don't belong." As in his description of his childhood, the poet is attracted to the world of the "not me," but also repelled by its difference from whatever thoughts and feelings he might have about it. The paintings "are scenes from [Strand's] own past" because they resist his contradictory will toward deductive analysis and narrative projections, even as the paintings simultaneously call forth the spectator's urge

to create meaning out of unreliable visual clues.

Observing Hopper's paintings, Strand is like many other contemporary authors who have written about why they think Hopper characters have arrived at the specific place and juncture in their lives. Hopper's paintings, however, are still and silent renderings of images of people experiencing inner strife. Like Edvard Munch's *The Scream* (1893), the paintings register an inaudible apprehension, and, therefore, Hopper's visualizations screen (in the dual senses of project and veil) a pain that is not marked on the surface of his models. Hopper's paintings suggest the limit to the communicability of human experiences of internality, the pain, as Elaine Scarry has remarked, that cannot be uttered, as well as the experience that cannot be translated to a spectator by visualizing it. As art critic, as participant in the production of meaning, and as the detective who wants to answer the question of "What is going on here?," Strand attempts to resist his own desire to know the story "behind" the painting, as well as to resist the writer's desire to tell the story: "Hopper's paintings are not vacancies in a rich ongoingness. They are all that can be gleaned from a vacancy that is shaded not so much by the events of a life lived as by the time before life and the time after. *The shadow of dark hangs over them, making whatever narratives we construct around them seem sentimental and beside the point* (1994, 23, italics mine)." Strand's willingness to project a memory of "a world glimpsed in passing" onto Hopper's paintings suggests his wish to see things in the paintings that he knows are not there but that he is supplying to them as a participant-observer. His "sentimental and beside the point" projections of his own life story onto the paintings suggest his desire to understand painting as a representational reflection of the world, both of his childhood experience in Canada when being driven around in his parents' station wagon, and of his historical imagination of what urban life must have felt like to citizens in places such as New York City and Cape Cod before World War II. This is Strand's "ekphrastic hope," a nostalgic wish, associated with childhood, that what we see can be translated through language into a statement that the world around us adequately reflects our limited vision of it as we pass by.

Performing Violence

Joyce Carol Oates on Boxing and the Paintings of George Bellows

Contemporary American authors have taken a pictorial turn, as well as a verbal re-turn, by exploring their autobiographical impulses, poetics, and the ethics of representation through writings on the formal elements of modern art. In some cases, as in Simic and Yau, writing about modernism has been part of a larger narrative project to construct personal identity in texts after traumatic experiences in childhood. In other cases, as in Beattie and Strand, the author questions the hope for communion between the verbal and the visual by implicating narrative in the displacement of life from the real to the symbolic. It is true that Strand and Beattie do translate the human image from one realm of appearance to another, but they retain the ethical dimension of contemporary art writings by showing that aesthetics involves erasure and the blurring of differences between persons. In this chapter on Joyce Carol Oates's writings on verbal and visual representations of boxing, I want to develop an analysis that deepens my account of the violence of modernist aesthetics. Oates's writing on boxing and its representation in the art of George Bellows

is concerned with how narrative may be implicated in the subject matter being displayed through forms that suggest authorial control, an aesthetic sensibility, and a claim to understanding the incomprehensible events witnessed in the ring. In her account of how Bellows situates himself in the two most famous boxing paintings in modern American painting, *Stag at Sharkey's* and *Dempsey and Firpo*, she identifies with his protean stylistics and his self-conscious comparison of boxing and painting as two acts of controlled violence. She also observes in her book *On Boxing* that Bellows shifts his relationship to the images he portrays from "ecstatic participation" to a more nuanced engagement. It is Oates's contention that Bellows's "ecstatic participation" associates the act of representation with the physical violation of the fighter's image. His later stance in a different kind of painting stresses an awareness that it is in the "aftermath" to the real event—in the way spectators remember what they have witnessed—that another kind of violation of the fighter's image takes place.

Theorists concerned with the depiction of violent subject matter have recently focused particular attention on the act of witnessing. Using as a point of departure Laura Mulvey's pioneering study of the "scopophilic gaze" (scopophilia being the desire to look at sexually stimulating scenes, especially as a substitute for actual participation), critics like Elaine Scarry, David B. Morris, and Laura Tanner have attempted to discover ways that the positioning of the spectator might offset some of the power politics involved in viewing another's pain. As they see it, by employing aesthetic techniques that present the experience of bodily violation as, paradoxically, inexpressible, rather than as an assertion of the spectator's power over the body of the other, the author or artist may enable the viewer to resist the translation of bodily pain into a statement of the victimizer's power.

For Oates, boxing is a sport that especially lends itself to such considerations. Best known for her fictional narratives of violence and emotional duress, as a young girl she became fascinated with boxing as a context in which pain might be converted into something other than pain. As she recalls in *On Boxing*, her 1987 critical commentary on the subject, when taken by her father to a Golden Gloves boxing tournament in Buffalo, New York, in the early 1950s, she asked him why boys were willing to get hurt in the ring, to this he replied that "boxers don't feel pain quite the way we do" (21). In addition to *On Boxing*, in 1990 she collaborated with Daniel Halpern in the publication of an anthology entitled *Reading the*

Fights: The Best Writing about the Most Controversial Sport, and most recently, in 1995, she published a study of the work of Bellows, the most celebrated American painter of boxing images, in which she similarly explores the relationship between witnessing, representation, and bodily pain. Oates focuses on the body of the prizefighter as what David B. Morris terms "the site of defeat" in a modern form of tragic theater involving pain and injury (262).

I want to argue that Oates is less sanguine than her father was about the sublimation of pain in boxing and that her work resists an optimistic world of Hollywood happy endings. More specifically I wish to explore the way that Oates attests to (and contributes to) a violent activity's lasting fascination. By writing about boxing without setting the pain generated by the event at a safe distance, Oates breaks through aesthetic conventions that erect an indelible boundary between spectator and participant. In the first part of my discussion I will focus on the writing-boxing connection and the paradoxes of representing pain that Oates outlines in *On Boxing* as well as in a short story she wrote at the time entitled "Golden Gloves." In the second part of my discussion I will then show how Oates interprets Bellows's two most famous boxing paintings as illustrations of her concern that representation may double the pain of the initial event by allowing violence to achieve invisibility through omission and redescription. Oates can be appreciated, as she is by David B. Morris, for calling attention to one of the only culturally sanctioned modes "we know for confronting death" (260). Oates's own reading of how Bellows presents himself as witness, however, reveals that confrontations with violence can turn into violations if the aesthetic returning or revisitation, in Scarry's terms, "leaves out the fact of bodily damage" (69).

In *On Boxing,* Oates compares the arduous months of training and sublimation that a boxer endures to prepare for a prizefight to the "frantic subordination of the self in terms of a wished-for destiny" that a novelist must undergo to complete a manuscript:

> Indeed, one of the reasons for the habitual attraction of serious writers to boxing (from Swift, Pope, Johnson to Hazlitt, Lord Byron, Hemingway, and our own Norman Mailer, George Plimpton, Ted Hoagland, Wilfrid Sheed, Daniel Halpern, et al.) is the sport's systematic cultivation of pain in the interests of a project, a life-goal: the willed transposing of the sensation we know as pain (physical, psychological, emotional) into its polar opposite. (26)

Oates, however, also stresses the uniqueness, the nonmetaphorical and untranslatable aspects of the pain of boxing:

> No one whose interest began as mine did in childhood—as an offshoot of my father's interest—is likely to think of boxing as a symbol of something beyond itself, as if its uniqueness were merely an abbreviation, or icono-graphic; though I can entertain the proposition that life is a metaphor for boxing—for one of those bouts that go on and on, round following round, jabs, missed punches, clinches, nothing determined, again the bell and again and you and your opponent *is* you: and why this struggle on an ele-vated platform enclosed by ropes as in a pen beneath hot crude pitiless lights in the presence of an impatient crowd?—that sort of hellish-writerly metaphor. Life *is* like boxing in many unsettling respects. But boxing is only like boxing. (5)

The further and perhaps better reason for connecting boxing and writ-ing, therefore, is that boxing relies on writing to be understood because it appears through an uncivilized and silent idiom, bodily pain. As Gerald Early has noted: "Boxing can only be understood through story: the oral tradition of eyewitnesses or the journalistic narratives of re-porters. . . . It is, in fact, an action that is meant to be nature itself. Boxing is always seeking its text" (177). Oates concurs with Early that although the scars and bruises etched directly onto the boxer's face and body are evidence of his participation, boxing's silent idiom of pain must be translated into a linguistic event if it is to be narrated as a story: "Its most immediate appeal [to writers] is that of spectacle, in itself wordless, lacking a language, that requires others to define it, celebrate it, com-plete it. Like all extreme but perishable human actions boxing excites not only the writer's imagination, but also his instinct to bear witness" (1994a, 50–52). At the same time, for Oates, boxing defies the prose writer's instinct for developing a coherent narrative line: "Ringside an-nouncers give to the wordless spectacle a narrative unity, yet boxing as performance is more clearly akin to dance or music than narrative." Moreover, not only is boxing a "story without words," but also a "text [that] is improvised in action; the language a dialogue between the box-ers of the most refined sort (one might say, as much neurological as psy-chological: a dialogue of split-second reflexes)" (11). Boxing, in short, *presents* information immediately, in contrast to narrative, which *represents* the internal (both psychological and neurological) experience of the main characters who, in boxing's case, are made of flesh and blood.

As a skillful (if barbaric) performance that takes place according to rules of conduct and stylistic conventions, boxing does, however, operate in codes that are similar to those which inform literary texts. The narrative shape of a match, for example, is controlled by the length and number of rounds and the requirement for ringside judges to interpret the fight by deciding on a winner, unless a knockout occurs. Most fights end in an official "decision" by ringside judges, just as the canvas ring functions as the setting where violence is made available for speculation, narration, and interpretation. These civilizing restrictions camouflage the horror of the thing itself, of course, in a fashion not unlike the verbal banner under which the "sweet science," as boxing is sometimes described, marches on as "the manly art of self-defense."

Inside the artificially restrained medium, the rules of boxing are enforced by a referee, the "shadowy third" figure who according to Oates is "so central to the drama of boxing" that without him "the spectacle of two men fighting each other unsupervised in an elevated ring would seem hellish, if not obscene—life rather than art. The referee makes boxing possible" (1994a, 47). The referee, moreover, is aligned with both audience and the artist. Usually male, he typically wears the clothes of a middle-class spectator—such as a tie, patent leather shoes, dress shirt with buttons and collar, and slacks, rather than the glossy trunks and high lace boots of the fighter. At the same time, the referee is unlike any spectator at ringside, because no boundary exists between him and the fighters with whom he stands in the ring.

The referee, furthermore, is seldom able to remain free of the blood spilled in the ring if he is doing his job properly and staying close to the fighters; punches delivered to or near any cuts on a fighter's face nearly always send blood in every direction, some of which frequently lands on the referee's shirt. Literally inside and figuratively outside the ring, he is also the only spectator who can influence the violent performance through a crude sign language that is used to count a fighter out, to point a standing fighter to a "neutral corner," or to indicate to the ringside judges a fighter's loss of points for infractions of the rules such as a "rabbit punch" or a "low blow." As the one who authorizes violence by allowing it to occur under rules and conditions established by state athletic commissions, he embodies the community's standards for behavior in a civic spectacle, but in judging which actions can be witnessed and tolerated, he is also like the

artist who directs the performance and enables the audience to behold what goes on. In functioning as an active form of witnessing, finally, refereeing can also become injurious to the body of fighters when it omits and redescribes a warlike activity, and the same is true of the novelist who "writes of violence, brutality, sordidness, sexual compulsion, and emotional duress," as Joanne Creighten says of Oates's own work (1).

In "Golden Gloves," Oates addresses this kind of situation in terms of the various rhetorical modes she uses to tell the story of an anonymous boy, born with a club foot, who, after surgery, attempts to live out an American fable by becoming a Golden Gloves champion. In the first part of the story, Oates uses a rhetoric of romance to describe the boy's striving for renown. Celebrating the youthful, invulnerable body of the up-and-coming fighter who has not yet faced punishment and loss, Oates emphasizes the intoxicating, erotic appeal of boxing:

> He loved the sinewy springiness of his legs and feet, the tension in his shoulders; he loved the way his body came to life, moving, it seemed, of its own will, knowing by instinct how to strike his opponent how to get through his opponent's guard how to hurt him and hurt him again and make it last. His clenched fists inside the shining gloves. His teeth in the mouthpiece. Eyes narrowed and shifting behind the hot lids as if they weren't his own eyes merely but those belonging to someone he didn't yet know, an adult man, a man for whom all things were possible. (2221)

At this stage in his story, the boy inflicts more pain on lesser fighters than he receives; he has yet to become the violated body in pain. In describing the way that the boy watches films of classic fights, Oates goes on to suggest how he has been shaped by the cultural tradition inscribed in boxing, whereby he functions as a conceptual version of the spectator at a boxing match:

> Sometimes on Saturday afternoons the boys were shown film clips and documentaries of the great fighters. Jack Dempsey—Gene Tunney—Benny Leonard—Joe Louis—Billy Conn—Archie Moore—Sandy Saddler—Carmen Basilio—Sugar Ray Robinson—Jersey Joe Walcott—Rocky Marciano. He watched entranced, staring at the flickering images on the screen, some of the films were aged and poorly preserved, the blinds at the windows fitted loosely so that the room wasn't completely darkened, and the boxers took on an oddly ghostly insubstantial look as they crouched and darted and lunged at one another. Feinting, clinching, backing off, then the flurry of gloves so swift the eye couldn't follow, one man suddenly down and the other in a neutral corner, the announcer's voice rising in excitement as if it

were all happening now right now and not decades ago. More astonishing
than the powerful blows dealt were the blows taken, the punishment
absorbed as if really finally one could not be hurt by an opponent, only
stopped by one's own failure of nerve or judgment. If you're hurt you
deserve to be hurt! (2221–2222)

Shortly after this romantic evocation, however, Oates's narrative style shifts
to a realistic mode. With the same abrupt shock that comes with an un-
seen punch to the fighter's jaw, the reader's expectations for the boy's tri-
umph over physical adversity are shattered with a blunt description of the
outcome of his boxing career: "Then of course he was stopped and his
'career' ended abruptly and unromantically. As he should have foreseen"
(22). In the same way that she undoes the boy's aspirations by having
him dealt a single quick punch by a fighter who will himself die of ring
injuries a few years later, Oates undoes the reader's initial reception of
boxing as a legendary form of self-actualization and masculine affirma-
tion. If the boy could not "foresee" the tragic outcome to his quest for
the Golden Gloves title, Oates seems to be implying, he has been made
blind by rhetoric of the kind that she has employed.

As in *On Boxing*, Oates's concern about how to display this sport—
whether realistically or romantically—reflects on her ambivalence about
her own verbal power to represent violence. On the one hand, "Golden
Gloves" evokes the glamorous dimensions of boxing and presents it as a
heroic theater of individual confrontation with fate, but on the other
hand it deflates this romanticizing and reveals the way that rhetorical
flourishes may influence readers into accepting the cultural myths that
foster boxing and authorize bodily pain. Thus, as an alternative to a cul-
ture of male-dominated violence, Oates concludes the story by describing
the childbearing labor of Annemarie, the boxer's wife. Whereas the
boxer is left experiencing a kind of death in life because of his early fail-
ure to achieve glory in the ring, Annemarie is presented as striving to
overcome adversity and bodily pain as she struggles for a second time to
give birth after an initial miscarriage.

In *On Boxing*, Oates observes how the fright a fellow novelist experi-
enced during the Marvin Hagler–Tommy Hearns bout of 1985 also func-
tioned as a kind of "ecstatic participation" (104). Such awareness of how
pain can be converted into "its polar opposite" is in keeping with the tra-
dition of understanding writing as a way to produce recognition through

wounds and scars. As Linda Rugg has noted, verbal representation has been imagined as the scar left after the stylus has disturbed the surface of stone, wood, or paper—aligning it with messages like the scar of Odysseus and the Old Testament story of Cain and leading up to Derrida's study of Nietzsche, *Eperons/Spurs*. The question that remains for Oates to answer, however, is whether any discursive formation could be an adequate medium to metaphorize, narrate, or translate boxing, which she describes as a modern remnant of ancient tragic theater, and as an act that occurs within culture but is itself uncivilized, taboo, pornographic.

Similar questions have also recently been posed by Laura Tanner in a study entitled *Intimate Violence*, in which she applies to novels such as *Sanctuary* by William Faulkner, *1984* by George Orwell, and *The Women of Brewster Place* by Gloria Naylor perspectives on representing violence developed by film theorist Laura Mulvey. In "Visual Pleasure and Narrative Cinema," Mulvey had analyzed how cinematic conventions produce structures of looking that reflect the "patriarchal unconscious" by enabling spectatorship to become a form of power and domination (Mulvey, 746). Following Mulvey, Tanner observes that in much Hollywood cinema, violent acts performed by men against women are depicted in ways that separate "the erotic identity of the viewing subject . . . from the object (usually a woman) on the screen" (27).

Tanner critiques the aestheticization of violent rape in *Sanctuary* by showing how Faulkner exploits "the reader's bodiless status to invite a voyeuristic participation in the scene of violence" (x). Formal techniques may distance spectators from coming to terms with their own participation in violence, but an author's formal choices can also force the viewer to explore his or her implication, complicity, and association with violence. Thus Tanner feels that in contrast to *Sanctuary*, Naylor's novel pins the reader "to the victim's body and communicat[es] an experience of rape that genders the reader—whatever sex he or she may be—female" (32). As in Tanner's readings of how Faulkner and Naylor situate the reader differently in two novels about rape, Oates analyzes her own relationship to boxing in a way that draws writing and boxing close together (as acts of violence and violation) and far apart (as legible and illegible acts).

By attempting to break down the aesthetically produced barrier between spectator and participant through her empathetic identification with the boxer's trauma, Oates attempts to distinguish her spectatorship

from the male gaze of domination. As in the career-ending knockdown scene from "Golden Gloves," she unmakes the separation between spectator and participant by describing boxing as an event more about "being injured" than about "injuring." In *On Boxing*, instead of focusing on the Hollywood image of boxing found, most notoriously, in Sylvester Stallone's *Rocky* series—which Oates describes as "comic book" boxing that is loosely based on the story of the only *undefeated* heavyweight champion, Rocky Marciano—she attends to the fighter who can't get up after a punch (58). By focusing on "the moment of visceral horror in a typical fight" when "one boxer loses control, cannot maintain his defense, begins to waver, falter, fall back, rock with his opponent's punches which he can no longer absorb," Oates attempts to resist the voyeuristic pleasure of the invisible viewer who turns the victim's pain into a statement of the victimizer's power (60).

In *On Boxing*, Oates is concerned with the ethical implication of writing about violence and its connection to issues of authorial control, an aesthetic sensibility, and a claim to understanding the events witnessed. As she sees it, boxing involves questions about the legitimacy of chronological accounts of incoherent events (a question of narrative), of metaphoric comparisons between objects that are unlike, but are related as acts of violence and violation (a question of poetics), and the responsibility of the writer to account for his or her role in the performance of violence (a question of art and ethics). Calling attention to the discomfort and yet also to the attractions that she experiences when she looks closely at boxing, she describes the sport as both a cathartic tragic theater and a perversion of seeing that induces "self-loathing."

In her readings of how George Bellows situates himself in his boxing paintings, she identifies both with his protean stylistics and his self-conscious comparison of boxing and visual representation as acts of controlled violence. In doing so, she also notices how Bellows shifts his relationship from the "ecstatic participation" in the immediate fight that characterizes *Stag at Sharkey's* (1909) to a different kind of painting in *Dempsey and Firpo* (1924) in which Bellows indicates his awareness that it is in the "aftermath" to witnessing the real event that another kind of violation takes place. Oates, who is herself a master of using various modes and rhetorical techniques, feels that this is the secret of Bellows's uniqueness: "What distinguishes Bellows from the majority of his renowned

contemporaries, among them Edward Hopper, Georgia O'Keefe, John
Marin, is the remarkable diversity of his work" (1995, 2).

In *On Boxing*, Oates speculates that boxers, on entering the ring and
disrobing, lose their identities as citizens as they become existential em-
bodiments (not unique individuals at play) of the primal violence and
insane demands made on the body and brain unleashed when the bell
rings. In her interpretation of *Stag at Sharkey's*, Oates suggests that a similar
self-transformation takes place when Bellows paints a scene that transgress-
es the norms of civil behavior. As she sees it, the rough, swirling texture of
his brush strokes and the thick application of paint that appears to have
been smeared on the canvas in a rush of skilled activity anticipates the drip
technique of Jackson Pollock and the masculine ethos of "action painting"
in the 1940s and 1950s. In this way, both boxing and painting are repre-
sented as aggressively masculine activities that involve unconscious drives
for dominance over other contestants in an arena in which personal fame
and survival are at stake. According to Oates, "the illusion is that the artist
(and by extension the viewer) is physically present at ringside, not coolly
detached from the violence but vicariously, voyeuristically participating in
it" (4). The individual boxers seem less important to the event that Bellows
witnesses and arranges than in calling attention to the painterly act of cap-
turing boxing's savagery, almost inhuman violence, and seedy magnetism.

Stag at Sharkey's is Bellows's depiction of a 1907 prizefight held in Tom
Sharkey's saloon, just across Broadway from the painter's studio in the
Lincoln Arcade. The event took place when boxing was officially banned
in New York State but still took place in private clubs under police "pro-
tection" and did not pretend to be a legitimate professional sport. The
painterly techniques that Bellows used to depict the fighters are designed
to signify the speed of execution of the painting as a form of personal ex-
pression as well as the fierce action in the ring. Like the sportswriters
who promoted Jack Dempsey's "killer instinct" as a courageous reaction
to bureaucratization and industrialization in the modern period by an
individual whose background recalled mythic versions of the lone fron-
tiersman, Bellows's representation of boxing in *Stag at Sharkey's* has the
quality of what Bruce Evensen calls "expressive involvement" (xvii).
Relating the painting to Bellows's own situation, Oates writes: "What
more visually compelling metaphor of man's aggression than the boxing

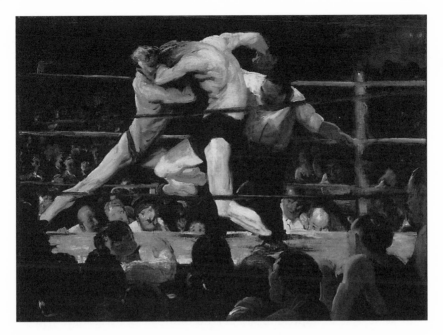

Figure 9. George Bellows. *Stag at Sharkey's* (1909). Oil on canvas,
92 x 122.6 cm. © The Cleveland Museum of Art. Hinman B. Hurlbut
Collection, 1133.1922.

ring? What more immediately striking image, for a fiercely ambitious and
competitive young artist from the Midwest, involved in his own struggle
for recognition?" (5).

Mahonri Sharp Young has described the painting as having "the rush
and wallop of the ring" (30). Like stag fights over breeding/feeding ter-
ritory, the two "boxers" are expressions of a fierce, degrading, clumsy,
animal clash—elbows, knees, and heads are the weapons employed, not
cleverly aimed fists; similarly the all-male spectators appear to share a dis-
torted neither-man-nor-beast appearance. As much as Bellows empha-
sizes the crude and brutal activity in the ring, however, he also represents
boxing as a form of controlled violence, comparable to the painter's appar-
ently spontaneous transformational attack on the materials of art. Al-
though the frenetic brush strokes have received more attention than the
form of the painting, Michael Quick has called attention to the architec-

tonic structures that undergirds the display: "While embodying the essential action, this geometry also serves as a firm armature, around which the action can swirl without dissipating its energy" (21–22).

Bellows also includes himself as a spectator in the painting, thereby doubly enacting the advice of his teacher, Robert Henri, who, according to Marianne Doezma, "encouraged his students to see life for themselves rather than train their vision according to classical prototypes and conventional formulas" (Doezma, 97). He appears in the background, on the right side of the painting, among the first row of spectators who sit behind the canvas ring. Glancing upward, presumably from a sketch pad, his characteristic balding head is half hidden by the canvas floor. Depicting himself as the up-and-coming artist as witness, he does not consider it important to depict the boxers' faces in any detail because the identity at stake in the violent interaction that produces the artistic expression is George Bellows. As Doezma has said of *Both Members of This Club*, Bellows's other boxing picture from 1909: "The painting is not the depiction of a static scene but an impressionistic record of the artist's visual and psychic experience of an event" (103). In this way *Stag at Sharkey's* reveals what Tanner, Mulvey, and Scarry call the complicity between violence and representation, or in David Morris's words, it "forces us to confront the suffering we normally evade, avert or deny" (263).

In *Stag at Sharkey's* Bellows suggests his complicity in the often fatal bouts held in Sharkey's Saloon by associating boxing with the masculinist ethos of the Ash Can School. In *Dempsey and Firpo* the focus is on the beholder's complicity in the violence of that famous event in its aftermath; Bellows's concentration here is on how ringside spectators respond as the champion, Jack Dempsey, falls out of the ring and as his half-naked body touches some of their fully clothed bodies. The fight depicted is one that was held before eighty-eight thousand fans at New York's Polo Grounds in September 1923. Dempsey eventually won after the Argentine challenger, Luis Firpo, was knocked down an outrageous seven times in two rounds. In her reading of this work, Oates argues that Bellows seems less interested in comparing the violence of boxing to the aggressive instincts of the painter than in memorializing a specific historical event that had already achieved mythic status by the time he painted it a year later.

Mahonri Sharp Young argues that *Dempsey and Firpo*, though famous, is "not one of his best" paintings because it fails as realism: "The figures are

unconvincing, the colors are ghastly green. . . . The referee is unreal" (144). Oates also draws attention to the lack of realism: "By choosing to paint 'Dempsey and Firpo' in a smoothly stylized manner, Bellows makes no attempt to communicate the essence of the fight, and of the fight's atmosphere" (58). Instead of being critical, however, Oates goes on to explain:

> Of course, *Dempsey and Firpo* is a work of the imagination, not journalism. It is under no obligation to be faithful to the historic event from which it derives. And there is something haunting, and indeed mythic, in these stiff, frozen figures—the statuesque Firpo with his improbably unbloodied, composed face; the helplessly plunging Dempsey with his slicked-down black hair; the referee, however impossibly, already in midcount; the flat tonalities of the colors; the compulsive painterly detail in, for instance, the newspapermen's clothing and the ring ropes. No figure strikes the eye as *alive*, let alone involved in a frenzied dramatic action—but perhaps that was the artist's point. That the Dempsey-Firpo match *was* unreal, best memorialized as illustration. (1995, 59)

Unlike *Stag at Sharkey's,* which expresses Bellows's psychic participation in "frenzied dramatic action" and registers the liveliness of the artist's perceptions at the expense of the distinct appearance of the subject matter, *Dempsey and Firpo* imagines the event from the perspective of a spectator who has filtered the harshness of bodily pain. The painting illustrates how in the aftermath of a violent event a viewer may reconstruct what he or she has witnessed in ways that turn reality into an illusion to the point of concealment. Discussing Bellows's late nature paintings, *The White Horse* and *Old Farmyard, Toodleums* (both 1922), in which an intense, dreamlike atmosphere prevails over the natural landscape, Oates states: "This is an art of reflection and memory. Not what the eye sees but what our deepest wishes would yield, had they sufficient power" (44). Like the utopian landscapes that display subjective desires rather than external nature, in *Dempsey and Firpo* Bellows cleans up the bloodied faces of the fighters and uses an abstract technique to sanitize the sport itself. Focusing on the moment when Firpo pushed or knocked the eventual winner, Dempsey, out of the ring in an improbable manner since the referee has begun the ten count as Dempsey falls between the ropes, the painting depicts what Donald Braider calls "Dempsey's unexpected flight into the arms of first-row spectators" (136). In *Stag at Sharkey's,* Bellows had interwoven foreground and background in a way that causes the viewer to experience the confusion of the arena during a fight. In *Dempsey and Firpo* Bellows's way of breaking the

boundary between art and experience involves casting Dempsey out of the ring ropes, a boundary that usually maintains a distance between boxer and spectator. In this painting, we can think of the ring ropes as the frame that surrounds a picture plane, another canvas that is the place where painters such as Bellows have enacted cultural violence.

In the moment that Bellows depicts from the first round of the title bout, Dempsey is being knocked by Firpo between the middle and top ring rope in the middle distance of the canvas and onto a group of ring-side reporters in the foreground who seem to be pictured as more shocked and repelled than anything else. It is as if they are forced to come into direct contact with the fighter's body and as if they cannot bear to see their beloved champion lose his title, but also that they want nothing to do with the results of their own blood lust when it falls on them. The referee, usually the mediator of ring violence, appears to be assisting in the breakdown of the distinction between actors and beholders. He holds the middle ring rope with his left hand as if he is pushing it down to help Dempsey reach the audience. With his right hand's index finger he points to the floor.

Oates suggests that the official is beginning to count Dempsey out of the fight, although she admits this is an improbable reading since Dempsey is still falling through the ropes. As I see it, if the referee is pointing to the canvas instead of enacting the count of ten, then he can be seen as anticipating, facilitating, and foretelling Dempsey's return to the ring; by pointing to the canvas (boxing and painting share this material) and by holding the ropes through which Dempsey must climb to return to the ring, the referee is, in fact, demanding that he reclaim his championship belt and legendary status or be counted out and forgotten.

As in *Stag at Sharkey's*, in *Dempsey and Firpo* Bellows again includes himself in the painting. His large, balding head is set in the first-row at the extreme left side of the canvas, where he is separated by two other spectators from the sportswriter on whose head and chest Dempsey falls. In this painting, he is thus self-consciously figured in the foreground, and his gaze is not fixed on the ring, as was the case with the way he depicted himself as a reporter in *Stag at Sharkey's*, but on the spectators who receive Dempsey's body. The crucial interaction, in short, is between reporters and fighters, not between the fighters, for what Bellows is emphasizing is how the response of the audience and reporters to what

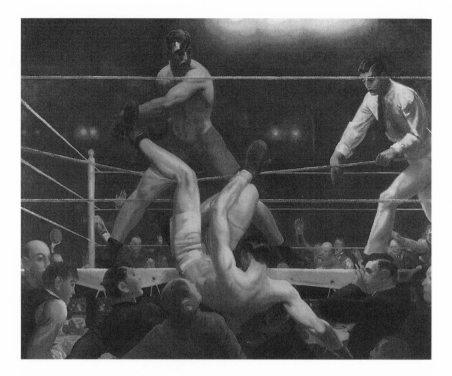

Figure 10. George Bellows. *Dempsey and Firpo* (1924). Oil on canvas,
51 x 63 1/4 in. (129.5 x 160.7 cm). Collection of Whitney Museum of
American Art, New York. Purchase, with funds from Gertrude Vanderbilt
Whitney, 31.95. Photograph © 2001, Whitney Museum of Art.

transpires in the Polo Grounds will transform the Dempsey and Firpo
bout into a cultural myth. Even more than the reporter's words and spec-
tator's memories, however, it is Bellows's own visual treatment of the
event—which hung among the nudes and nobles on the walls of New
York's Metropolitan Museum of Art—that will transform injury and pain in-
to the legend depicted as *Dempsey and Firpo*. As the contemporary sports-
writer Heywood Broun quickly understood: "Bellows painted well and for
all time. By and by everything the sportswriter ever said of Dempsey will be
forgotten. He will belong, then, to the ages and the art critics." (Roberts,
200). In *Stag at Sharkey's* Bellows had presented his own painting as a
masculine activity performed on the spot with a sense of frenzy for re-
nown that is comparable to boxing itself as a form of wild execution that

also requires training and skill. In contrast, *Dempsey and Firpo*, a second self-conscious painting about boxing, implicates the spectators of both art and boxing as cocreators of meaning in the aftermath to a spectacle of injury and pain.

Dempsey and Firpo is based on a historical event, but it documents the transformation of the real into the symbolic that occurs when an event of personal significance or cultural magnitude is revised and recast according to the requirements of memory. In *On Boxing* and "Golden Gloves" Oates shows not only how representing violent events can be an act of engagement that unmakes aesthetic barriers but also the extent to which verbal or graphic art may increase rather than reduce the distance between actor and beholder. In *Dempsey and Firpo*, Bellows paradoxically does both at the same time: he calls attention to his own complicity in enabling memory and narrative to translate violence into a remote myth by thrusting Dempsey out of the confines of the ring, onto the laps of the audience, and toward the viewers of his legendary painting. In this way, Bellows's shift from expressionism in *Stag at Sharkey's* to the stylized illustration of a legendary and historic event in *Dempsey and Firpo* illustrates as well Oates's theory that representation is also an act of interpretation that may distance what happens from what is recorded. *Dempsey and Firpo* is an act of remembering, but as Oates painfully notes in all of her discussions about representing boxing, it is also an act of forgetting.

Conclusion

Surviving Death

Andy Warhol, artist, New York City, 8/20/69

There is a well-known black-and-white image by New York fashion photographer Richard Avedon called *Andy Warhol, artist, New York City, 8/20/69*. The photograph depicts Warhol, standing and staring into the camera eye, wearing black jeans, a leather jacket, and a black shirt that he has lifted above his left nipple to expose two train-track scars and the indentation where a bullet had entered his abdomen a year earlier. The scars are the trace of evidence on Warhol's body that he has survived his own near fatal event, his being shot by Valerie Solanis, a disgruntled "Superstar" and the founder and sole member of SCUM (Society for Cutting Up Men) at the Factory on June 3, 1968. Avedon's photograph displays the fact that the wound has healed. Warhol has not only survived the terrorist act, but he now bears the scars as evidence signifying the achievement of closure after the shooting. The scars become a physical and emotional seal that registers the separation between June 3, 1968, when a bullet punctured Warhol's body, and the aftermath to the trauma in the form of scars that he showcases in a fashion photographer's por-

trait. In the photograph, Warhol gazes outward, toward the camera eye, and not down at his body, not down at the wound. He appears to have just finished lifting his shirt so that the camera can have full access to the scarred flesh, and he is in the process of pulling down his waist bandage as if it were a curtain or a veil or a garment that is part of a strip tease act. Avedon's version of Warhol performing a theatrical display of his midsection might be entitled "Showing Off: Torso with Two Scars," or "Saint Andrew and the Stigmata: Evidence of Life after Death." The "what happened" of Warhol's brush with death at the Factory in June 1968 has been, in effect, airbrushed into the performative display of the healed wound in the fashion photographer's depiction of Warhol's display of the scarred but healed skin. As in the *Death and Disaster* series, conceived by Warhol but produced by assistants in his Factory studio using mechanical processes, in the Avedon photograph, Warhol is depicted as a performance artist engaged in framing a wounded body after a violent episode. In this case, however, he is framing a wound to his own body, and in the act of framing, he is distancing the gristle of the actual wound from the imagined version of the fictional construct, Andy Warhol. In *Andy Warhol, artist, New York City, 8/20/69*, Warhol's brush with death has become one more of his "after" images. His framing of an earlier framed event—the photograph taken by Avedon that is like the Charles Moore photographs from *Life* on which Warhol based his *Car Crash* series— becomes a doubly mediated event. Warhol appears to demand a response from the beholder by looking directly into the camera eye. The process of double mediation, via Warhol and Avedon, however, has the effect of separating the viewer and the artist. This double mediation hinders the viewer from realizing that Warhol's injured body is a reflection of a living human being, made out of flesh and blood, who may be on the verge of death.

Warhol does not look like a flesh and blood human being in *Andy Warhol, artist, New York City, 8/20/69*. He is posed in a way that makes his wounded torso appear to be part of an archaic sculpture fragment. The wounded torso does not appear to belong to the rest of his body, his famous blond-mopped head and skinny limbs. Because he is wearing a very black sweater in contrast to the very white skin tone, his head and face, especially, seem bloodless and disconnected from the injured part of the body. The way Warhol's hands are positioned, the way the left

hand clasps his hips, and the way the right hand pinches down on a ban-
dage, coupled with the sharp contrast between the black clothes and the
scarred white skin, contributes to the disconnection between the wound-
ed torso and the implacable face. Because Warhol's hands form an oval
frame around the wounded area it is as if the torso were a cameo pen-
dant. His pale face, cast in an uncanny expression of bewilderment, gives
the impression that Warhol is alive but also frozen. In fact, Warhol
appears in the state of being frozen alive. Cryogenic, he has become an
uncanny living corpse, the face, like Marilyn's, removed from the sensual
body that wounds. Because of the color contrast between the clothing
(black) and the Warhol skin tone (white), it appears as if there are two
aspects to Andy Warhol. One is the mind, represented by the face and
head, and the other is the body, represented by the scarred torso. These
two aspects of Andy Warhol seem to be unrelated and are available to
separation, like a machine made out of movable parts: the famous face
in a state of bewilderment and frozen shock, and the scarred torso,
which Warhol's hands—the hands of the maker—encourage spectators
to view as a framed self-portrait. Avedon's picture, with the image of the
wound as stigmata, encourages spectators to believe that "Saint Andrew"
has escaped from the world of perishable bodies and that he now resides
in the immaculate world of appearances, the fictive space of Avedon and
Marilyn, and not Solanis. *Life* not life.

Warhol wanted to exist as an "after" image in the realm of appear-
ances alongside such celebrated survivors of cultural violence as Jackie
O., whom Warhol depicted in a series of panels as she appeared on the
day of President John F. Kennedy's assassination and in the sad days that
followed. Warhol depicts Jackie Kennedy smiling as she rides in the presi-
dential motorcade in Dallas prior to the assassination. She is wearing
black clothes, a black veil or kerchief, and a subdued expression at her
husband's funeral in *16 Jackies* (1964). As Riva Castleman has written,
"The choice of gray colors overprinted in black adds to the tragic aspect
of the subject, but the overall drabness of the black tone, and overex-
posed faces, drains all expression and empathy from the image" (*Prints
of Warhol*, 16). In the Avedon photograph, it is as if Warhol has become a
transgendered icon, at once the slain victim of a terrorist act, Jack Kennedy,
and the living mourner in black veil, Jackie Kennedy. Viewing the picture
makes me feel a chill because it is as if Warhol has represented himself as

surviving, witnessing, and staging his own death so that he can make a cameo appearance in life as a celebrated image of cultural mourning. As John Yau points out, Warhol made a cameo appearance as himself in an episode of *Love Boat*, a television comedy-drama from the 1970s in which celebrities guest star by entering a vacation cruise ship with a specific personal crisis. In the course of the segment, the celebrity comes to terms with the problem, and then, at the very end of the sixty-minute episode, leaves the ship, relieved of the pain—the emotional baggage— they had brought aboard along with their carry-on luggage.

According to David Bourdon, art editor at *Life* at the time when the artist was shot in 1968, Warhol had described the wish to survive his own death, the uncanny act being staged in the Avedon photograph. Just out of intensive care where surgeons had given him only a 50 percent chance of survival, Warhol telephoned Bourdon at *Life*. He expressed his disappointment that because Senator Robert Kennedy had been assassinated by Sirhan Sirhan the same week he, Warhol, had survived his assassination attempt by Solanis, a photo essay on Warhol that editors had planned to run before the shooting of either man took place had been put on hold so *Life* could focus exclusive attention on Kennedy.

> He wanted to find out what sort of press coverage he'd been getting. He knew that I was about to do an article on him for *Life* magazine, and he wanted to know how that was coming along. Actually, the piece had been finished and it was in the house before Andy was shot. We had all the photographs, the layout, everything. Then Andy was shot. The *Life* editors were ecstatic. It was going to be a lead story—eight or ten pages—a major space in the following issue.
>
> But then Robert Kennedy got shot. Andy's story was killed, and the cover story came out on the Senator . . . which was the obvious choice. The following week the Andy story was much less exciting to the editors, and they said to me, "Well, the only reason to run the story now would be if Andy . . . you know . . . died."
>
> So Andy kept calling me up: "Are they going to run the story this week?"
>
> I told him, "Andy, they're very mean. They'll only run the story if you die. I'd much rather have you alive, even if it means that my story doesn't get published."
>
> Andy wouldn't believe me. He kept saying, "Oh-h-h, can't you get it in anyway?"
>
> He wanted it both ways. (Stein, 292, 294)

In the Avedon photograph, Warhol frames the aftermath to his own

brush with death in a way that makes death seem unreal, unimaginable. Death seems to be the event that can happen to the car and plane crash victims that appeared in *The Daily News*, and to the civil rights protesters in Birmingham, not to him. The Death of Andy Warhol is an event that Warhol could once again situate himself as framing and observing. Warhol's expression in the Avedon photograph is uncanny because he is aware that he is having it both ways. Like Avedon's photograph of the healed wounds, Warhol in his *Car Crash* series represents the freeze-dried afterward to the impact of bodily trauma, but he ignores the slow, painful process of mourning, disfigurement, loss, and possible recovery as the effect of the crash would, in the real time of lived experience, resonate in the lives of the crash victims and their friends and relatives for years to come.

Sometimes, in writing about Yau writing about Warhol, I have felt uneasy with the poet/critic for not giving the artist enough credit as a visual critic, as well as a harbinger, of postmodernism. Yau focuses on Warholian grids and the "before" and "after" boxes that do seem to separate art from embodied life in their rigidity and denial of temporal flow. But I wonder about those haunting panels of images of Marilyn that seem to smear and darken and finally blur into oblivion as the viewer moves her or his eyes from left to right? For me, Warhol's multiple frames of Marilyn become as much a poignant lamentation for the hypermediated self as they are a celebration of the immortal staying power in the popular imagination of Marilyn's face, her red, red lips and dimple and golden hair. Even if Yau overstates the case of Warhol's own embrace of postmodernism, there is no doubt that his art has entered into the consumer network in a big way. In "Postmodernism, or the Cultural Logic of Late Capitalism" (1984), Fredric Jameson observes that contemporary economic formations, when viewed from a global perspective, are best represented by Warhol's glittery step into the intense pleasures of the surface of things in his colorful acrylic and silk screen with diamond dust on canvas *Diamond Dust Shoes* (1980) and by Bob Perelman's "Language" poem "China." Jameson contends that Warhol's attention to the intense surface of things, which appear to exist without background, historical con-

text, or hidden psychological depth, and Perelman's literary mode of "schizophrenic disjunction" display a fundamentally dehistoricized and, therefore, postmodern understanding of representation through their "virtual deconstruction of the very aesthetic of expression itself" (Jameson, 60).

Unlike the visual and verbal texts that I have been discussing throughout *Remarkable Modernisms*, Warhol's *Diamond Dust Shoes* illustrates to Jameson that conditions for the representation of personal interiority and public critique are unavailable to writers and artists at the present moment. Jameson compares the inadequacy of Warhol's shoes to reflect a place or a subjective "presence" with a modernist "depth" model of the same object, Van Gogh's *Old Boots with Laces* (1886?):

> There are . . . significant differences between the high modernist and the postmodernist moment, between the shoes of Van Gogh and the shoes of Andy Warhol. . . . The first and most evident is the emergence of a new kind of flatness or depthlessness, a new kind of superficiality in the most literal sense—perhaps the supreme formal feature of all the postmodernisms. . . . [W]hat we have said about the commodification of objects holds as strongly for Warhol's human subjects, stars—like Marilyn Monroe—who are themselves commodified and transformed into their own images. (60–61)

Jameson's pessimistic diagnosis of the postmodern style (depthless, simulated, intense, schizophrenically structured, dehistoricized, and blocking the completion of the interpretative circle between artist and beholder) may be an appropriate way to, in John Yau's words, "uncover the assumptions inherent in the ideals Warhol and his art are said to either so fully and radically embody or so completely and cynically negate." Warhol's art and Jameson's critique of it are valuable documentations of postmodernism, when viewed as a period, rather than a stylistic practice. They are among our most powerful testimonies to the pernicious effects of postnational corporate capitalism, telemediation, and a consumerist ideology on what Walter Benjamin called the "tiny, fragile human body" (84). Warhol's career testifies to the delegitimation of the integrity of the human body as a meaningful frame of reference as well as to the person's relationship to citizenship as a meaningful way of speaking about human relations as a shared public sphere of responsibility for other persons. For this reason, Warhol's art becomes the visual spur to Jameson's belated perception that the postmodern situation has troubled the possibility of communicating the depth of an artist's feelings to other citizens. In

Jameson's reckoning, the pain, lack, sympathy, and shock at trauma char-
acteristic of the greatest modernist paintings, such as *The Scream* by
Edvard Munch and *Guernica* by Pablo Picasso, are not available to post-
modernist artists.

Of course, I am not alone in expressing reservations about Jameson's
conclusions about the restricted and diminished scope of visual repre-
sentation. As Philip Harper, Linda Hutcheon, and Gayatri Spivak have
contended, Jameson's writings exclude the perspective of too many sub-
ject positions (besides that of a well-to-do, white male heterosexual pro-
fessor living in the United States) to meet the criteria for being an accu-
rate reflection on how artists and writers may respond to a normative set
of social, economic, and cultural arrangements.

As my introduction makes clear, I hope my study might contribute to
new readings of modern art that have fallen under the academic label of
the new modernism. I also hope my study contributes to renegotiations
of the meaning of postmodernism by considering the term in relation to
the complex perspectives on the nature of the self, the body, and the
visual and verbal textures of contemporary cultures in the United States
made evident in *Remarkable Modernisms*. Although their writings have not
been adequately taken into account in major theories of postmodernism,
the authors I have treated reflect on a world that Jameson or Baudrillard
must count as postmodern. Besides Simic's "My Shoes" and Yau's prose
poems that enact his call for an art that takes account of the "now" of
temporal experience and the relationship between language and the visi-
bility of the human body, the other texts I have addressed contest the
division of culture into "high" and "low" as well as perceive the lyric sub-
ject to be a construct that cannot be said to be grounded in a full pres-
ence outside of linguistic mediation. Writers as various in subject matter,
style, and personal "subject position" as Simic, Yau, Oates, Strand, and
Beattie confront fragmentation, cultural and geographic disorientation,
semiotic disturbances, personal lack, and the superficial aspects of every-
day life that have created an unmistakable legitimation crisis in terms
of understanding the subject in postmodernity. These authors inscribe
the self in texts even as they also understand the act of representation
in terms Paul de Man set forth in "Autobiography as De-facement" as acts
of disfiguration. As my penultimate chapter has indicated, Oates's com-
parison of writing *about boxing* to the grotesque ring violence that she has

been attracted to and repelled by since her father began to take her to boxing matches as a child represents representation not only as a way to work through trauma but also as a repetition of psychic and physical wounds that might have been made more meaningful if left uncovered. The writers on art respond in distinctive ways to the symptoms of the postmodern condition delineated by Jameson. What their responses have in common is the acceptance of death, as well as the confident, if temporary, display of contingent (not essential, but mediated) forms of reconstruction of the self after experiences of personal disorientation and political trauma. These confrontations with death have turned them in the direction of representation to embrace life.

Notes

Introduction

1. To make "discriminations of value" among individual works, Fried described the need to protect the integrity of painting from "contamination" with other types of discourse (116). By aestheticizing ethics, Fried denies art's relation to a world external to the framed canvas. In "Three American Artists," Fried is a dialectician, but within the limited context of solving problems specific to the enclosed sphere of advanced painting. He insists that tension, struggle, and change are evident in advanced painting, but are only evident to the extent that the artist responds to problems such as representing three-dimensional forms within the flat, two-dimensional surface of the picture plane, or the problem Greenberg described as the "sacrifice [of the] integrity of the object almost entirely to that of the surface" (Kuspit 27). Fried, in *Realism, Writing, and Disfiguration* (1987), a study of Thomas Eakins and Stephen Crane, has since developed a psychobiographical approach to intertext comparisons that negotiates the relationship between representation and trauma.

2. For Greenberg's comments see Kuspit, 18, 32, 45.

3. According to Ashbery: "The painting depicts the artist looking into a

convex mirror. He is holding his hand out in front of him, so that the hand is twice as large as his head, and the whole room is a sphere. It was actually painted on the convex surface of a wooden ball" (Bellamy, 17).

4. John Ashbery perceives representation as an enclosed sphere, and so strays from the paradigm of my study. In his "interpretative biography" of Pablo Picasso, *Portrait of Picasso as a Young Man* (New York: Atlantic Monthly Press, 1995), Norman Mailer emphasizes "my individual understanding of him" to such a degree that Picasso appears to be another mask through which Mailer can inscribe an "advertisement for myself" (xii). Picasso's life in Paris in the 1910s becomes a mirror through which Mailer reflects on his own obsessions with fame, crime, machismo, sex, and a bohemian lifestyle that flies in the face of middle-class norms in America after World War II. Mailer's narcissism stands in stark contrast to the authors I discuss in *Remarkable Modernisms* in that it disables him from negotiating the relationship between author and artist, self and other, in a way that extends beyond the scope of his own autobiographical impulses. Mailer admits his study offers "no original scholarship, much personal interpretation" (xii). He interprets Picasso's behavior–especially his sexuality, possible homosexuality, opium use, toting a hand gun in Paris, and competitiveness with other artists such as Matisse and Braque—by drawing on cultural references that directly link Picasso's Paris of the 1910s to Mailer's New York City of the 1950s and 1960s. For example, Mailer compares Picasso's competitiveness and vanity to Muhammad Ali's (239), Picasso's reticence about talking about his own work in interviews to Marlon Brando's (293), his interpretation of the difference between how to respond to an opponent with a gun and a knife by quoting Jimmy Hoffa (198), and Picasso's sex life and narcissism by quoting from *Genius and Lust*, Mailer's own study of Henry Miller. Mailer likens Picasso's evenings of charades to "gatherings that artists sixty years later would refer to as happenings" (274). Picasso's opium smoking and love affair with Fernande Olivier are events that "personify at this point all those delicate, lovely, and exploratory romances that flourished like sensuous flowers on slender stems, those marijuana romances of the Fifties and Sixties in America where lovers found ultimates in a one-night stand, and on occasion stayed together" (145). Discussing Picasso's cubism, Mailer quotes from his own book on the Apollo space mission, *Of a Fire on the Moon* (Boston: Little Brown, 1969). "One had no sense of scale. It was not possible to tell whether the photograph was of a square mile or of a square five hundred miles. Craters the size of New York were indistinguishable from craters the size of a house" (*Portrait of Picasso*, 255).

5. Katz created two-dimensional, stand-up cutouts of Hessian soldiers as the backdrop for Koch's play *Washington Crossing the Delaware*, a theme based on a nineteenth-century painting by Emanuel Leutze, later depicted in a famous early pop work by Rivers from 1953 that also sparked Frank O'Hara's poem called "On

Seeing Larry Rivers' *Washington Crossing the Delaware* at the Museum of Modern Art."

Chapter One

1. Arthur Danto celebrates Warhol in *Beyond the Brillo Box* for performing the radical and postmodern act of breaking down the hierarchy of "high" and "low" culture by following John Dewey in challenging the distinction between art and experience:

> What made Pop Art popular is that the meanings its works embodied belonged to the common culture of the time, so that it was as if the boundaries of the art world and of the common culture coincided. . . . The art redeemed the signs that meant enormously much to everyone, as defining their daily lives. Warmth, nourishment, orderliness, and predictability are profound human values which the stacked cans of Campbell's soups exemplify. The Brillo pad emblemizes our struggle with dirt and the triumph of the domestic order. (41)

By placing consumer goods such as the stacked cartons of Brillo boxes, the Campbell's soup cans, and the Coke bottle as objects of attention, Danto argues that Warhol embraced the tenets of mass production and mechanical reproduction. He did so, Danto claimed, to delegitimate the elitist and expensive museum culture and to bring an end to the aura surrounding the history of art because no one could any longer teach art history by example if everything (or nothing) could be defined as art outside of what Stanley Fish calls a "community of interpretation."

2. Buchloh writes: "The evidence of Warhol's essentially reactionary political attitudes does not answer the question which his work provokes aesthetically and there is not a single instance of a direct correspondence between Warhol's political consciousness (or, rather, the absence of it) and the oeuvre's interventions in traditional ideologies of artistic production and reception" (61–62).

3. "It is impossible . . . to discuss the origins and development of pop art—and especially the use of banal imagery so central to the style—without first remarking on the influence of Jasper Johns and Robert Rauschenberg. Both painters unleashed into the art ambiance various alternative proposals to abstract expressionism, chiefly by opening up painting (once again) to a greater range of imagistic content. . . . Warhol was undoubtedly aware of Johns' and Rauschenberg's art . . . but his direct use of comic-strip imagery as in *Dick Tracy* (1960) and *Nancy* and *Popeye* (both 1961) was an unexpected extension of their vocabulary" (Coplans, 47).

Chapter Two

1. In an essay on John Ashbery and Frank O'Hara, Davidson contrasts the contemporary "painterly poem" to the "classical painter poem," or a poem "about a painting or work of sculpture which imitates the self-sufficiency" of the object:

> A poem "about" a painting is not the same as what I am calling a "painterly poem," which activates strategies of composition equivalent to but not dependent on painting. Instead of pausing at a reflective distance from the work of art, the poet reads the painting as a text, rather than as a static object, or else reads the larger painterly aesthetic generated by the painting. (72)

2. In "Electric Drills" the "you" is a friend at Adolph's, the campus bar at Bard. During a phone conversation years after meeting Yau at the bar, the friend becomes involved in Yau's story by prompting him to write about what happened in 1971. Yau takes seriously his friend's suggestion by extending the meaning of "what happened" to include the complex history of the transmission of the event. The dialogic quality of autobiographical storytelling to a specific "you" extends beyond the scene at Adolph's in the early 1970s, however, as Yau meditates on his contemporaneous relationship to his friend: "Recently, I called him up. We haven't seen much of each other in the last seven years, but we manage to keep in touch. He asked me if I ever thought about writing down the story I told him" (1980, 74). In "Electric Drills" the communicative act that turns Yau toward writing his story is also the event that keeps him "in touch" with an old friend by recounting a trauma in which two other friends died.

Chapter Four

1. For Cornell's influence on poets besides Simic, see Trudy Gunee, "Dream Palaces and Crystal Cages: Dialogue between the Work of Herbert Morris and Joseph Cornell," and John Ashbery, *Reported Sightings. Art Chronicles: 1957–1987.*

2. Bakhtin continues: "Non-being cannot become a moment in the being of consciousness—it would simply not exist for me, i.e., being would not be accomplished through me at that moment. Passive empathizing, being-possessed, losing oneself—these have nothing in common with the answerable act/deed of self-abstracting or self-renunciation" (16).

3. *Dime-Store Alchemy* displays the qualities of improvisation and surprise that critics such as Gary Saul Morson and Caryl Emerson have identified as signs of a "genuine dialogue" between authors and readers: "Something unforeseen results, something that would not otherwise have appeared. The text allows for and invites this sort of interaction, but does not contain its result" (Morson and Emerson, 4).

4. In *On the Grotesque*, Geoffrey Harpham writes: "I argue that the grotesque appears to us to occupy a margin between 'art' and something 'outside of' or 'beyond' art. In other words, it serves as a limit to the field of art and can be seen as a figure for a total art that recognizes its own incongruities and paradoxes" (xxii).

5. In a notebook entry, Simic suggests his interest in juxtaposing sacred and profane materials: "If I make everything at the same time a joke and a serious matter, it's because I honor the eternal conflict between life and art, the absolute and the relative, the brain and the belly, etc. . . . No philosophy is good enough to overcome a toothache . . . that sort of thing" (1990b, 87).

Chapter Five

1. Joseph Epstein described Beattie as having "a deadly eye for right details," (58) and David Kubal noted that her "aesthetic surfaces are coolly brilliant" (Montressor, 8). With regard to the stripped-down quality of Beattie's prose, Deborah DeZure has pointed to Beattie's attention to the sculptural use of negative space in one of her stories as a metaphor for the protagonist's sense of void and loss of self, while in a more general sense, Susan Jaret McKinstry urges us to "[l]isten to the tale not being told" (Montressor, 8). In addition to this summary, writers have described her style in ways that are strikingly close to how Katz's paintings have been described by art critics. One writer has described her style as "straightforward, unadorned sentences in which metaphor is surprising because of its rarity"(Taylor, 208) and another critic has interpreted her fiction in spatial terms as "flat severity" (Bell, 44).

2. For Beattie, Katz's style reflects a general crisis in what Maeera Y. Shreiber has described in the context of Jewish identity and its Diasporic poetics as the emphasis on dissociation that "necessarily precludes a discourse that can imagine other configurations of community and belonging" (274).

3. John W. Coffey writes that Katz has claimed his *Self-Portrait with Sunglasses* was "inspired by a popular series of Chrysler ads featuring the ever-charming Richard Montalban" (Coffey, 10).

4. One of his first large-scale paintings, a self-portrait called *Passing* (1962), similarly registers Katz's ambivalent response to the construal of identity as an artifact. The title, *Passing*, holds an ambiguous relationship to the image of Katz-a Jewish man born in 1927 who has a studio in SoHo—who is portrayed in the Fedora hat, tie, and overall formal attire most often associated with a thirties gumshoe such as Sam Spade in a film noir such as *The Maltese Falcon*, a gangster, or with a traveling salesman. According to John W. Coffey, Katz has said the title has a double meaning. "The first alludes to a fleeting experience—a stranger glimpsed in passing. The second suggests the artist's attempt to pass himself off

as that stranger" (Coffey, 9). Among the various meanings of the term *passing* that I would add to Katz's own "double meanings" is the way a member of a scapegoat minority group, such as a Jew, might wish to "pass" as a non-Jewish (white) male by constructing his appearance to conform to mainstream expectations, styles, manners, and tastes. The ability to "pass himself off" as a member of a social group associated with the normative subject position—straight, white, male gentile businessman—is related to the degree of abstraction through which the person is seen by others. The word passing also suggests how self-portraits are, like a still life of a bowl of fruit and flowers (*life killed*), acts that call attention to the simultaneous process of living and dying whenever a person is transformed into an object of attention in art. By titling his theatricalized self-portrait *Passing*, Katz calls attention to the vitality of the artist through the skill of his hand in the creation of his own image, but he also registers the ephemeral, or "passing," nature of his existence. Katz, in fact, has in the 1980s painted a self-portrait, the tripaneled *Sweatshirt III* (1986), that reveals the effects of time and aging on the human face, the process of passing into late middle age. In *Sweatshirt III* the marks of difference that produce a recognizable facial image, such as the crow's feet or laugh lines around the eyes and mouth, are also in Katz's later self-portrait a sign of the personal image as impermanent, passing.

5. Similarly, discussing *Ada with Superb Lily* (1967), Carl Belz has described Ada as having composed her appearance before she sat down in front of Katz to paint her: "Whenever she appears . . . you can be sure of one thing: she will be composed and ready to meet here audience, a model of urbane decorum, fully in control, and invariably in style, glamorous even when casually attired" (Belz, 26).

Chapter Six

1. In "Eating Poetry" and "The New Poetry Handbook," which includes the stanzas "If a man understands a poem, / he shall have troubles" and "If a man gives up poetry for power, / he shall have lots of power," Strand represents experience as informed by artifacts.

2. Mitchell continues: "If ekphrastic hope involves what Françoise Meltzer has called a 'reciprocity' or free exchange and transference between visual and verbal art, ekphrastic fear perceives this reciprocity as a dangerous promiscuity and tries to regulate the borders with firm distinctions between the senses, modes of representation, and the object proper to each" (1994, 154–55).

3. One could argue that ekphrastic fear also rejects modernistic totalization, as it is a posture disturbed by the transformation of dialogic exchange into a monological unity. Ekphrastic hope erases spectatorial difference in favor of an assertion of verbal control.

4. In "The Visible and the Invisible" (1995), Strand critiques Deborah Lyons's *Hopper and the American Imagination*, Hopper's biographer, Gail Levin, as well as fiction and poetry based on Hopper paintings by authors such as Leonard Michaels, Joyce Carol Oates, and John Hollander. Each fails to acknowledge the significance of form as a conceptual block that repels interpretations of Hopper paintings as an unmediated expression of actual life. These authors have adapted Hopper's urban landscape paintings into poems and stories without acknowledging how aesthetic form destabilizes and subverts a picture's figurative power and narrative potential. Strand is especially unimpressed by Levin's thesis in her biography that because Hopper's wife, Jo Nivison Hopper, has been identified as the model for many of the female characters, it follows that his depiction of men and women who exist in physical proximity but in emotionally and psychologically distinct realms comments on his unhappy marriage. Strand argues that Levin's error is to concentrate on the relationship between the figurative content of Hopper's paintings and the artist's experience, rather than on the relations between the figurative and conceptual aspects of his art. In Levin's view, Hopper is a realist who works in what Norman Bryson calls the "natural attitude" tradition. He paints to act out and, potentially, to work through his unhappy intersubjective experience with Jo Hopper by reordering his personal life in art.

Just as Strand dismisses Levin's application of Hopper's biography onto the paintings, he disavows narratives by authors such as Hollander and Michaels, both of whom have projected their own experiences onto the paintings: "What people see in his pictures is not clear. . . . It is the impulse to create a network of contributing and qualifying factors for Hopper that diminishes his work. Deborah Lyons tends to read Hopper's paintings as continuous with the world instead of a world unto themselves; but Hopper's work does not need such contextualizing, as if it were made of puzzling slices of life that had to be put back in place" (31). Contradicting the popular version of Hopper as a documentarian of an apprehensive version of urban modernity, Strand argues that Hopper is instead an ambivalent formalist who invokes an ekphrastic crisis that pivots between hope and fear. I want to suggest that the contradictions within Strand's analysis of Hopper illustrate the tendency in his criticism to pivot between the "ekphrastic hope" evident in the writings of Hollander and Michaels and an "ekphrastic fear" that enables spectators to distinguish his art writings from the interpretations of paintings by the authors he criticizes.

5. In Allen Grossman's formulation, Oates's intrusive reading of *Nighthawks* is an example of the ekphrastic poet's refusal to exchange "the absolute claim of the will to actualization . . . for its symbolic and regulative diminishment as representation" (1900a, 274).

Works Cited

Allert, Beate, ed. 1996. *Languages of Visuality: Crossings between Science, Art, Politics, and Literature.* Detroit: Wayne State University Press.

Alloway, Lawrence. 1974. *American Pop Art.* New York: Macmillan.

Altieri, Charles. 1984. *Self and Sensibility in Contemporary American Poetry.* New York: Cambridge University Press.

Ashbery, John. 1991. *Reported Sightings. Art Chronicles. 1957–1987.* Cambridge: Harvard University Press.

Bacchilega, Cristina. 1981. "An Interview with Mark Strand." *Missouri Review* 4, no. 3: 51–64.

Bakhtin, Mikhail. 1993. *Toward a Philosophy of the Act.* Translated by Vadim Liapunov. Edited by Vadim Liapunov and Michael Holquist. Austin: University of Texas Press.

Balken, Debra Bricker. 1994. *Philip Guston's Poem-Pictures.* Andover, Mass: Addison Gallery of American Art.

Beattie, Ann. 1983. *Secrets and Surprises.* New York: Warner Books.

———. 1987. *Alex Katz by Ann Beattie.* New York: Harry N. Abrams.

Beaujour, Michel. 1991. *Poetics of the Literary Self-Portrait.* Translated by Yara Milos. New York: New York University Press.

Bell, Pearl K. 1993. "Literary Waifs." In *The Critical Response to Ann Beattie*, edited by Jaye Berman Montresor, 42–44. Westport, Conn.: Greenwood Press.

Bellamy, Joe David. 1984. *American Poetry Observed: Poets on Their Work*. Urbana: University of Illinois Press.

Belz, Carl. 1995. *The Herbert W. Plimpton Collection of Realist Art*. Waltham, Mass.: Brandeis University Publications.

Benjamin, Walter. 1969. *Illuminations*. Edited by Hannah Arendt. Translated by Harry Zohn. New York: Schocken.

Bensko, John. 1986. "Reflexive Narration in Contemporary American Poetry: Some Examples from Mark Strand, John Ashbery, Norman Dubie, and Louis Simpson." *Journal of Narrative Technique* 16, no. 2: 81–96.

Benstock, Shari, and Suzanne Ferriss, eds. 1994. *On Fashion*. New Brunswick, N.J.: Rutgers University Press.

Bergman, David. 1991. Introduction to John Ashbery, *Reported Sightings. Art Chronicles. 1957–1987*. Cambridge: Harvard University Press.

Berkson, Bill. 1971. "Alex Katz's Surprise Image." In *Alex Katz*, edited by Irving Sandler and Bill Berkson, 21. New York: Praeger Publishers.

Bloom, Harold. 1976. *Wallace Stevens: The Poems of Our Climate*. Ithaca, N.Y.: Cornell University Press.

Braider, Donald. 1971. *George Bellows and the Ashcan School of Painting*. Garden City, N.J.: Doubleday.

Bryson, Norman. 1983. *Vision and Painting: The Logic of the Gaze*. New Haven, Conn.: Yale University Press.

Buchloh, Benjamin H. D. 1989. "The Andy Warhol Line." In *The Work of Andy Warhol*, edited by Gary Garrels, 52–69. Seattle: Bay Press.

Buchwald, Emilie, and Ruth Roston, eds. 1984. *The Poet Dreaming in the Artist's House: Contemporary Poems about the Visual Arts*. Minneapolis: Milkweed.

Caruth, Cathy. 1996. *Unclaimed Experience*. Baltimore: Johns Hopkins University Press.

Castleman, Riva. 1990. *The Prints of Andy Warhol*. Flammarion: Jouy-en-Josas, Cartier Foundation for Contemporary Art.

Clark, T. J. 1982. "Clement Greenberg's Theory of Art." *Critical Inquiry* 9, no. 1: 139–56.

Coffey, John W. 1990. *Making Faces: Self-Portraits by Alex Katz*. Raleigh: North Carolina Museum of Art.

Cohen, David. 1998."A Scaled-Up World." *Art in America*, May, 102–9.

Coles, Katherine. 1992. "In the Presence of America: A Conversation with Mark Strand." *Weber Studies: An Interdisciplinary Humanities Journal* 9, no. 3: 9–28.

Cooper, Philip. "The Waiting Dark: Talking to Mark Strand." *The Hollins Critic* (Hollins College, Va.) 21:4 (October 1984): 1–7.

Coplans, John. 1971. *Andy Warhol.* New York: Graphic Society, 1971.

Costello, Bonnie. 1995. "John Ashbery's Landscapes." In *The Tribe of John Ashbery and Contemporary Poetry,* edited by Susan M. Schultz. Birmingham: University of Alabama Press.

Creigthon, Joanne V. 1992. *Joyce Carol Oates: Novels of the Middle Years.* New York: Twayne.

Crone, Rainer. 1989. "Form and Ideology: Warhol's Techniques from Blotted Line to Film." In *The Work of Andy Warhol,* edited by Gary Garrels, 70–92. Seattle: Bay Press.

Crow, Thomas. 1996. *Modern Art in the Common Culture.* New Haven, Conn.: Yale University Press.

Danto, Arthur C. 1992a."The Art of Giving." *Harper's Bazaar,* December, 61–62.

———. 1992b. *Beyond the Brillo Box: The Visual Arts in Post-Historical Perspective.* New York: Farrar, Straus, Giroux.

Davidson. Michael. 1983. "Ekphrasis and the Postmodern Painter Poem." *Journal of Aesthetics and Art Criticism* 42: 69–79.

De Man, Paul. 1984. "Autobiography as De-facement." *The Rhetoric of Romanticism.* New York: Columbia University Press.

De Salvo, Donna. 1992. "Subjects of the Artists: Towards a Painting without Ideals." In *Hand-Painted Pop: American Art in Transition, 1955–1962,* edited by Russell Ferguson, 67–94. New York: Rizzoli.

Dettmar, Kevin J. H., ed. 1992. *Rereading the New: A Backward Glance at Modernism.* Ann Arbor: University of Michigan Press.

DeZure, Deborah. 1993. "Images of Void in Beattie's 'Shifting.'" In *The Critical Response to Ann Beattie,* edited by Jaye Berman Montresor, 30–35. Westport, Conn.: Greenwood Press.

Dickinson, Emily. 1955. *The Complete Poems.* Edited by Thomas H. Johnson. Boston: Little, Brown.

Doezma, Marianne. 1992. *George Bellows and Urban America.* New Haven, Conn.: Yale University Press.

Doyle, Jennifer, Jonathan Flatley, Jose Esteban Munoz, eds. 1996. *Pop Out: Queer Warhol.* Durham, N.C.: Duke University Press.

Early, Gerald. 1988. "The Grace of Slaughter: A Review-Essay of Joyce Carol Oates's *On Boxing." Iowa Review* 18, no. 3: 173–86.

Edelstein, Teri, and James Wood, eds. 1993. *The Art Institute of Chicago: The Essential Guide.* Chicago: Art Institute of Chicago.

Epstein, Joseph. 1993. "Ann Beattie and the Hippoisie." In *The Critical Response to Ann Beattie,* edited by Jaye Berman Montresor, 57–64. Westport Conn.: Greenwood Press.

Evensen, Bruce J. 1996. *When Dempsey Fought Tunney: Heroes, Hokum, and*

Storytelling in the Jazz Age. Knoxville: University of Tennessee Press.

Fairbrother, Trevor. 1989. "Skulls." In *The Work of Andy Warhol,* edited by Gary Garrels, 93–114. Seattle: Bay Press.

Ferguson, Russell, ed. 1992. *Hand-Painted Pop: American Art in Transition, 1955–1962.* New York: Rizzoli.

Fisher, Philip. 1991. *Making and Effacing Art: Modern American Art in a Culture of Museums.* New York: Oxford University Press.

Foster, Edward. 1990. "John Yau." *Talisman: A Journal of Contemporary Poetry and Poetics* 5 (Fall): 31–50, 113–51.

Francis, Richard. *Jasper Johns.* New York: Abbeville Press. 1984.

Fried, Michael. 1982. "How Modernism Works: A Response to T. J. Clark." *Critical Inquiry* 9, no. 1: 217–34.

———. 1984. "Painting Memories: On the Containment of the Past in Baudeliare and Manet." *Critical Inquiry* 10, no. 3: 510–42.

———. 1987a. *Realism, Writing, Disfiguration: On Thomas Eakins and Stephen Crane.* Chicago: University of Chicago Press.

———. 1987b. "Three American Painters." In *Modern Art and Modernism: A Critical Anthology,* edited by Francis Frascina and Charles Harrison, 115–21. New York: Harper and Row.

———. 1998. *Art and Objecthood.* Chicago: University of Chicago Press.

Froula, Christine. 1996. "The X-Rayed Gaze: Self-Portraiture, Censorship, and Narrative of Public Conscience in Twentieth-Century Art." Paper presented at the 10th International Narrative Conference, April 27, Ohio State University, Columbus, Ohio.

Gaiger, Jason. 1996. "Constraints and Conventions: Kant and Greenberg on Aesthetic Judgement." *British Journal of Aesthetics* 39, no. 4: 376–91.

Gelfant, Blanche. 1993. "Ann Beattie's Magic Slate or The End of the Sixties." In *The Critical Response to Ann Beattie,* edited by Jaye Berman Montresor, 21–29. Westport Conn.: Greenwood Press.

Geok-lin Lim, Shirley. 1999. "Japanese American Women's Life Stories: Maternality in Monica Sone's Nisei Daughter and Joy Kagawa's Obasan." In *Asian-American Writers,* edited by Harold Bloom, 89–108. Philadelphia: Chelsea House.

Gerlach, John. 1993. "Through 'The Octascope': A View of Ann Beattie." In *The Critical Response to Ann Beattie,* edited by Jaye Berman, 36–41. Westport, Conn.: Greenwood Press.

Gery, John. 1995. "Ashbery's Menagerie and the Anxiety of Influence." In *The Tribe of John Ashbery and Contemporary Poetry,* edited by Susan M. Schultz. Birmingham: University of Alabama Press.

Gessinger, Joachim. 1996. "Visible Sounds and Audible Colors: The Ocular Harpsichord of Louis-Bertrand Castel." In *Languages of Visuality:*

Crossings between Science, Art, Politics, and Literature, edited by Beate
 Allert, 49–96. Detroit: Wayne State University Press, 1996.

Golub, Adrienne, M. 1997. "Towards A Newer Critique/The Missing Link: The
 Influence of T. S. Eliot's Ultra-Conservative Criticism on Clement
 Greenberg's Early Rhetoric and Themes." *Art Criticism* 12, no. 1: 5–37.

Greenberg, Clement. 1940. "Toward a Newer Laocoön." *Partisan Review* 7 (Fall):
 296–310.

———. 1993. *The Collected Essays and Criticism.* 4 vols. Edited by J. O'Brian.
 Chicago: University of Chicago Press.

Gregerson, Linda. 1981. "Negative Capability." *Parnassus: Poetry-in-Review* 9, no.
 2: 90–114.

Grossman, Allen. 1990a. "On Management of Absolute Empowerment: Nuclear
 Violence, the Institutions of Holiness, and the Structures of Poetry."
 Agni 29–30: 268–78.

———. 1990b. "Remarks toward a Jewish Poetry as a Theophoric Project."
 Tikkun (May/June): 47–48, 103–5.

Gunee, Trudy. 1996. "Dream Palaces and Crystal Cages: Dialogue between the
 Work of Herbert Morris and Joseph Cornell." *Denver Quarterly* 30, no. 3:
 105–119.

Harpham, Geoffrey. 1982. *On the Grotesque: Strategies of Contradiction in Art and
 Literature.* Princeton, N.J.: Princeton University Press.

Hart, Kevin. 1989. "Writing Things: Literary Property in Heidegger and Simic."
 New Literary History: A Journal of Theory and Interpretation 21, no. 1:
 199–214.

Haynes, Deborah J. 1995. *Bakhtin and the Visual Arts.* New York: Cambridge
 University Press.

Heffernan, James. 1991. "Ekphrasis and Representation." *New Literary History: A
 Journal of Theory and Interpretation* 22: 297–316.

Heidegger, Martin. 1987. "The Origin of the Work of Art: Poetry, Language,
 Thought." Translated by Albert Hofstadler. In *Art and Its Significance: An
 Anthology of Aesthetic Theory*, edited by Stephen David Ross, 258–87.
 Albany: State University of New York Press.

Heller, Scott. 1999. "New Life for Modernism." *Chronicle of Higher Education*,
 November 5, A21–A22.

Hirsch, Edward. 1992. "Joseph Cornell: Naked in Arcadia." *New Yorker*, December
 21, 130–35.

———, ed. 1994. *Transforming Vision: Writers on Art.* Boston: Little, Brown.

Hollander, John. 1988. "The Poetics of Ekphrasis." *Word and Image* 4: 209–19.

Iyer, Pico. 1993. "The World according to Beattie." In *The Critical Response to Ann
 Beattie*, edited by Jaye Berman Montresor, 65-69. Westport, Conn.:
 Greenwood Press.

Jameson, Fredric. 1984. "Postmodernism, or The Cultural Logic of Late Capitalism." *New Left Review* 146 (July/August): 59–92.

Jay, Paul. 1994. "Posing: Autobiography and the Subject of Photography." In *Autobiography and Postmodernism*, edited by Kathleen Ashley, Leigh Gilmore, and Gerald Peters, 191–211. Amherst: University of Massachusetts Press.

Johnson, Anne Janette. 1991. "Charles Simic." In *Contemporary Authors*. New Revision Series, vol. 33. Detroit: Gale.

Jones, Caroline A. 1996. *Machine in the Studio: Constructing the Postwar American Artist.* Chicago: University of Chicago Press.

Kant, Immanuel. 1929. *Critique of Pure Reason.* Translated by Norman Kemp Smith. Basingstoke: Macmillan, 1929.

Kelen, Leslie. 1991. "Finding Room in the Myth: An Interview with Mark Strand." *Boulevard* 5/6, nos. 3-1: 61–82.

Kirby, David. 1990. *Mark Strand and the Poet's Place in Contemporary Culture.* Columbia: University of Missouri Press.

———. 1991. "Charles Simic." In *American Poets since World War II.* 2d ser. Detroit: Gale.

Krieger. Murray. 1967. "Ekphrasis and the Still Movement of Poetry; or Laokoon Revisited." In *The Poet as Critic*, edited by Frederick McDowell, 3–26. Evanston, Ill.: Northwestern University Press.

Kristeva, Julia. 1991. *Strangers to Ourselves.* Translated by Leon Roudiez. New York: Columbia University Press.

Kuspit, Donald. 1979. *Clement Greenberg: Art Critic.* Madison: University of Wisconsin Press.

LaCapra, Dominick. 1993. "The Personal, the Political, and the Textual: Paul de Man as Object of Transference." Paper presented to the NEH Summer Seminar for College Teachers on Critical and Theoretical Approaches to the Modern Novel, July. Cornell University, Ithaca, N.Y.

———. 1998. *History and Memory after Auschwitz.* Ithaca, N.Y.: Cornell University Press.

Landi, Ann. 1998. "Innocent Perceptions." *ARTnews* 97, no. 4: 170–72.

Lessing, Gotthold Ephraim. 1969. *Laocoön: An Essay on the Limits of Painting and Poetry* (1766). Translated by Ellen Frothingham. New York: Farrar, Straus and Giroux.

Levin, Gail, ed. 1995a. *The Poetry of Solitude: A Tribute to Edward Hopper.* New York: New York University Press.

———. 1995b. *Edward Hopper: An Intimate Biography.* New York: Knopf.

Ling, Amy. 1990. *Between Worlds: Women Writers of Chinese Ancestry.* New York: Pergamon Press.

———. 1999. "Writer in the Hyphenated Condition: Diana Chang." In *Asian-American Writers*, edited by Harold Bloom, 13–29. Philadelphia: Chelsea House.

Lippard, Lucy. 1971. "Alex Katz Is Painting a Poet." In *Alex Katz*, edited by Irving Sandler and Bill Berkson, 3. New York: Praeger.

Lyons, Deborah. 1995. *Edward Hopper and the American Imagination*. New York: W. W. Norton.

Lyotard, Jean Francois. *Postmodern Condition: A Report on Knowledge*. Translated from French by Geoff Bennington and Brian Mussumi. Minneapolis: University of Minnesota Press, 1984.

McClatchy, J. D., ed. 1988. *Poets on Painters: Essays on the Art of Painting by Twentieth-Century Poets*. Berkeley: University of California Press.

Malin, Irving. 1993. "Review of *Dime-Store Alchemy*." *Review of Contemporary Fiction* 13 (Summer): 267.

Miller, Nolan. 1981. "The Education of a Poet: A Conversation between Mark Strand and Nolan Miller." *Antioch Review* 39, nos. 1–2: 106–18, 181–93.

Mitchell, W. J. T. 1986. *Iconology: Image, Text, Ideology*. Chicago: University of Chicago Press.

———. 1992. "Ekphrasis and the Other." *South Atlantic Quarterly* 91, no. 3: 695–719.

———. 1994. *Picture Theory*. Chicago: University of Chicago Press.

———. 1996. "What Do Pictures Really Want?" *October* 77 (Summer): 71–82.

Modern American Painting. 1997. Editors of Time-Life Books. Alexandria, Va.: Time-Life Books.

Montresor, Jaye Berman, ed. 1993. *The Critical Response to Ann Beattie*. Westport Conn.: Greenwood Press.

Moon, Michael. 1996. "Screen Memories, or, Pop Comes from the Outside: Warhol and Queer Childhood." In *Pop Out: Queer Warhol*, edited by Jennifer Doyle, Jonathan Flatley, and Jose Esteban Munoz, 78–100. Durham, N.C.: Duke University Press.

Morris, Daniel. 1996. "'My Shoes': Charles Simic's Self-Portraits." *a/b/: Auto/Biography Studies* 11, no. 1: 109–27.

Morris, David B. 1991. *The Culture of Pain*. Berkeley: University of California Press.

Morson, Gary Saul, and Caryl Emerson. 1989. *Rethinking Bakhtin: Extensions and Challenges*. Evanston, Ill.: Northwestern University Press.

Mulvey, Laura. 1975. "Visual Pleasure and Narrative Cinema." *Screen* 16, no. 3: 6–18.

Nussbaum, Martha C. 1997. *Cultivating Humanity: A Classical Defense of Reform in Liberal Education*. Cambridge: Harvard University Press.

Oates, Joyce Carol. 1994a. *On Boxing.* New York: Ecco Press.

———. 1994b. "Golden Gloves." In *The Norton Anthology of American Literature.* 4th ed. Vol. 2. Edited by Nina Baym, 2219–28. New York: Norton.

———. 1995a. *George Bellows: American Artist.* New York: Ecco Press.

———. 1995b. "Edward Hopper, 'Nighthawks' (1942)." In *The Poetry of Solitude.* New York: Universe.

———, and Daniel Halpern, eds. 1990. *Reading the Fights: The Best Writing about the Most Controversial Sport.* New York: Prentice Hall.

O'Connor, Francis V. 1967. *Jackson Pollock.* New York: Museum of Modern Art.

Oliver, Mary. 1994. *A Poetry Handbook.* New York: Harcourt, Brace.

Orlich, Ileana A. 1992. "The Poet on a Roll: Charles Simic's 'The Tomb of Stephane Mallarme.'" *Centennial Review* 36, no.2: 413–28.

Owens, Craig. 1992. *Beyond Recognition: Representation, Power, and Culture.* Berkeley: University of California Press.

Peterson, Eric. 1994. "A Bughouse Interaction." *Bughouse* 2 (Summer): 47–59.

Poster, Mark, ed. 1988. *Jean Baudrillard: Selected Writings.* Palo Alto, Calif.: Stanford University Press.

Quick, Michael. 1992. *The Paintings of George Bellows.* New York: Harry N. Abrams.

Rabine, Leslie W. 1994. "A Woman's Two Bodies: Fashion Magazines, Consumerism, and Feminism." In *On Fashion,* edited by Shari Benstock and Susan Ferriss, 59–75. New Brunswick, N.J.: Rutgers University Press.

Ratcliff, Carter. 1991. "Alex Katz: Drawings." *Alex Katz: A Drawing Retrospective.* Utica, N.Y.: Munson-William-Proctor Institute.

Roberts, Randy. 1979. *Jack Dempsey: The Manassa Mauler.* Baton Rouge: Louisiana State University Press.

Rosenblum, Robert. 1999. *On Modern American Art: Selected Essays.* New York: Abrams.

Rugg, Linda. 1996. "Writing on the Body: Scarring and the Mark of History." Paper presented at the 10th International Narrative Conference, April 27. Ohio State University, Columbus, Ohio.

Sandler, Irving. 1996. *Art of the Postmodern Era.* New York: Harper Collins.

Scarry, Elaine. 1985. *The Body in Pain: The Making and Unmaking of the World.* New York: Oxford University Press.

Schimmel, Paul. 1992. "The Faked Gesture: Pop Art and the New York School." In *Hand-Painted Pop: American Art in Transition, 1955–1962,* edited by Russell Ferguson, 19–66. New York: Rizzoli.

Schmidt, Peter. 1982. "*White*: Charles Simic's Thumbnail Epic." *Contemporary Literature* 23, no. 4: 528–49. 1988.

———. *William Carlos Williams, the Arts, and Literary Tradition.* Baton Rouge: Louisiana State University Press.

Schneiderman, Leo. 1993. "Ann Beattie: Emotional Loss and Strategies of
 Reparation." *American Journal of Psychoanalysis* 53, no. 4: 317–33.
Schwarz, Daniel R. 1993. "Searching for Modernism's Genetic Code: Picasso,
 Joyce, and Stevens as a Cultural Configuration." *Weber Studies* 10, no. 1:
 67–86.
———. 1997. *Reconfiguring Modernism.* New York: St. Martin's Press.
Shapiro, Alan. 1996. *The Last Happy Occasion.* Chicago: University of Chicago
 Press.
Shapiro, David. 1979. "Poets and Painters: Lines of Color, Theory and Some
 Important Precursors." In *Poets and Painters,* edited by Dianne Perry
 Vanderlip, 7–27. Denver: Denver Art Museum.
———. 1984. "Art as Collaboration: Toward a Theory of Pluralist Aesthetics,
 1950-1980." In *Artistic Collaboration in the Twentieth Century,* edited by
 Cynthia Jaffee McCabe, 45–62. Washington, D.C.: Smithsonian
 Institution Press.
Shreiber, Maeera. "The End of Exile: Jewish Identity and Its Diasporic Poetics."
 PMLA 113, no. 2 (March 1998): 273–87.
Simic, Charles. 1985. *Uncertain Certainty: Interviews, Essays and Notes on Poetry.* Ann
 Arbor: University of Michigan Press.
———.1990a. *Selected Poems (1963–1983).* Expanded. New York: Braziller.
———. 1990b. *Wonderful Words, Silent Truth: Essays on Poetry and a Memoir.* Ann
 Arbor: University of Michigan Press.
———. 1992. *Dime-Store Alchemy: The Art of Joseph Cornell.* Hopewell, N.J.: Ecco Press.
———. 1994. *The Unemployed Fortune-Teller: Essays and Memoirs.* Ann Arbor:
 University of Michigan Press.
———. 1996. "Secret Maps: Holly Wright's Photographs of Hands." *Yale Review*
 84, no. 4: 26–28.
Smith, Jeanne Rosier Smith. 1999. "Monkey Business: Maxine Hong Kingston's
 Transformational Trickster Texts." In *Asian-American Writers,* edited by
 Harold Bloom, 201–216. Philadelphia: Chelsea House.
Smith, Roberta. 1998. "A 2d Look Reveals Surprises." *New York Times,* May 1,
 Weekend, B35, B40.
Solomon, Deborah. 1997. *Utopia Parkway: The Life and Work of Joseph Cornell.* New
 York: Farrar, Straus and Giroux.
Spindler, Amy M. 1997. "The Decade That Won't Go Away." *New York Times,*
 October 13, Living Arts, B1, B5.
———. 1998. "Tracing the Look of Alienation." *New York Times,* March 24,
 Fashion, A25.
Stein, Jean. 1982. *Edie: An American Biography.* Edited by George Plimpton. New
 York: Knopf.

Stone, Albert E. 1991. "Modern American Autobiography: Texts and
 Transactions." In *American Autobiography: Retrospect and Prospect*, edited by
 John Paul Eakin, 95–122. Madison: University of Wisconsin Press.

Strand, Mark. 1980. *Selected Poems*. New York: Atheneum.

———, ed. 1983. *Art of the Real: Nine Figurative Painters*. New York: Clarkson N.
 Potter.

———. 1987. *William Bailey*. New York: Harry N. Abrams.

———. 1991. "Views of the Mysterious Hill: The Appearance of Parnassus in
 American Poetry." *Gettysburg Review* 4, no. 4: 669–79.

———. 1994. *Hopper*. Hopewell, N.J.: Ecco Press.

———. 1995. "The Visible and the Invisible." *New Republic*, December 4, 29–35.

———. 2000a. "Fantasia on the Relations between Poetry and Photography." *The
 Weather of Words: Poetic Invention*, 17–32. New York: Knopf.

———. 2000b. "A Poet's Alphabet." In *The Weather of Words: Poetic Invention*,
 3–16. New York: Knopf.

Swanson, Dean. 1971. "Alex Katz." In *Alex Katz*, edited by Irving Sandler and Bill
 Berkson, 52–53. New York: Praeger.

Tanner, Laura E. 1994. *Intimate Violence: Reading Rape and Torture in Twentieth-
 Century Fiction*. Bloomington: University of Indiana Press.

Tashjian, Dickran. 1992. *Joseph Cornell: Gifts of Desire*. Miami Beach: Grassfield
 Press.

Taylor, David M. 1982. "Ann Beattie." In *Dictionary of Literary Biography*, 206–12.
 Detroit: Gale.

Thurley, Geoffrey. 1977. *The American Moment: American Poetry in the Mid-Century*.
 London: Edward Arnold.

Tomkins, Calvin. 1971. "Raggedy Andy." In *Andy Warhol*, edited by John Coplans,
 8–47. New York: Graphic Society.

Vanderlip, Dianne Perry, ed. 1979. *Poets and Painters*. Denver: Denver Art
 Museum.

Vendler, Helen, ed. 1985. *The Harvard Book of Contemporary American Poetry*.
 Cambridge, Mass: Harvard University Press.

———. "Totemic Shifting." 1992. *Parnassus* 18, no. 2: 86–99.

Wald, Priscilla. 1994. "'Chaos Goes Uncourted': John Yau's Dis(-)Orienting
 Poetics." In *Cohesion and Dissent in America*, edited by Carol Colatrella
 and Joseph Alkana, 133–58. New York: State University of New York
 Press.

Watney, Simon. 1989. "The Warhol Effect." In *The Work of Andy Warhol*, edited by
 Gary Garrels, 115–23. Seattle: Bay Press.

Weigl, Bruce, ed. 1996. *Charles Simic: Essays on the Poetry*. Ann Arbor: University
 of Michigan Press.

Yau, John. 1986. "Alan Cote: The Role of Drawing." *Sulfur* 13: 142.

———. 1988. "Meeting Thomas Daniel." *Sulfur* 23: 44–46.

———. 1989. *Radiant Silhouette: New and Selected Works, 1974–1988.* Santa Rosa, Calif.: Black Sparrow Press.

———. 1991a. *Don Van Vliet.* New York: Michael Werner.

———. 1991b. "Neither about Art nor about Life, but about the Gap between Seeing and Knowing: The Sculpture of Jackie Winsor." *Jackie Winsor.* Milwaukee: Milwaukee Art Museum.

———. 1992. "Famous Paintings Seen and Not Looked at, Not Examined." In *Hand-Painted Pop: American Art in Transition, 1955–1962,* edited by Russell Ferguson, 121–46. New York: Rizzoli.

———. 1993. *In the Realm of Appearances: The Art of Andy Warhol.* New York: Ecco Press.

———. 1994. "Three Statements about the Paintings of Robert Mangold." In *Robert Mangold: Recent Paintings and Drawings,* 5–9. New York: Pace Wildenstein.

———. 1995a. "Continuous Change." In *Chuck Close, Recent Paintings.* New York: Pace Wildenstein.

———. 1995b. "A New Set of Rules Every Other Day." In *Hawaiian Cowboys.* Santa Rosa, Calif.: Black Sparrow Press.

———. 1996. *The United States of Jasper Johns.* Boston: Zoland Press.

———. 2000a. "Active Participant: Robert Creeley and the Visual Arts." In *In Company: Robert Creeley's Collaborations,* edited by Amy Cappellazzo and Elizabeth Licata, 45–82. Chapel Hill: University of North Carolina Press.

———. 2000b. "A Matter of Pride." *Thomas Daniel: Into My Eyes. A Retrospective Exhibition, 1967–1999.* Seattle: University of Washington Press.

Young, Mahonri Sharp. 1973. *The Paintings of George Bellows.* New York: Watson-Guptill.

Index

Page references for illustrations are in italics.

DANIEL MORRIS was born in New York City and received his education at Northwestern University, Boston University, and Brandeis University, where he earned a Ph.D. in English and American literature in 1992. He is the author of *The Writings of William Carlos Williams: Publicity for the Self* (1995) and of numerous articles and essays on modern literature and art, as well as original poetry. He has taught at Harvard University and joined the faculty at Purdue University in 1994, where he is associate professor of English. Professor Morris lives in Indianapolis, Indiana, with his wife Joy and son Issac.